ntinople
or
ncealed.
Imagery
n Scully.

Eine Ausstellung der · An exhibition by the
Stiftung für Kunst und Kultur e.V. Bonn

Prestel Munich · Berlin · London · New York

Preface

A city, a landscape, a machine or an atmosphere – regardless of where and in which situation Scully finds himself, he transforms each scene and experience into colour. And his colours serve as synonyms for the atmospheric images which he has assimilated on his travels, for example, to Constantinople, Barcelona or New York. With Scully colour is possessed of a very special materiality. In a certain respect, the world of Sean Scully is a collection of material, which he arranges and constructs using colour. And his perspective on this world is imbued with sensuality.

Growing up in a working-class area of South London, he attended convent school and was captivated by the paintings in the churches which he visited almost daily and which eventually inspired him to become a painter. In his early years, he focused on figurative painting – apart from a brief flirtation with rhythm & blues music. Van Gogh, Nolde or Schmidt-Rottluff are the artists for whom he soon developed a keen fascination. It was his intensive preoccupation with Abstract Expressionism, and his ultimate discovery of Rothko which saw him embark upon a new path, which he has since pursued unwaveringly.

Lines and stripes, complex grid systems, vertical and horizontal coloured panels and fields characterise the language of form in Scully's painting. His works evince a lucid pictorial structure, rich in various combinations of geometric forms. And yet colour plays a crucial role, literally "charging" his paintings with great emotionality and intensity, and it heralds the beginning of the Scully phenomenon. By virtue of the colouration and expressive brush strokes, he succeeds in filling his abstract compositions with substance. The colour evokes associations of materiality, and behind the actual painting there is still something to discover – as the exhibition in Duisburg so spectacularly highlights. Influenced by the figurative tradition, Sean Scully allows the colour to become the subject in his abstract paintings, and his coloured stripes and fields are transformed into a window onto the material world.

Scully's work is infused with a sensuality which is mediated through the atmosphere, spirituality and materiality of the colour. As our minds fill with associative images and we glean from the works' titles the cause or location of the action, we can place ourselves into the position of the artist, who, for example, renders a sombre night in a dark brown hue or a jovial atmosphere in a specific blue. With this exhibition, Scully is inviting us to join him on a journey to Duisburg, Barcelona, New York – or Constantinople. His abstract compositions evoke clearly articulated images. Susanne Kleine has graphically decoded these associations in her contribution to this catalogue, and I trust that the journey to Constantinople reveals to the visitors to the MKM the mysteries which we identify with such exotic names such as Istanbul, Byzantium, Constantinople and rediscover in the paintings of Sean Scully.

The fact that this exhibition could be staged at such short notice is, of course, attributable in the first instance to the artist, who relished the opportunity of exhibiting in these rooms and of entering into dialogue with the collection. I would like to express my sincere thanks to the artist's team, to the lenders and, of course, to our curator Susanne Kleine, whose untiring dedication and commitment have proved so crucial in realising this exhibition. However, this show has also been made possible once again by the generous support of our partners and sponsors, without which the Museum Küppersmühle would not be able to stage its programme of temporary exhibitions. My heart-felt gratitude also goes to the Sal. Oppenheim bank, the Duisburg-based GEBAG and to Willis GmbH & Co. KG.

I am delighted that further partners will also be presenting the exhibition "Constantinople or the Sensual Concealed", namely the Ulster Museum in Belfast, the Weserburg | Museum für moderne Kunst in Bremen, together with the Kunstsammlungen Chemnitz. I would like to thank the directors of these institutions, Tim Cooke, Carsten Ahrens and Ingrid Mössinger for their kind cooperation and for the trust they have placed in us.

Walter Smerling
Director MKM

Vorwort

Eine Stadt, eine Landschaft, eine Maschine oder eine Stimmung – ganz gleich wo und in welcher Situation Sean Scully sich befindet, er transformiert das Gesehene und das Erlebte in Farbe. Seine Farben sind Synonyme für Stimmungsbilder, die er z.B. in Konstantinopel, Barcelona oder New York erlebt hat. Die Farbe ist bei ihm von besonderer Materialität. Die Welt des Sean Scully ist in gewisser Hinsicht eine Materialsammlung, die er mit Farbe komponiert und rekonstruiert. Und sein Blick auf die Dinge ist von Sinnlichkeit geprägt.

Sean Scully, der in einem Südlondoner Arbeiterviertel aufwuchs und eine Klosterschule besuchte, war schon als Kind beeindruckt von der Malerei in Kirchen, die er fast täglich aufsuchte, und fasste schließlich den Entschluss, Maler zu werden. In jungen Jahren gilt sein Hauptaugenmerk - abgesehen von einem kurzen Abstecher in die Rhythm & Blues Musik - der figurativen Malerei. Van Gogh, Nolde oder Schmidt-Rottluff sind Maler, die eine große Faszination in ihm auslösen. In dem Moment, in dem er sich jedoch intensiver mit dem abstrakten Expressionismus beschäftigt und schließlich Rothko für sich entdeckt, beginnt er einen ganz neuen Weg. Und diesen Weg geht er seither ganz konsequent.

Linien und Bänder, komplizierte Gittersysteme, vertikale und horizontale Farbstreifen und -felder prägen die Formensprache von Scullys Malerei. Seine Gemälde zeigen einen klaren Bildaufbau mit verschiedenen Kombinationen geometrischer Formen. Und doch spielt die Farbe die entscheidende Rolle, da sie die Bilder mit Emotionalität und Intensität regelrecht »auflädt«. Mit ihr beginnt nun das Phänomen Scully. Es gelingt ihm nämlich, seine abstrakten Kompositionen durch die Farbe und die Art, wie sie auf der Leinwand aufgetragen wird, mit Inhalt zu füllen. Die Farbe weckt Assoziationen der Gegenständlichkeit, es gibt hinter dem eigentlichen Bild noch etwas zu entdecken, dies macht die Ausstellung in Duisburg in besonderer Weise deutlich. Sean Scully, von der Gegenständlichkeit kommend, lässt in seinen abstrakten Gemälden die Farbe zum Gegenstand werden. Seine Farbstreifen und -felder werden zum Fenster in eine gegenständliche Welt.

Die Sinnlichkeit gilt es mithin bei Scully zu entdecken, die sich über die Stimmung, die Seele und die Materialität der Farbe mitteilt. Wenn das assoziative Denken in Gang kommt und die Titel der Werke uns Aufschluss geben über den Grund oder Ort des Geschehens, können wir uns in die Situation des Malers versetzen, der beispielsweise mit einem dunklen Braun eine schwere Nacht wiedergibt oder mit einem bestimmten Blau eine glückliche Stimmung in Barcelona. Der Künstler lädt uns mit der Ausstellung auf eine Reise ein, Duisburg, Barcelona, New York - oder Konstantinopel. Mit seinen abstrakten Kompositionen verbinden sich ganz klare Bilder. Susanne Kleine hat diese Assoziationen in ihrem Katalogbeitrag anschaulich entschlüsselt, und ich hoffe, dass dem Betrachter im MKM die Reise nach Konstantinopel Geheimnisse vermittelt, die wir mit dem Klang des Namens Istanbul, Byzanz, Konstantinopel verbinden und in der Malerei von Sean Scully wiederfinden.

Dass diese Ausstellung so kurzfristig möglich wurde, ist natürlich in erster Linie dem Künstler zu verdanken, den die Ausstellungsräume begeistert haben, den aber auch der Dialog zur Sammlung sehr gereizt hat. Auch beim Team des Künstlers sowie bei unseren Leihgebern möchte ich mich an dieser Stelle ausdrücklich bedanken. Auf das herzlichste danke ich zudem unserer Kuratorin Susanne Kleine, die mit großem Engagement diese Ausstellung realisiert hat. Ermöglicht wird die Schau abermals von unseren Partnern und Sponsoren, deren Unterstützung das Museum Küppersmühle sein Wechselausstellungsprogramm verdankt. Mein herzlicher Dank gilt dem Bankhaus Sal. Oppenheim, der Duisburger GEBAG sowie der Willis GmbH & Co. KG.

Ich freue mich ganz besonders, dass weitere Partner die Ausstellung »Konstantinopel oder Die versteckte Sinnlichkeit« in ihren Häusern präsentieren werden: das Ulster Museum in Belfast, die Weserburg | Museum für moderne Kunst in Bremen sowie die Kunstsammlungen Chemnitz. Den Direktoren der Häuser, Tim Cooke, Carsten Ahrens und Ingrid Mössinger, danke ich sehr herzlich für die Kooperation und das in uns gesetzte Vertrauen.

Walter Smerling
Direktor MKM

My paintings talk of relationships

Could you describe to a viewer the working process during the creation of a painting?
I draw. Often with charcoal on the end of a stick; a trick I learned from Matisse. You can look and draw with distance, all at the same time. Then I paint. And I paint wet into wet until I arrive at something that fascinates me. Then I stop. Either it is finished or not. If it is not, after a day or two I start again.

How do your works function? Which is more defining in the act of creation, spatial thinking or thinking which relates to colour? Or are they both of equal importance? In the act of creation, the colour is emotional and intuitive. I don't think about it. It is made as I paint. The drawing is significantly more conceptual.

What do your paintings tell us? What stories are contained within them? My paintings talk of relationships. How bodies come together. How they touch. How they separate. How they live together, in harmony and disharmony. The character of bodies changes constantly through my work. According to colour. The opacity and transparency of how the surface is made. This gives it its character and its nature. Its edge defines its relationship to its neighbor and how it exists in context. My paintings want to tell stories that are an abstracted equivalent of how the world of human relationships is made and unmade. How it is possible to evolve as a human being in this.

Do you have a favorite painting and a favorite story? I had a friend who was a great reader who died of AIDS in the eighties in New York. I finished a big red and white painting that had a dark window in it, that seemed to suck the light out of the great field of red and white. My friend said it was a portrait of America. Instead of the window giving light, it is taking light, as if it was feeding off the body of the work. He gave me his copy of *Pale Fire* by Nabakov. I read it and called the painting *Pale Fire*.
Last night some 20 years later, I was talking to a living friend of my dead friend in my apartment in New York. Talking of his importance to me and pointing out things, like strange chairs, that used to belong to him, that I now have. In my library I found his copy of *Pale Fire*, and on the first page he had written his name: Charles Choset. *Pale Fire* is not in this exhibition. Though it was shown in the Lenbachhaus in 1989.

Which artists and historical works have influenced you? I would say that I come from a clear line of artists that have expressed a deep moving spirituality in their work, that although austere, includes humanism. This would include Cimabue, Masaccio, Velázquez, Caspar David Friedrich, Matisse, Van Gogh, Monet, Manet, Rothko, Morandi and Agnes Martin. I forgot Kandinsky and Paul Klee.

Meine Bilder erzählen von Beziehungen

Wie würden Sie dem Betrachter Ihren Arbeitsprozess bei der Entstehung eines Bildes beschreiben? Zuerst zeichne ich. Oft mit einem Kohlestift, den ich an einem langen Stab befestige, ein Trick, den ich mir bei Matisse abgeschaut habe. Der Vorteil dabei ist, dass man zeichnen und gleichzeitig das Gezeichnete aus einer gewissen Entfernung betrachten kann. Anschließend male ich, und zwar nass in Nass, solange bis ich etwas zustande gebracht habe, das mich fasziniert. Dann höre ich auf. Entweder das Bild ist fertig oder nicht. Wenn es noch nicht fertig ist, mache ich ein, zwei Tage später weiter.

Wie funktionieren Ihre Arbeiten? Ist bei der Gestaltung das räumliche oder das farbliche Denken stärker ausgeprägt oder sind beide gleichbedeutend? Während des Schaffensprozesses setze ich die Farbe nach Gefühl ein, also völlig intuitiv. Ich denke nicht darüber nach. Es geschieht einfach beim Malen. Beim Zeichnen hingegen gehe ich sehr viel konzeptueller vor.

Was erzählen Ihre Bilder? Welche Geschichten stecken dahinter? Meine Bilder erzählen von Beziehungen. Wie Körper zusammenkommen, wie sie sich berühren, sich trennen. Wie sie zusammenleben, in Harmonie oder in Disharmonie. Der Charakter dieser Körper verändert sich ständig in meiner Arbeit, abhängig von der Farbe, von der Opazität und Transparenz der Oberfläche. Das alles verleiht ihnen ihre Eigenart, ihr Wesen. Der Rand definiert die Beziehung zum benachbarten Körper, er setzt sie in einen Kontext. Meine Bilder wollen Geschichten erzählen, die ein abstraktes Gegenstück zu dem Auf- und Ab menschlicher Beziehungen sind. Sie wollen erzählen, wie es möglich ist, sich als Mensch in diesem Geflecht zu entwickeln.

Gibt es ein Lieblingsbild und eine Lieblingsgeschichte? Ich hatte einen Freund in New York, der sehr gerne las; er ist in den Achtzigerjahren an AIDS gestorben. Ich hatte damals ein großes, rotweißes Bild gemalt, mit einem dunklen Fenster in der Mitte, das das Licht aus dem Feld aus Rot und Weiß förmlich herauszusaugen schien. Als mein Freund das Bild sah, sagte er sofort, »das ist ein Porträt von Amerika«. Anstatt es hereinzulassen, absorbierte das Fenster das Licht, als würde es sich von dem Werkkörper ernähren. Mein Freund lieh mir damals seine Ausgabe von Nabokovs *Pale Fire* (»Fahles Feuer«). Ich las das Buch und nannte das Bild *Pale Fire*.

Gestern Abend, also gut zwanzig Jahre später, habe ich mit einem gemeinsamen Freund über unseren verstorbenen Freund gesprochen, darüber wie wichtig er mir war. Ich habe noch Dinge von ihm in meiner New Yorker Wohnung, ein paar seltsame Stühle zum Beispiel. In meiner Bibliothek habe ich seine Ausgabe von *Pale Fire* gefunden, mit seinem Namen auf der ersten Seite, Charles Choset. *Pale Fire* wird in dieser Ausstellung übrigens nicht zu sehen sein. Aber es wurde 1989 im Lenbachhaus gezeigt.

Welche Künstler, welche Werke der Kunstgeschichte haben Sie beeinflusst? Ich sehe mich in der Tradition einiger Künstler, die in ihrer Arbeit eine tiefe, bewegende Spiritualität ausgedrückt haben, eine Spiritualität, die – obwohl streng – auch humanistisch ist. Dazu zählen Namen wie Cimabue, Masaccio, Velázquez, Caspar David Friedrich, Matisse, Van Gogh, Monet, Manet, Rothko, Morandi und Agnes Martin. Und natürlich Kandinsky und Paul Klee.

You maintain a studio in New York as well as near Munich, where you have taught at the Akademie der Bildenden Kunste from 2002–2007. Which American and European artists and their works have particularly formed your work? I would say that most of the German artists of the seventies and eighties have been very interesting to me. In some way I am in a dialogue with them. In the seventies I was friends with Robert Ryman which was important to me. He was very kind.

You have a special relationship to Germany and feel deeply connected to it. Why is that? What makes you have such a strong bind to this culture? When I was a young, I mean young artist, I was afraid of Germany. Because I was, I realize now, afraid of what I wanted. To say it simple, the deep cultivated sense of profundity that exists in German culture has affected me deeply, and assisted me tremendously in getting where I am now. The holocaust is something that cannot be taken out of history, but neither can Goethe and the age of Romanticism. This has produced, in German culture, an informed imperative to achieve progress and redemption. We can all do better, not just Germany. But first we all have to look at what has been, in order to make what will be better. Germany and France have made Europe. I am a great believer in this, in a bigger sense of society. And I am part of it. Having taught here. Having produced a class, I have been in the position of leader or father, sometimes captain of a small ship. So now I am no longer afraid of it. I am in it.

What makes this exhibition at the Museum Küppersmühle special for you? I love to show in Germany. Museum Küppersmühle has an incredible collection. In addition it has a high reputation maintaining an uncompromising exhibition program.

In your paintings you combine an austere formal language with colour quality that is haptic and expressive; sensuality and rationality are therefore not mutually exclusive? Our big problem, not just in art, is to unify cultures. I am committed to impurity, so I compress the rational and the sensuous.

How do you define abstraction? Abstraction is this: it is the possibility to see human structures out of context. It is a way of starting again.

What relationship does your work have to nature? Kandinsky thought that artists should be spiritual teachers. I agree absolutely with this position. Indeed it is my position. But our nature was made first and evolved out of the nature we live in. My work feeds off this. Off the colours of the sky and the sea and the land and the animals that live on it. No matter how abstract we become, we must always understand that we are the children of our world. A world we have not yet learned to love.

New York, December 21, 2008
The Interview with Sean Scully was conducted by Walter Smerling

Sie unterhalten ein Atelier in New York und eines in der Nähe von München, wo Sie von 2002 bis 2007 an der Akademie der Bildenden Künste gelehrt haben. Welche amerikanischen und europäischen Künstler bzw. Werke haben Ihre Arbeit besonders geprägt? Ich finde die meisten deutschen Künstler der Siebziger- und Achtzigerjahre interessant und stehe in gewisser Weise in einem Dialog mit ihnen. In den Siebzigern war ich mit Robert Ryman befreundet, das war eine sehr wichtige Verbindung. Ein ziemlich netter Zeitgenosse.

Sie fühlen sich Deutschland in besonderer Weise verbunden und empfinden eine tiefe Beziehung. Woran liegt das? Was macht diese Verbundenheit aus? Als sehr junger Künstler hatte ich Angst vor Deutschland, und zwar, wie ich heute weiß, weil ich Angst vor meinen eigenen Zielen und Wünschen hatte. Dafür gibt es eine einfache Erklärung: Die Tiefgründigkeit der deutschen Kultur hat mich schon damals stark berührt. Ohne sie wäre ich nicht da, wo ich heute stehe. Die deutsche Geschichte, das ist der Holocaust, aber das sind eben auch Goethe und die Romantik. Beides zusammen hat dazu geführt, dass man in der deutschen Kultur stets nach Fortschritt und Wiedergutmachung strebt. Wir alle können es besser machen, nicht nur Deutschland. Aber bevor wir an die Zukunft denken, sollten wir in die Vergangenheit blicken. Deutschland und Frankreich haben Europa gebaut. Ich halte viel vom europäischen Gedanken, in einem weiteren Sinn, nämlich einer europäischen Gesellschaft. Ich bin ein Teil davon. Weil ich dort unterrichtet habe, weil ich in München eine Meisterklasse geleitet habe, als eine Art Vaterfigur, sozusagen als Kapitän eines kleinen Schiffs. Jetzt habe ich keine Angst mehr vor Deutschland. Ich bin angekommen.

Was ist für Sie das Besondere an der Ausstellung im Museum Küppersmühle? Ich stelle prinzipiell gern in Deutschland aus. Und das Museum Küppersmühle besitzt eine großartige Sammlung. Außerdem hat es einen ausgezeichneten Ruf und ist bekannt für sein kompromissloses Ausstellungsprogramm.

Sie kombinieren eine strenge Formensprache mit haptischer, expressiver Farbqualität: Rationalität und Sinnlichkeit schließen sich also nicht aus? Unser großes Problem, nicht nur in der Kunst, ist das Miteinander der Kulturen. Ich stehe auf der Seite der Unreinheit, des Fremden, also vermische ich das Rationale mit dem Sinnlichen.

Wie definieren Sie Abstraktion? Abstraktion ist die Möglichkeit, menschliche Strukturen außerhalb ihres Zusammenhangs zu betrachten. Sie ist ein Weg, neu anzufangen.

Welche Beziehung haben Ihre Werke zur Natur? Kandinsky war der Meinung, Künstler sollten geistige Lehrer sein. Darin kann ich ihm nur beipflichten. Doch bevor es den Menschen gab, gab es die Natur. Aus ihr sind wir entstanden. Auch meine Arbeit nährt sich von der Natur, von den Farben des Himmels und des Meeres und der Erde und der Tiere. Ganz gleich, welchen Grad von Abstraktion wir erreichen, wir dürfen nie vergessen, dass wir alle die Kinder unserer Welt sind. Einer Welt, die zu lieben wir noch nicht gelernt haben.

New York, 21. Dezember 2008
Die Fragen an Sean Scully stellte Walter Smerling.

The Imagery of Sean Scully

Glancing from a moving train or car at the world flashing by, at the landscape and the people, the objects distort into coloured stripes. The greater our speed the less discernible these objects appear. Leaving behind and surrendering their materiality, the stripes encapsulate in their growing deformation and abstraction the minor and major events transpiring 'outside'.

It is this intimation of the real world, of the objects, of the countless stories lying beyond, beneath and between the geometrical form of the rectangle – which characterise the enormous power of the paintings of Sean Scully. [1]

Born in 1945, the Irish artist Sean Scully incorporates in his paintings initially the European, then the American, and subsequently more strongly once again European pictorial traditions – mirroring his own biographical journey. He requires a pictorial structure, formally stringent and architectural, which divides up the canvas into grid-like, abstract compositions with a restricted vocabulary: The stripe – in horizontal and vertical formation – is his only element. This is accompanied by the use of impasto, with over-painting and layering featuring strongly as his key methods. Emotional, almost intuitive, the selection of colours is shaped by his own experiences, and accommodates the desire for a narrative; in contrast to the formal pictorial structure, it appears in a range of variants. The narrow gaps between the stripes or the "traces of experience" flanking the borders of the individual elements which he deliberately leaves untouched, are like window slits, revealing momentary glimpses of the mysteries and sensuality beyond.

The haptic quality of his paintings – evoked by his opulent, layered application of paint – the wet-in-wet painting with broad brush strokes, which necessarily remain identifiable, captivate the viewer: He perceives almost on a tactile level an implicit, concealed sensuality, which occasionally reveals itself; he senses the rich pictorial world of which he cannot partake, yet which is always present and arouses curiosity. [1]

By means of this painterly dialogue – between the formal austerity of the pictorial architecture and the expressive application of paint, which long since been his "hallmark features" – Scully succeeds in executing something quite contradictory: On the basis of objective, abstract, rational compositions, he conjures a subjectivity, i.e. emotions, moods, associations and 'images'. Titles such as *Wall of Light Dog* [2], *Happy Days* or *Königin der Nacht* underscore the narrative moment and the foreshadowed emotions.

Initially Scully's paintings are alien to us, appearing too abstract to admit easy access. Yet the deeper one immerses oneself into the paintings and appropriates its structure (or experiences), the more one senses the enormous tension, the breadth of emotions, the almost spiritual quality which imbues each single form, and his entire oeuvre.

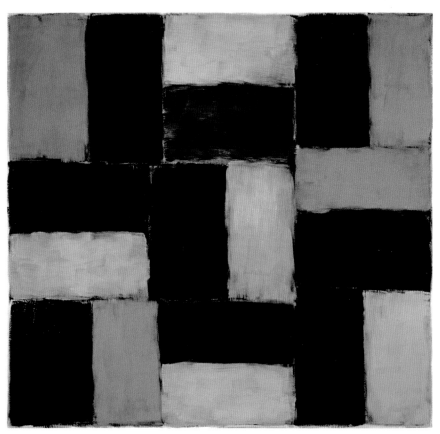

[2]

Die Bilderwelt von Sean Scully

M it dem Blick aus einem fahrenden Zug oder Auto auf die vorbei-
ziehende Welt, die Landschaft, die Menschen, verzerren sich die
Gegenstände – je nach Geschwindigkeit mehr oder weniger diffe-
renziert – zu farbigen Streifen, die das Gegenständliche hinter sich lassen,
es auflösen und in der Verzerrung, Abstraktion in sich bündeln, was sich an
großen und kleinen Geschichten »draußen« ereignet.
Das Erahnen der realen Welt, der Gegenstände, der unzähligen Geschichten
hinter, unter, zwischen der geometrischen Form des Rechtecks – das ist es,
was die große Kraft der Bilder von Sean Scully ausmacht. **[1]**

Der 1945 geborene irische Künstler Sean Scully verbindet in seiner Malerei –
auch aufgrund seiner biografischen Stationen – zunächst europäische, dann
amerikanische und später verstärkt wieder europäische Bildtraditionen. Er
benötigt einen starken, formal sparsamen architektonischen Bildaufbau
und gliedert die Leinwand in rasterartig unterteilte, abstrakte Kompositi-
onen mit begrenztem Vokabular: Der Streifen in horizontaler und vertika-
ler Formation ist sein einziges Element. Darauf folgt der pastose Farbauftrag
und Übermalungen / Schichtungen sind dabei die wichtigste Vorgehens-
weise. Die Wahl der Farben orientiert sich am Erlebten, folgt dem Wunsch
der Nach-Erzählung und ist emotional, fast intuitiv; sie durchläuft im
Gegensatz zur formalen Bildstruktur zahlreiche Varianten. Die schmalen
Stellen zwischen den Streifen oder die »Erfahrungsspuren« an den Rän-
dern der einzelnen Elemente, die er bewusst stehen lässt, sind wie Fenster-
spalten, durch die es geheimnisvoll und sinnlich blitzt.

Die haptische Qualität seiner Bilder – entstanden durch den üppigen,
geschichteten Farbauftrag, der Nass-in-Nass-Malerei mit dem breiten Pin-
sel, dessen Spuren unbedingt und notwendig erkennbar bleiben sollen –
zieht den Betrachter in ihren Bann: Er spürt fast körperlich eine angedeu-
tete, versteckte, ab und zu durchscheinende Sinnlichkeit, er erahnt eine
reiche Bilderwelt, derer er nicht habhaft werden kann, die aber immer prä-
sent ist und neugierig macht. **[1]**

Mit diesem malerischen Dialog – der formal strengen Bildarchitektur und
dem expressiven Farbauftrag, die schon seit langem sein »Erkennungsmerk-
mal« sind – gelingt Scully scheinbar Widersprüchliches: Auf der Grundlage
von objektiven, abstrakten, rationalen Kompositionen bannt er Subjektivi-
tät, das heißt: Emotionen, Stimmungen, Assoziationen und »Bilder«. Titel
wie *Wall of Light Dog* **[2]**, *Happy Days* oder *Königin der Nacht* unterstreichen
den erzählerischen Moment und die zu erahnende Emotion.

Scullys Malerei ist uns zunächst fremd, scheint anfangs zu abstrakt, als dass
man einen schnellen Zugang findet. Je tiefer man jedoch in die Bilder ein-
taucht, ihre Struktur zu unser eigenen Struktur (oder der von Erlebnissen)
werden lässt, um so mehr spürt man die enorme Anspannung, die große
Emotionalität, das fast Spirituelle, gebannt in der einzelnen Form und im
gesamten Werk.

[3]

Scully continually explores the underlying foundations of abstraction by highlighting the intrinsic value of the artistic means – the aesthetics of form and colour – and places it at the heart of his work. Yet he is not striving to produce the perfect 'dead' paintings, and consequently his emotional treatment of colour and his playful disregard of formal order enable him to fulfil his aspiration "to humanise abstract painting". Each painting is afforded an open structure, strives not for perfection, but is fragile. Rather than providing the ultimate solution, a range of possibilities is raised. It is an offer by the artist, furnishing space for our own associations, predicated on his conviction that the distance between the artist, the painting as the mediator and the viewer can be overcome. He pays tribute to his conviction that life does not form a unified entity, but is fragmented, isolated and fractured. His paintings are "a desperate attempt to hold the world together, and I seem to be running around [travelling], trying to piece it together from these broken pieces and parts."

By virtue of the artistic exploration of interior and exterior, figuration and abstraction, tension and relaxation, light and darkness, subjectivity and objectivity, of the relationship between content and form, his works appear powerful, sensual, life-affirming, optimistic – albeit strangely 'constrained', yet open.

To refer to Sean Scully superficially as an abstract artist who paints only – often dark – geometric forms and decorative variations thereof, is a common misconception, which fails to grasp the exuberant richness which lies behind the facade.

Possible explanations for his artistic approach lie in his biography – an unsurprising observation, which probably applies to every artist. Conscious of the theatrical nature of his Irish mentality, Scully himself looks back on his childhood and youth as a time of extreme tension, aggression and anger, as a time of social and religious upheaval and diverse relationships (also to places), which continually have to be redefined. He grew up surrounded by storytellers and songwriters and subsequently had to prove himself in London's Irish ghetto. Captivated and inspired by the highly colourful images in the Catholic churches, he decides at early age to become an artist. These "few happy moments of his childhood", to quote the artist himself, grant him the stability he needs to contend with the harsh realities of life, and allow his deep, inner needs to take shape.

These upheavals give an early indication of the formal elements (stripes, lines), with which he came to compose his paintings, and which conferred upon his narratives, emotions and memories, a certain (formal) protection. Consequently his interest lies not in fashioning the one harmonious story, but in the many autonomous narratives/sequences/relationships, which find their raison d'être in mutual juxtaposition, vie with each other and generate tension. The basic concept of his work is to transport this content into repositories, which sometimes (formally) forge mutual relationships or yield further possibilities – independently of each other. Scully's focus here lies in the relationship and communication between form and content. "Instead of painting a relationship, I therefore paint fields and piece them together. (...) I treat the fields separately from each other and then throw them together. This introduces a certain violence or immediacy; it also implies the possibility that relationships can be broken."

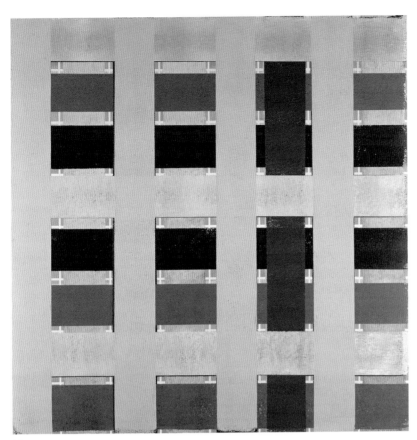

[4]

Scully hinterfragt immer wieder die Voraussetzungen der Abstraktion, indem er den Eigenwert der künstlerischen Mittel – die Ästhetik von Form und Farbe – betont und in das Zentrum seiner Arbeit stellt. Dennoch will er keine perfekten, »toten« Bilder, und so erlauben ihm sein emotionaler Umgang mit Farbe und sein spielerisches Nicht-Einhalten der formalen Ordnung seinen Wunsch, »to humanize abstract painting« umzusetzen. Jedes Bild erhält eine offene Struktur, ist nicht perfekt, ist brüchig, bietet nicht die eine Lösung, sondern impliziert viele Möglichkeiten. Es ist ein Angebot des Künstlers, bietet Platz für eigene Assoziationen und beruht auf seinem Glauben, dass die Distanz zwischen dem Künstler, dem Bild als Vermittler und dem Betrachter überwunden werden kann. Es trägt seinem Empfinden Rechnung, dass das Leben nicht eine Einheit bildet, sondern fragmentiert, isoliert und zersplittert ist. Seine Malerei ist »ein verzweifelter Versuch, die Welt zusammenzuhalten, und ich scheine herumzulaufen [zu reisen] und zu versuchen, sie aus diesen zerbrochenen Stücken und Teilen zusammenzusetzen.«

Malerische Umsetzungen der Fragen nach Innen und Außen, nach Figuration und Abstraktion, nach Anspannung und Entspannung, nach Licht und Dunkelheit, nach Subjektivität und Objektivität, nach den Beziehungen von Inhalten und Formen zueinander lassen seine Arbeiten kräftig, sinnlich, lebensbejahend, hoffnungsvoll und dennoch eigenartig »gebannt« aber offen erscheinen.

Sean Scully oberflächig als einen abstrakten Maler zu bezeichnen, der nur – oft dunkle – geometrische Formen malt und sich dekorativ wiederholt, nimmt zwar ein häufig geäußertes Vor-Urteil auf, begreift aber niemals den üppigen Reichtum, der hinter der Fassade steckt.

Mögliche Erklärungsmodelle für sein malerisches Vorgehen liegen in seiner Biografie – was nicht verwunderlich ist (und wohl für jeden Kunstschaffenden zutrifft). Scully selbst – sich durchaus der Theatralik seiner irischen Mentalität bewusst – bezeichnet seine Kindheit und Jugend als eine Zeit extremer Anspannung, Aggression und Wut, als eine Zeit voll von sozialen und religiösen Brüchen und unterschiedlichsten Beziehungen (auch zu Orten), die immer wieder neu definiert werden müssen. Er wächst auf mit Geschichtenerzählern und Liedermachern und muss sich später im irischen Ghetto in London beweisen. Ergriffen und inspiriert von den farbenprächtigen Bildern in den katholischen Kirchen, möchte er schon früh Künstler werden. Diese von ihm selbst so bezeichneten »wenigen Glücksmomente seiner Kindheit« geben ihm den Schutz, den er in der rauen Wirklichkeit benötigt, und lassen sein tiefes, inneres Bedürfnis reifen.

Schon diese Brüche geben Hinweise auf die formalen Elemente (Streifen, Linien), mit denen er später seine Bilder komponiert und die den Geschichten, Emotionen, Erinnerungen, einen gewissen (formalen) Schutz geben.

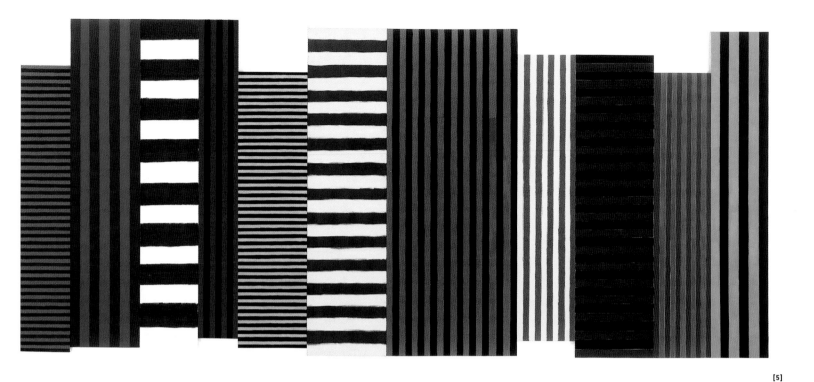

Steeped in the figurative style of a Karl Schmidt-Rottluff, an Emil Nolde or even a Henri Matisse, Scully is finally admitted to the Croydon College of Art in 1965 to study art after many failed attempts. During this time he is also influenced by the works of Piet Mondrian (essentially the later works with reference to New York's street grid plan). Initially he paints figuratively, but also develops an interest in Op-Art, Abstract Expressionism and above all in the paintings of Mark Rothko. In 1969 he travels to Morocco for the first time, where he is enthralled by the abstract colour compositions and luminous colours of the Moroccan textiles – marking the beginning of a fascination with African culture which has endured until the present day. In 1972 he is awarded a scholarship to Harvard and soon Scully devotes himself to Minimalism and the formal Purism of the time, executing a kind of all-over paintings, in which he dispenses entirely with gesture. **[3]** The only form he permits is the vertical or horizontal line (diagonals feature only occasionally as a contrasting element) – as a "signifier for modernism". He binds his canvasses with masking tape in order to create more radical, clearer forms and his colour palette is reduced, static and full of clarity **[4]**.

In the early 80s he departs from this perfection once again, deeming this form of art to be too formal, empty, detached and inhumane. As he himself subsequently stated: "And the Minimalists removed the content from Abstract Expressionism. Accordingly art reached the point where it had lost its ability to communicate" – a capacity and function of art, which Scully regards as elemental.

However, rather then returning to figuration, he sees in abstraction a generosity which admits all kinds of subjectivity, sensuality and openness, without assuming a dominance.

This upheaval is best exemplified in *Backs and Fronts* from 1981 **[5]** and in the *Catherine paintings* from 1981 **[6]** onwards: These paintings comprise autonomous elements, are possessed of a narrative structure and a more expressive paint palette. They are open-ended, abounding in perspectives, yet do not have the exclusive character of Minimalism and hold the prospect – not in plagaristic sense – of becoming the abstract variant of Matisse' artistic realm. These paintings now recall the glance from the moving train and reflect the almost filmic character of his work.

A decisive criterion distinguishing these works from his earlier output, are the different sizes/heights/widths and variously painted sections of the canvass which Scully – without prior planning – eventually combines to form an almost sculptural composition. And a title such as *Backs and Fronts*, for example, underscores the narrative component and traces the painting back to a concrete experience (that of a long queue of waiting people): Thus Scully uses the formal element as a metaphor for human behaviour. Whilst furnishing an indication of the emotions, his titles have hitherto never alluded to the stories and inter-relationships (substantive or formal).

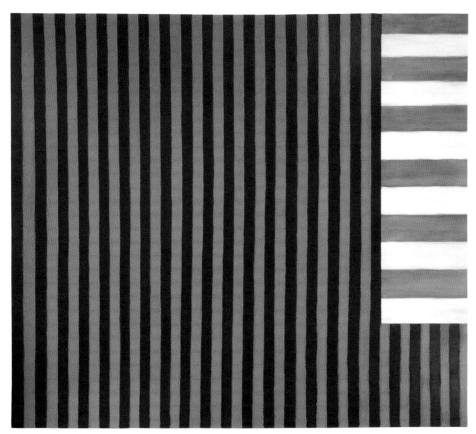

[6]

So interessiert ihn nicht die eine harmonische Geschichte, sondern die vielen autonomen Geschichten/Beziehungen/Sequenzen, die nebeneinander eine Berechtigung haben, sich konkurrierend verhalten und Spannung aufbauen. Das Grundkonzept seiner Arbeit ist das Unterbringen von Inhaltlichkeit in formalen Körpern, die manchmal (formal) eine Beziehung zueinander aufbauen oder unabhängig voneinander weitere Möglichkeiten ergeben. Sein Anliegen sind Beziehungen und Kommunikation zwischen Form und Inhalt. »Anstatt eine Beziehung zu malen, male ich also Felder und setzte sie zusammen. (...) Ich behandle die Felder getrennt voneinander und werfe sie dann zusammen. Das bringt eine gewisse Gewalttätigkeit oder Unvermitteltheit mit ins Spiel; es impliziert auch die Möglichkeit, dass Beziehungen gebrochen werden.«

Aus der Figuration kommend, im Sinne eines Karl Schmidt-Rottluff, eines Emil Nolde oder im weitesten Sinne eines Henri Matisse, erhält er nach vielen vergeblichen Versuchen 1965 die Möglichkeit, am Croydon College of Art, ein Kunststudium aufzunehmen. Auch die Werke Piet Mondrians begleiten sein Schaffen (vor allem dessen Spätwerke mit Bezug auf das Straßenblockraster New Yorks). Er malt zunächst figurativ, zugleich wird aber sein Interesse für Op-Art, den Abstrakten Expressionismus und vor allem für die Malerei Mark Rothkos geweckt. 1969 reist er erstmals nach Marokko und ist fasziniert von den abstrakten Farbkompositionen und den leuchtenden Farben der marokkanischen Tücher – eine Faszination für die afrikanische Kultur, die bis heute anhält. 1972 erhält er ein Stipendium für Harvard und schon bald verpflichtet sich Scully dem Minimalismus und formalen Purismus seiner Zeit, in der er eine Art All-over-Malerei betreibt und auf jegliche Gestik verzichtet. [3] Als einzige Form lässt er die vertikale oder horizontale Linie zu (Diagonalen tauchen nur ab und an als kontrastierendes Element

auf) – als »signifier for modernism«. Er klebt seine Leinwände mit Klebeband ab, um so radikalere, klarere Formen zu erhalten, seine Farbpalette ist reduziert, statisch und klar [4].

Von dieser Perfektion wendet er sich Anfang der 80er-Jahre wieder ab, zu formal, leer, separiert und unmenschlich erscheint ihm diese Form der Kunst. Später sagt er einmal: »Und die Minimalisten haben dem Abstrakten Expressionismus den Inhalt genommen. So war die Kunst an einem Punkt angekommen, wo sie ihre Kommunikationsfähigkeit eingebüßt hat« – eine Fähigkeit und Funktion von Kunst, die für Scully elementar wird.

Dennoch wird er nicht (wieder) figurativ, sondern sieht weiterhin in der Abstraktion eine Generosität, die jegliche Subjektivität, Sinnlichkeit und Offenheit zulässt, ohne dominant zu sein.

Anhand von *Backs and Fronts* von 1981 [5] und den *Catherine paintings* ab 1981 [6] ist der Umbruch am Besten nachzuvollziehen: Die Bilder bestehen aus autonomen Elementen, haben eine Erzählstruktur und eine expressivere Farbpalette, sind offen, entwickeln Perspektiven, haben nicht den exklusiven Ausschlusscharakter des Minimalismus und versprechen – jedoch nicht im Sinne eines Plagiats – die abstrakte Variante von Matisse' malerischem Reichtum zu werden. Die Bilder erinnern nun an den Blick aus dem fahrenden Zug und spiegeln den fast filmischen Charakter seiner Werke.

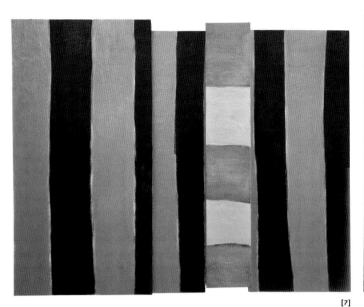

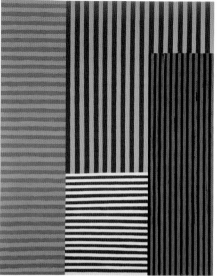

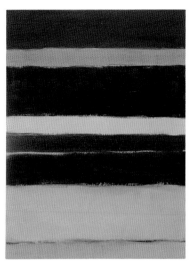

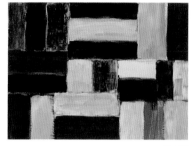

[7] [8] [9 + 10]

Paintings such as *The Bather* from 1983 **[7]**, which rank as among the most important from the ensuing period, herald the beginning of Scully's international breakthrough. It is a hommage to Matisse, in which he reformulates the figuration and coloration to affectionately express the colourful richness we associate with the French painter. Scully describes it more appositely: "... [it] has a kind of giddy craziness about it, an ecstatic quality. It's physical and highly structured, but not with the structure of reason. It is the structure of feeling." Here his focus lies not in the figure itself, but in the significance/ feeling/nostalgia of a figure, and thus with great poignancy, the formally powerful image enters into a dynamic dialogue with the empathetic and intimate title.

Scully's art is strongly influenced by his own visual experiences, gathered on his extensive travels, and his paintings reflect his encounters with other countries **[8]**, other cities, people, events, the history of art, literature, film and music. He documents photographically the things he observes in passing. The photos are frequently of architectural motifs; coloured doors and windows, walls, panels and layers of stones or scenic landscape/stripes, which are artistically transformed into paintings, such as *Colored Landline*, 2003 **[9]** and which reflect simple horizontal structures such as land, sea, sky, sun and clouds.
Scully describes his preoccupation with this other medium as a "shopping spree", on which he collects visual material.

His studios – maintained in the three very different locations of New York (since 1975), Barcelona (since 1994) and in the rural outskirts of Munich (since 2002) – are symbolic of his artistic and personal development, and find their reflection in his paintings. **[10]**

His output throughout the 1980s until the early 90s is characterised by variants and repetitions (in the positive sense of further development), in which his paintings are highly condensed. Frequently Scully combines an ensemble of canvas elements within large-format works; paintings such as *Falling Wrong*, 1985 **[11]**, and *Happy Days*, 1991 **[12]**, convey a sense of how intensively he works and grapples with the structure in order to continually arrive at new solutions. The stripe, once so rigidly orientated towards the vertical and horizontal axes of the painting, is now rendered in ever new variations. The canvasses appear almost corporeal and sculptural. Here it is evident that he is pursuing his highly personal objective of establishing interrelationships, which – based on his own experience – reflect interior and exterior structures and lure the viewer in by holding up a mirror to him. Scully himself describes this as a natural phenomenon: "And since art... comes from life itself, it mirrors one's own life – warts and all."

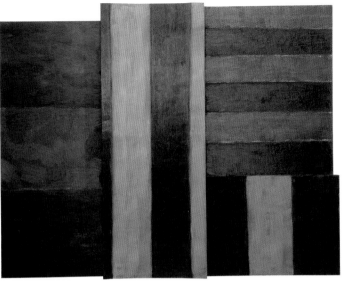

[11]

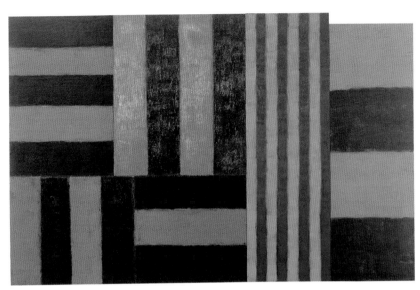

[12]

Ein entscheidendes Kriterium, durch das sich nun diese Arbeiten von früheren Werken unterscheiden, sind die unterschiedlich großen/hohen/breiten und unterschiedlich bemalten Leinwandteile, die Scully am Ende – ohne vorherige Festlegung – zu einer fast skulpturalen Komposition zusammenfügt. Und ein Titel wie *Backs and Fronts* zum Beispiel unterstreicht die erzählerische Komponente und führt das Gemalte auf ein konkretes Erlebnis (das einer langen, wartenden Menschenschlange) zurück: So benutzt er das Formale als Metapher für menschliches Verhalten. Bisher gaben die Titel zwar auch Hinweise auf Emotionen, aber nie auf Erzählungen und nie auf verschiedene Beziehungsgeflechte (inhaltlich oder formal).

Bilder wie *The Bather* von 1983 **[7]**, das zu den stärksten aus der nun folgenden Zeit gehört, belegen den nun beginnenden internationalen Durchbruch Scullys. Es ist eine Hommage an Matisse, in der er die Figuration und Farbigkeit in eine eigene Formulierung transformiert, die mit farblichem Reichtum freudvoll das ausdrückt, was wir mit dem französischen Maler assoziieren. Scully beschreibt es noch besser: »(…) [es] hat etwas Leichtfertiges, Verrücktes, Ekstatisches. Gleichzeitig besitzt es eine Körperhaftigkeit und ist durchstrukturiert, wobei es sich nicht um eine Struktur der Vernunft, sondern um eine Struktur des Gefühls handelt.« Es geht ihm nicht um die Figur an sich, sondern um die Bedeutung/das Gefühl/die Nostalgie einer Figur, und auf eine sehr zarte Art tritt das formal kräftige Bild mit dem sensiblen, intimen Titel in einen spannungsreichen Dialog.

Scullys Kunst ist geprägt von visuellen Erfahrungen, die er auf seinen Reisen sammelte. So spiegeln seine Bilder Reisen in andere Länder **[8]**, andere Städte, zu Menschen, zu Erlebnissen oder durch die Kunstgeschichte, die Literatur, den Film und die Musik … Er dokumentiert fotografisch die Dinge, die er im Vorbeigehen sieht. Die Fotos zeigen häufig architektonische Motive. Oftmals farbige Türen und Fenster, Mauern, Bretter und geschichtete Steinlagen oder landschaftliche Ebenen/Bänder, die in Bildern wie *Colored Landline*, 2003 **[9]** malerisch transformiert werden und schlicht horizontale Strukturen wie Land, Meer, Himmel, Sonne und Wolken spiegeln. Scully beschreibt seine Tätigkeit mit dem anderen Medium als »Einkaufsbummel«, auf dem er visuelles Material sammelt.

Seine Ateliers an drei so unterschiedlichen Orten wie New York (seit 1975), Barcelona (seit 1994) und auf dem Land in der Nähe von München (seit 2002) stehen stellvertretend für seine malerische und persönliche Entwicklung und werden in den Bildern reflektiert. **[10]**

Seine Arbeiten in den 80-Jahren bis Anfang der 90er-Jahre sind gekennzeichnet von Varianten und Wiederholungen (im positiven Sinne der Weiterentwicklung), in denen er malerisch höchste Konzentration aufweist. Häufig vereint Scully ein Ensemble von Leinwandelementen in einem großformatigen Gemälde, und Bilder wie *Falling Wrong*, 1985 **[11]**, und *Happy Days*, 1991 **[12]**, lassen erahnen, wie intensiv Scully mit der Struktur arbeitet und sich an ihr reibt, um immer wieder neue Lösungen anzubieten. Der einst streng an der vertikalen und horizontalen Bildachse orientierte Streifen wird in immer neuen Variationen komponiert. Beinahe körperhaft, skulptural treten die Leinwände hervor. Hier wird offensichtlich, wie sehr er seinem

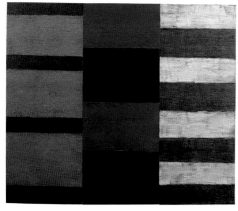

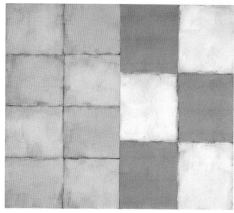

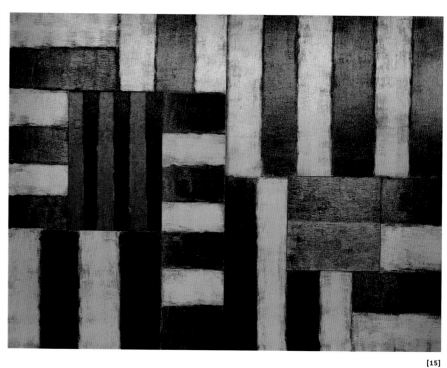

[13+14]

[15]

He attaches great important to the aspect of 'open-endedness'. "Every time one does a painting, the question of how one remains both open and closed at the same time must be addressed once again." The message of the painting is continually undergoing modification, assuming just one of many possibilities. The viewer becomes aware of the interchangeability of the structures, of the process of seeing between construction and destruction, division and addition. The plurality of the formal relationships is source of fascination to Scully. Triptychs, paintings structured like checkerboards feature strongly, occurring in a multitude of different facets **[13+14]**; or the stripe/surface itself is ruptured, and appears to dissipate and 'lose' itself **[15]** – a kowtow to the abundance of content?

This surging momentum of all these possibilities continually impel him to fashion ever new, finely-tuned facets of the formal repertoire. Works such as *Darkness and Heat*, 1988 **[16]**, *Uriel*, 1997 **[17]**, or *Pink Inset*, 1991 **[18]**, highlight his return to working with surface, (in contrast to a work such as *Backs and Fronts*), and leaving the figures as isolated forms, as core(s). Leading its own existence, the single form appears to have its own 'personality', which transforms it into an individual, and it is only this that the title reflects.

This core is either protected, hermetically sealed off, encased by other formal elements (strongly redolent of the form of the medieval 'Hortus Conclusus', and consequently of the iconography of the Virgin Mary), or the enclosed painting surface is breached by fissures, then enclosed again by the insertion of an *inset*. Often these paintings-in-a-painting carry the title of *Passenger*, who is always located beyond the actual structure, intimating movement, and thus incorporating the viewer more directly. **[19]**

In these works, and in the *Window-* and *Figure* paintings **[20+21]**, one recognises clearly that Scully is availing himself of another modus operandi: Seemingly he is not adding here in order to relate 'the' story, but augmenting a form with further structures to render it comprehensible. He appears to find greater appeal in working from the inside to the outside, rather than vice versa. The motif of the window and the door plays a central role, assuming in his work the function of a prototype or metaphor. Throughout the history of art, the window has served as a symbol for the link between the internal and external worlds, and conversely it affords an almost voyeuristic insight from the exterior into the interior.

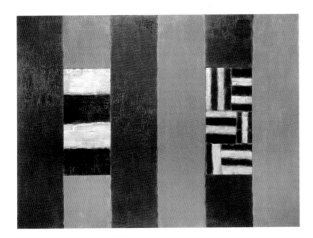

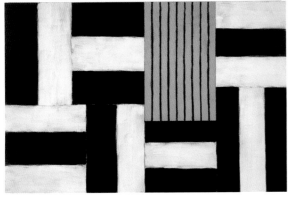

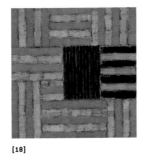

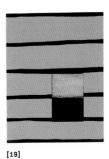

[16+17]　　　　　　　　　　　　　　**[18]**　　　　　**[19]**

ureigenen Anliegen folgt, Beziehungsgeflechte herzustellen, die – basierend auf Erlebtem – innere und äußere Strukturen spiegeln und den Betrachter in ihren Bann ziehen, indem ihm ein Spiegel vorgehalten wird. Scully selbst beschreibt dies als natürliches Phänomen: »Und da die Kunst (...) aus dem Leben hervorgeht, spiegelt sie das eigene Leben schonungslos wider.«

Ganz wichtig ist ihm dabei der Aspekt der Nicht-Abgeschlossenheit: »Jedes Mal, wenn man ein Bild macht, muss die Frage, wie man gleichzeitig geschlossen und offen bleibt, aufs Neue beantwortet werden.« Die Aussage des Bildes wird immer relativiert, wird zu einer von vielen Möglichkeiten. Die Austauschbarkeit der Strukturen, der Prozess des Sehens zwischen Konstruktion und Destruktion, Teilung und Addition wird dem Betrachter bewusst. Die Pluralität der formalen Beziehungen reizt Scully. Triptychen oder schachbrettartig strukturierte Bilder spielen eine große Rolle und werden in vielen Facetten variiert **[13+14]**, oder der Streifen / die Fläche ist in sich gebrochen und scheint sich aufzulösen, zu »verlieren« **[15]** – ein Kotau vor der inhaltlichen Fülle?

Dieser enorme Antrieb aller Möglichkeiten führt ihn zu immer neuen fein austarierten Facetten des formalen Repertoires. Werke wie *Darkness and Heat*, 1988 **[16]**, *Uriel*, 1997 **[17]**, oder *Pink Inset*, 1991 **[18]**, machen deutlich, wie er wieder zur Fläche zurückkehrt und damit arbeitet (im Gegensatz zu einem Werk wie *Backs and Fronts*), die Figuren als isolierte Form, als Kern(e) stehen zu lassen. Die einzelne Form führt eine eigene Existenz, hat scheinbar eine eigene »Persönlichkeit«, die sie zu einem Individuum macht, und nur sie spiegelt sich im Titel.

Dieser Kern wird entweder geschützt, hermetisch abgeschlossen, ummantelt von den weiteren formalen Elementen (dies erinnert sehr stark an die Form des mittelalterlichen »Hortus Conclusus« und damit an die Mariensymbolik), oder die geschlossene Bildfläche wird durch Einschnitte zerstört und mit einem eingesetzten *Inset* wieder geschlossen. Oftmals tragen diese Bild-in-Bild-Arbeiten den Namen *Passenger*: Der Passagier befindet sich immer außerhalb der eigentlichen Struktur, er suggeriert auch Bewegung und schließt den Betrachter direkter mit ein. **[19]**

Man erkennt deutlich, dass Scully mit diesen Werken – oder auch mit den *Window*- und *Figure*-Bildern **[20+21]** – eine andere Vorgehensweise nutzt: Er scheint nicht zu addieren, um »die« Geschichte zu erzählen, sondern er fügt weitere Strukturen einer Form hinzu, um diese nachvollziehbar zu machen. Hier reizt ihn also scheinbar die Arbeit von Innen nach Außen und nicht umgekehrt. Das Motiv des Fensters, der Tür spielt eine zentrale Rolle, es erscheint in seinem Werk wie ein Prototyp, eine Metapher. Das Fenster ist in der Kunstgeschichte ein Symbol für die Verbindung zwischen der Innen- und Außenwelt und bietet umgekehrt von außen nach innen einen fast voyeuristischen Einblick.

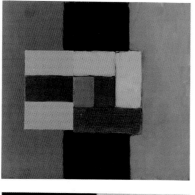

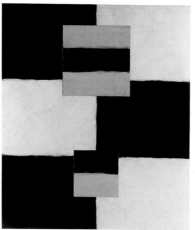

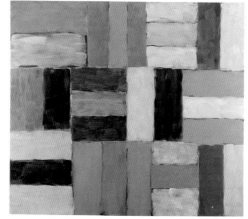

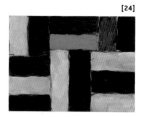

[24]

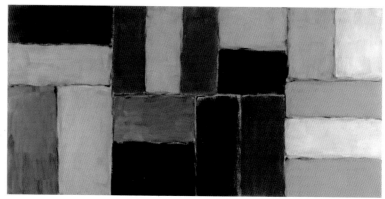

[20+21]

[22+23]

The works dating from the late 1990s, such as *Wall of Light Light*, 1999 **[22]**, *Königin der Nacht*, 2003 **[23]**, or *Abend* from 2003 **[24]** – whose titles speak for themselves – exquisitely embody Scully's key interests and concerns. They exude a poetic, almost painful melancholy. They radiate an astonishing softness of structure, furnishing evidence of Scully's unwaveringly positive attitude to life, despite his acknowledgement of the negative (without which he would not be able to heed his inner compulsion and thus accomplish his work) and reveal to us how the warm colours shake off their gravity to become ever brighter. The theme of light, the illuminating and melancholic aspect of light, is another key feature of Scully's work which is matched by an increasingly fluid, transparent and highly varied brush technique – rich in playful nuances. Many of these shimmering, silvery paintings originated in Barcelona.

The most recent works – now on copper or gleaming aluminium – such as *Mirror Silver*, 2007 **[25]**, or *Cut Ground Colored Triptych 6.08* from 2008 **[26]** – attest to Scully's creative power and dynamism, his courage to reflect reality and hold up a mirror, and the ongoing process of change, of seeking, of open-endedness: They reveal his current interest in the impact of painting on another surface. In *Titian's Robe Pink* from 2008 **[27]** he embarks upon a journey, forges a relationship, analyses, confronts, transforms and engages in a conscious dialogue with Titian's paint palette, in an affectionate hommage to that by-gone age.

One is almost tempted to say that the greater abstraction of many of the earlier works, the still clearly formulated resolution of the external and internal conflict, his inner compulsion have given way with age to a more relaxed approach to himself, to his painting, to the structure of relationships and to a greater freedom.

Sean Scully appears to have found his inner harmony – without losing his dynamism, sensuality and curiosity.

Susanne Kleine
December 2008

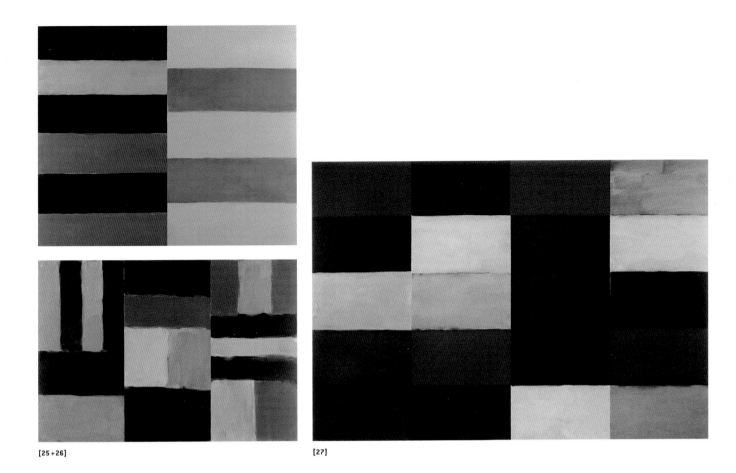

[25+26]　　　　　　　　　　　[27]

Die Werke ab dem Ende der 90-er Jahre, deren Titel fast für sich selbst sprechen, wie *Wall of Light Light*, 1999 **[22]**, *Königin der Nacht*, 2003 **[23]**, oder *Abend* von 2003 **[24]**, fassen Scullys Bemühen, sein Anliegen auf das Schönste zusammen. Sie tragen eine poetische Melancholie in sich, die fast schmerzhaft ist. Sie weisen eine erstaunliche Weichheit der Strukturen auf, belegen Scullys noch immer anhaltende positive Lebenseinstellung - in Kenntnis des Negativen - (ohne die er sich den inneren Aufgaben und damit seinem Werk nicht stellen könnte) und lassen beobachten, wie die warme, weiche Farbigkeit alles Schwere verliert und immer heller wird. Das Thema Licht, der erhellende und der melancholische Aspekt des Lichtes, ist ein weiteres zentrales Sujet in seinem Werk. Damit korrespondiert ein zunehmend flüssiger und variationsreicher Farbauftrag voller Transparenz und spielerischer Nuancen. Viele dieser lichtflirrenden, silbrigen Werke entstehen in Barcelona.

Neuste Arbeiten - nun auf Kupfer oder glänzendem Aluminium - wie *Mirror Silver*, 2007 **[25]**, oder *Cut Ground Colored Triptych 6.08* von 2008 **[26]** - belegen Scullys schöpferische Kraft und Dynamik, seinen Mut, Realität zu reflektieren und den Spiegel vorzuhalten, und dem noch immer anhaltenden Prozess der Veränderung, des Suchens, des Noch-Nicht-Abgeschlossenen; sie offenbaren sein gegenwärtiges Interesse an der Wirkung der Malerei auf einer anderen Oberfläche. In *Titian's Robe Pink* von 2008 **[27]** begibt er sich wieder auf eine Reise, stellt eine Beziehung her, analysiert, konfrontiert, transformiert und bildet einen bewussten Dialog mit der Farbpalette Tizians: seine liebevolle Hommage an die jeweilige Zeit.

Fast ist man geneigt zu sagen, dass das Abstraktere vieler früherer Werke, das noch klar formulierte Zusammenfügen der äußeren und inneren Zerrissenheit, der innere Auftrag, im Alter einem leichteren Umgang mit sich, der Malerei und den Beziehungsgefügen sowie einer größeren Freiheit gewichen ist.

Sean Scully scheint sein Gleichgewicht gefunden zu haben, ohne seine Dynamik, Sinnlichkeit und Neugierde verloren zu haben.

Susanne Kleine
Dezember 2008

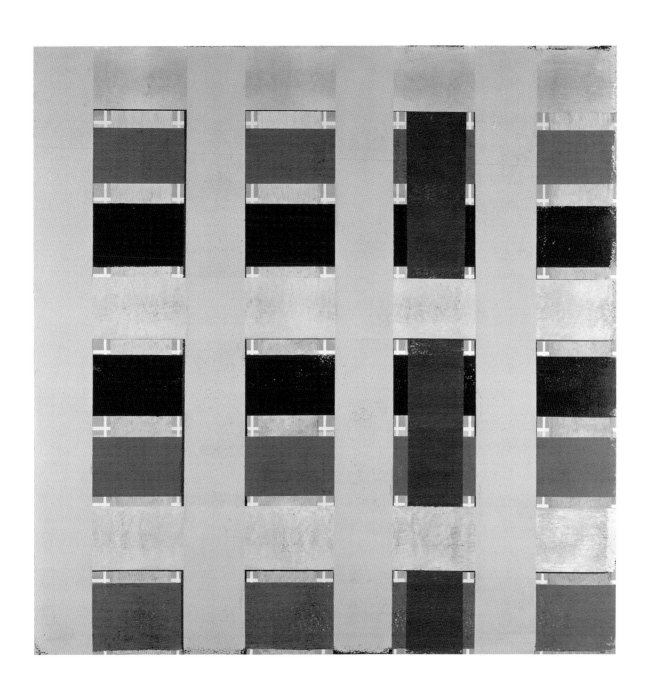

001 Crossover Painting #1 1974

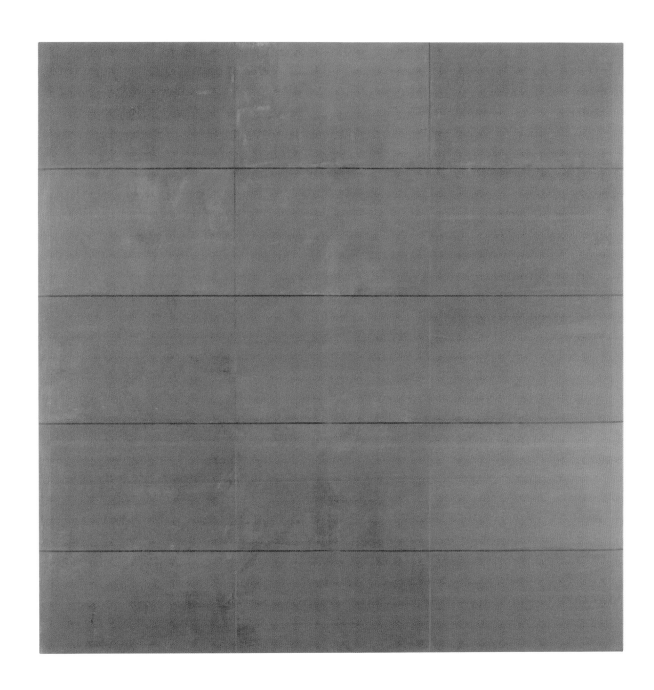

002 Overlay #1 1974

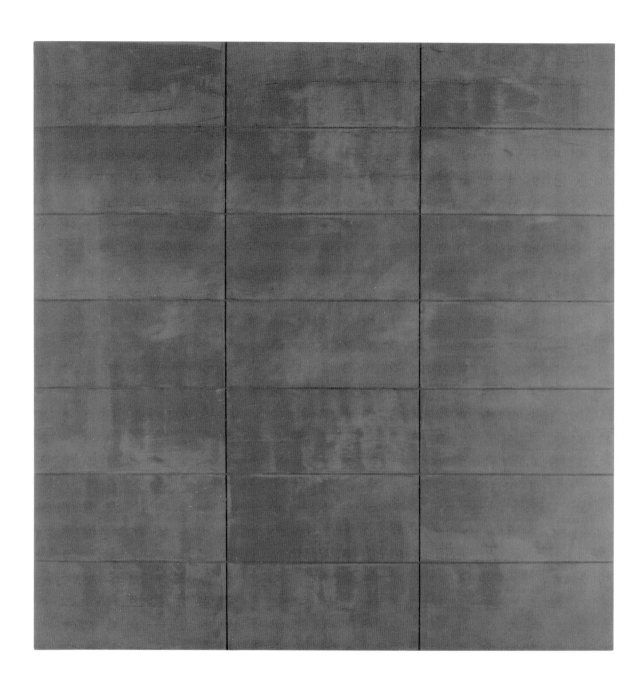

003 Overlay #4 1974

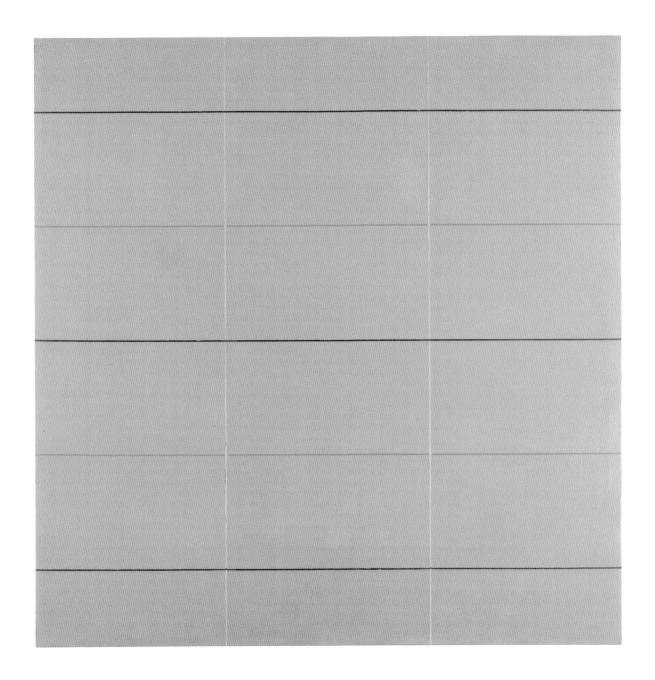

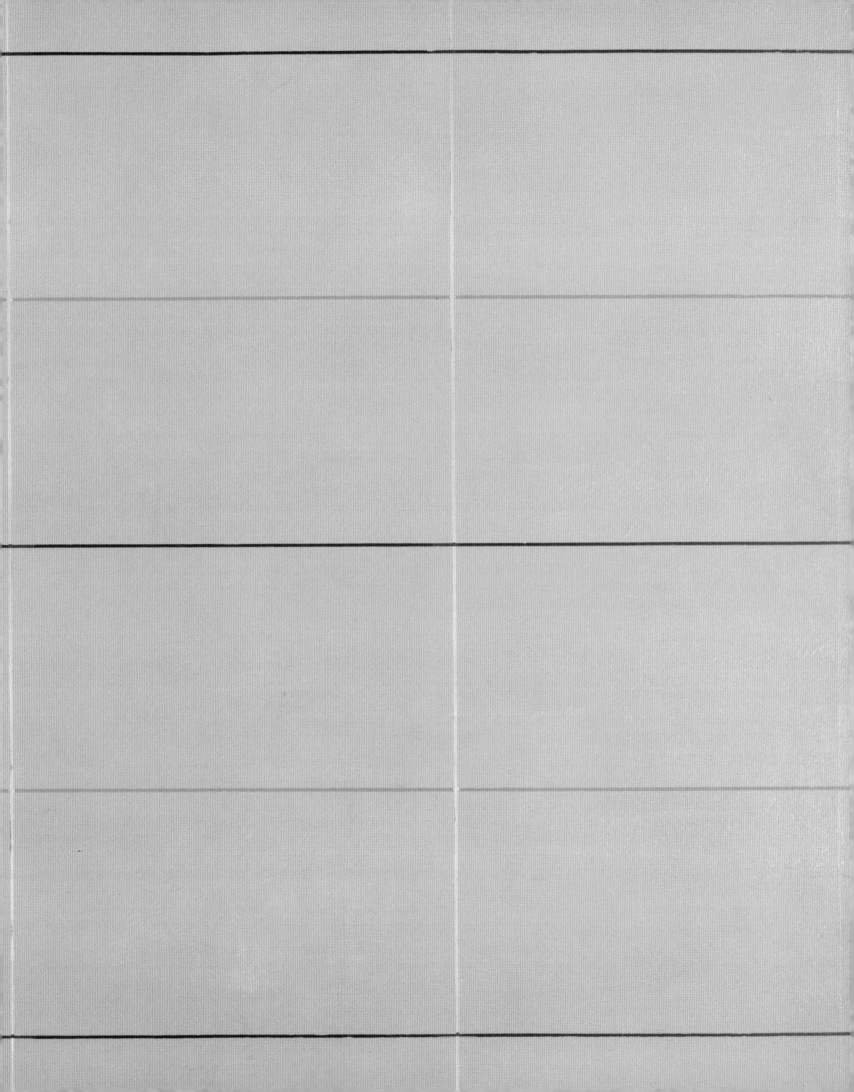

005 Overlay #9 1974

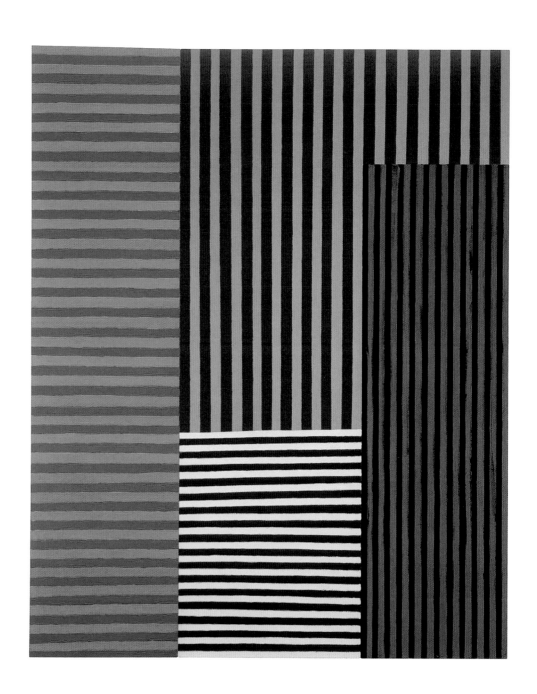

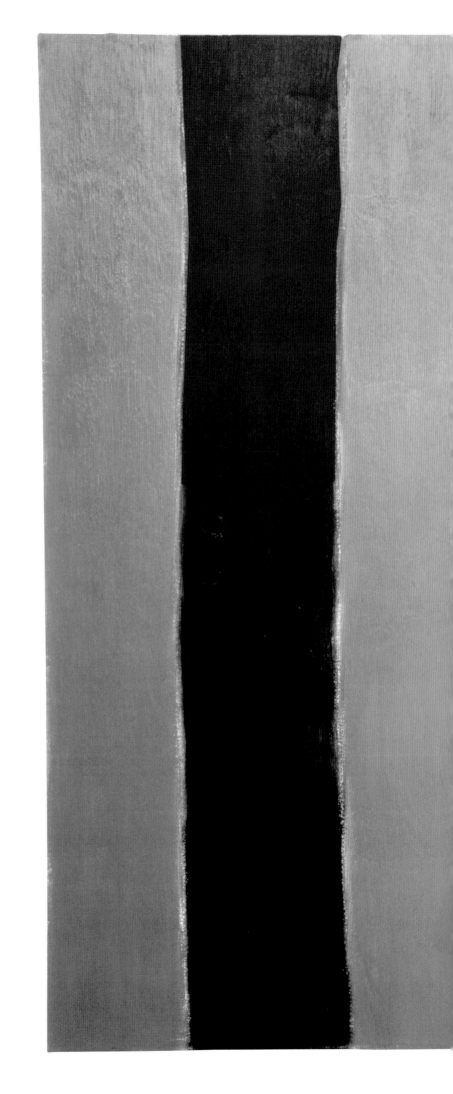

007 The Bather 1983

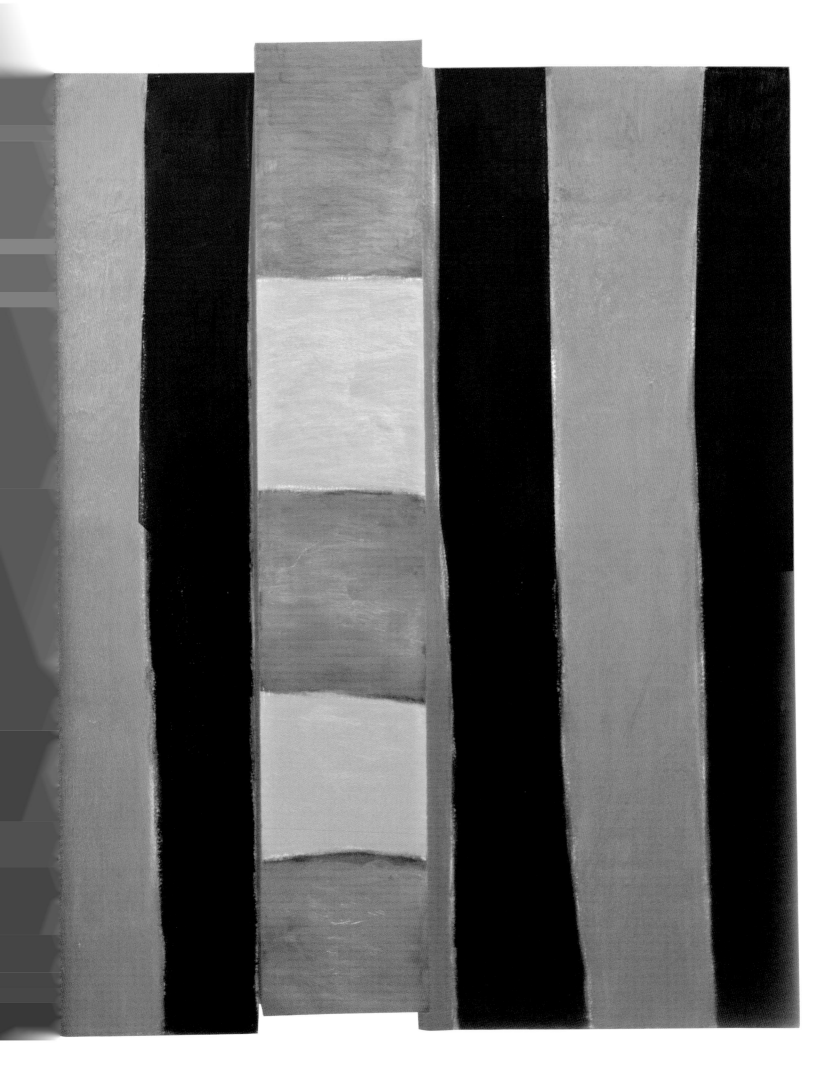

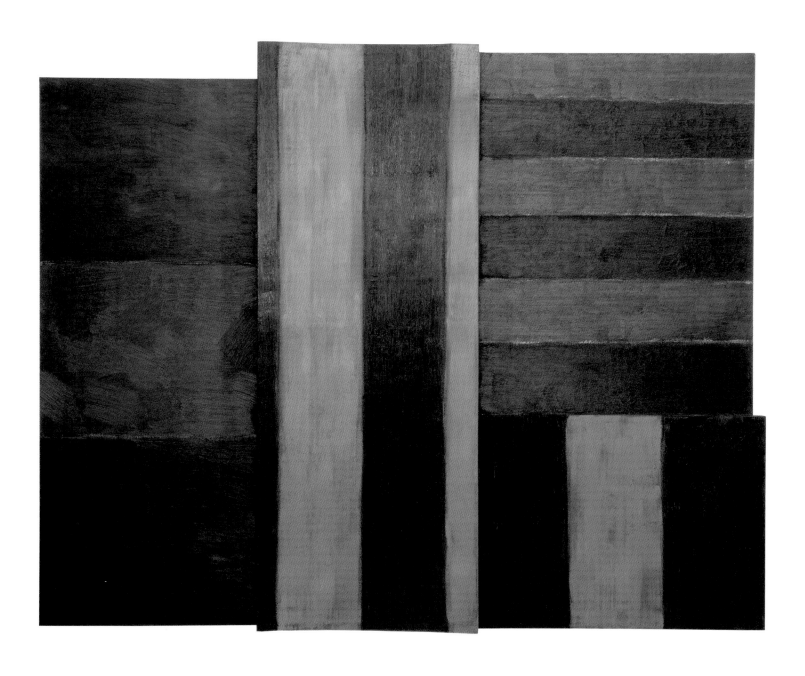

008 Falling Wrong 1985

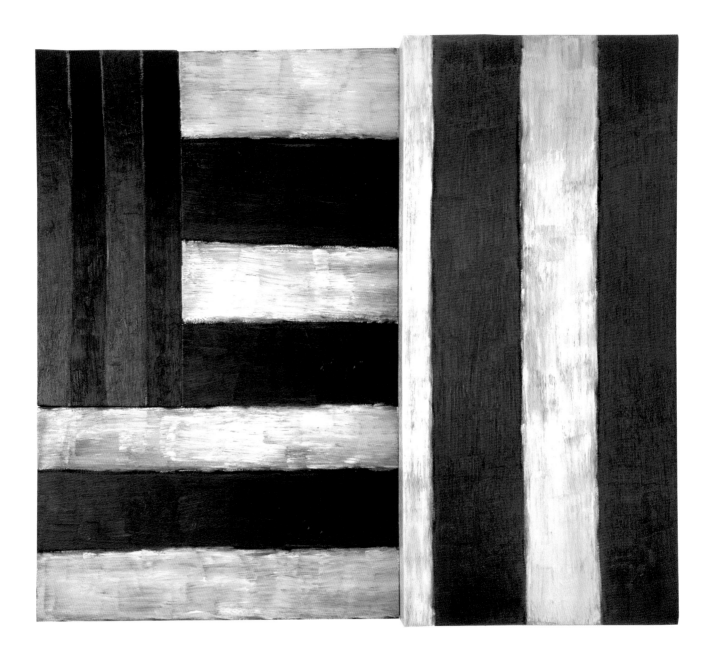

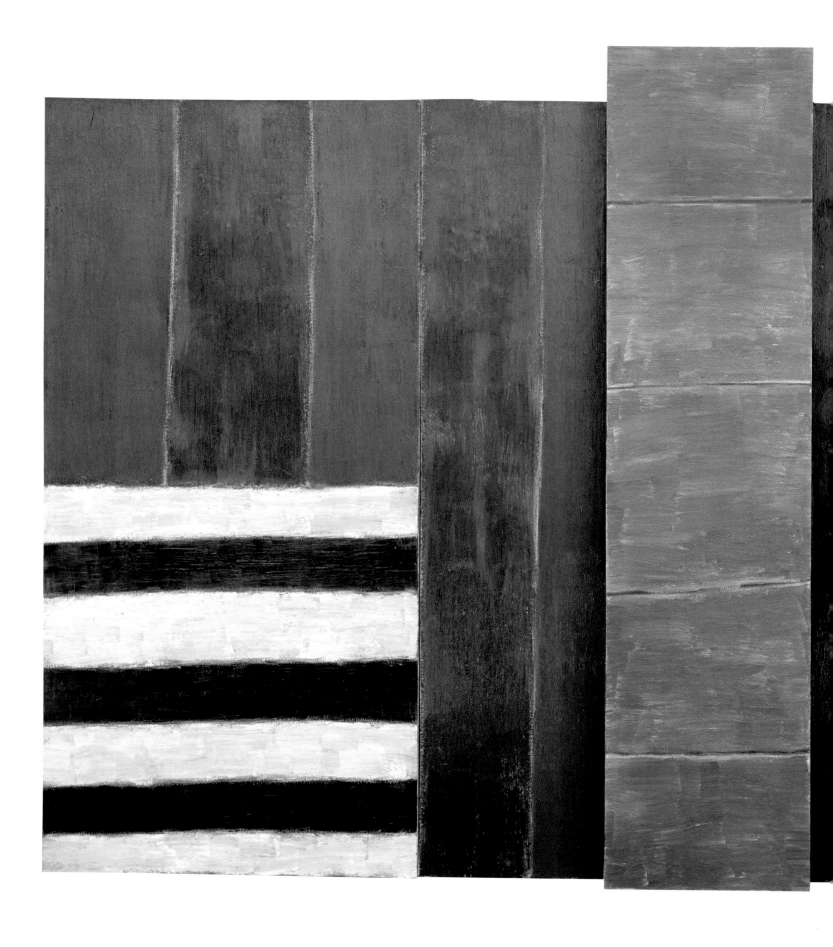

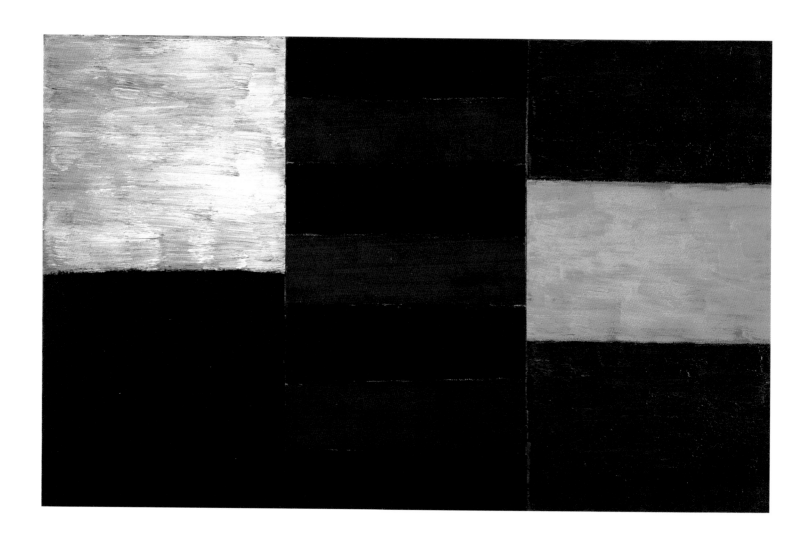

011 One Yellow 1985

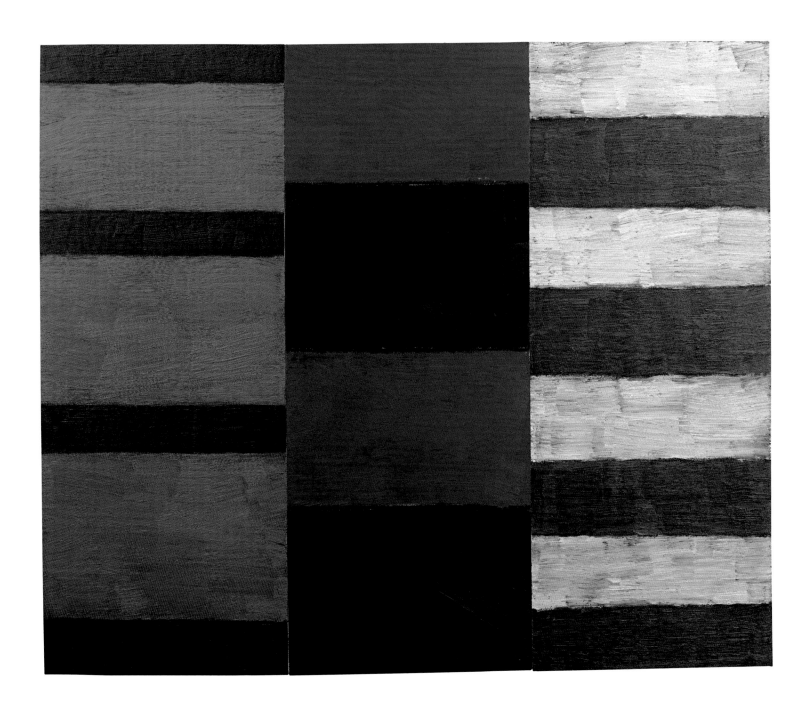

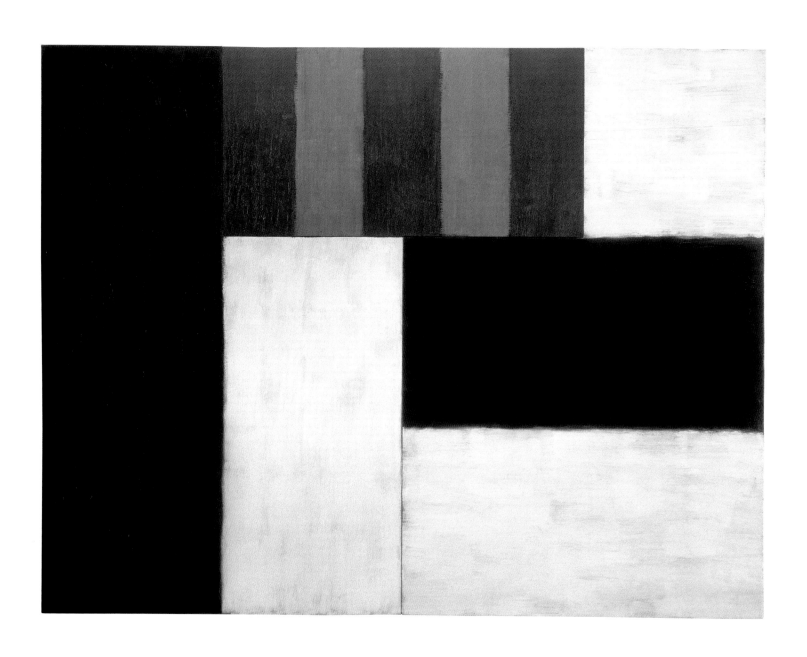

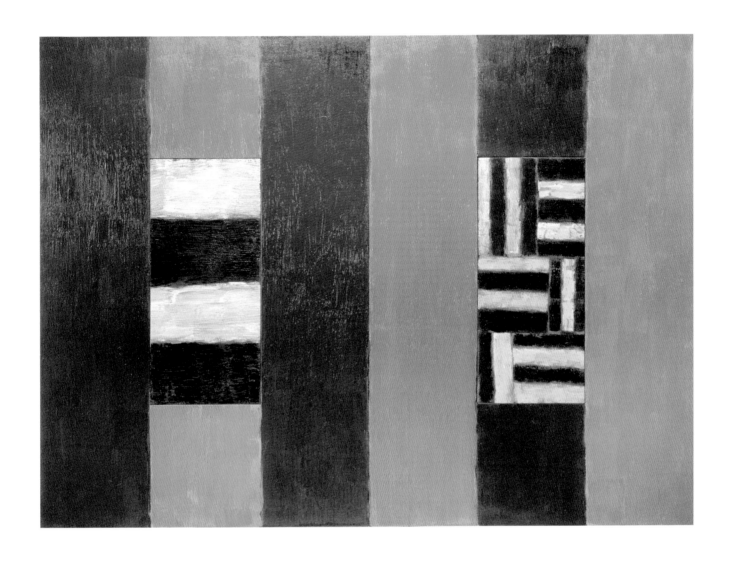

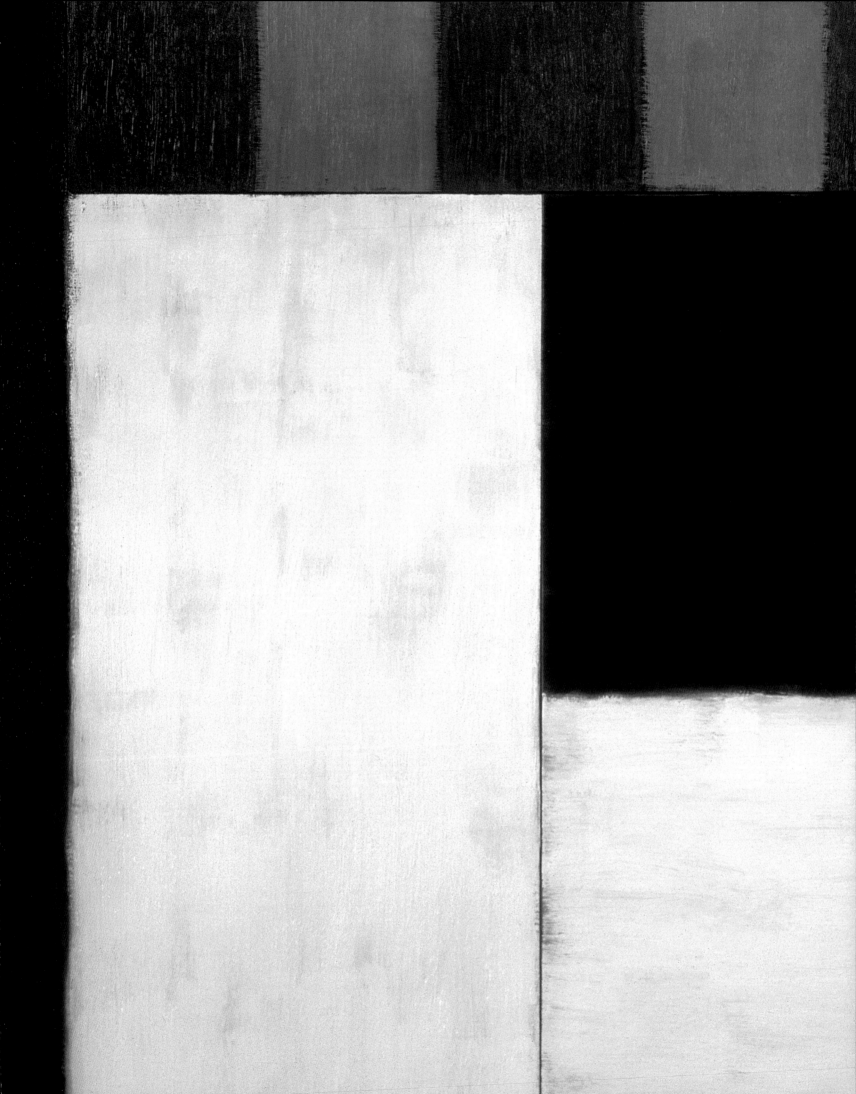

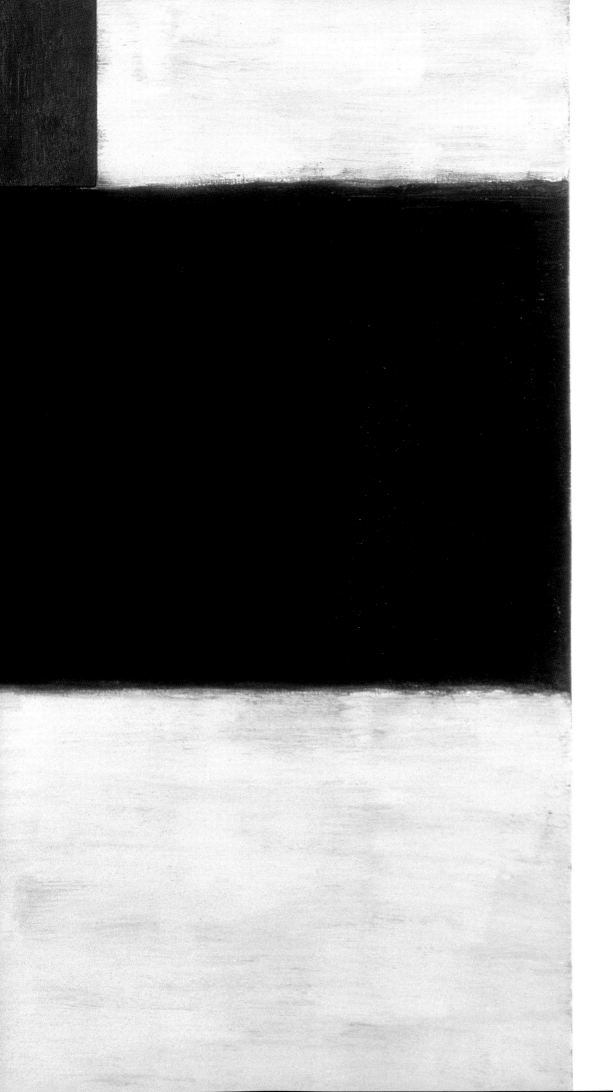

DETAIL OF Dreamland 1987

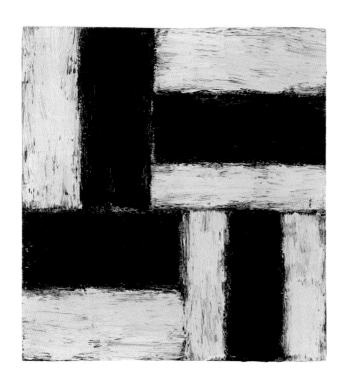

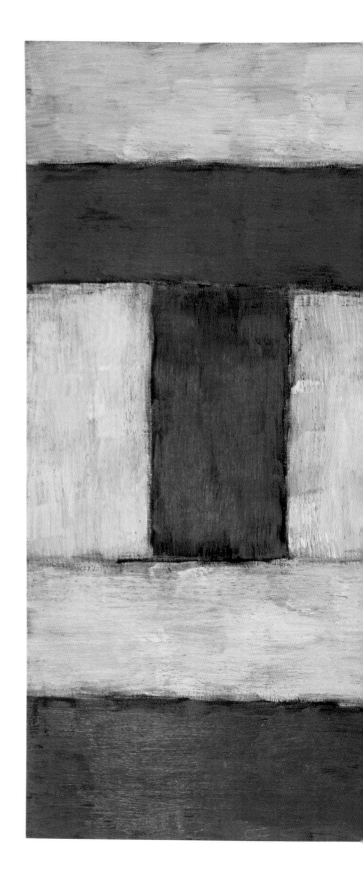

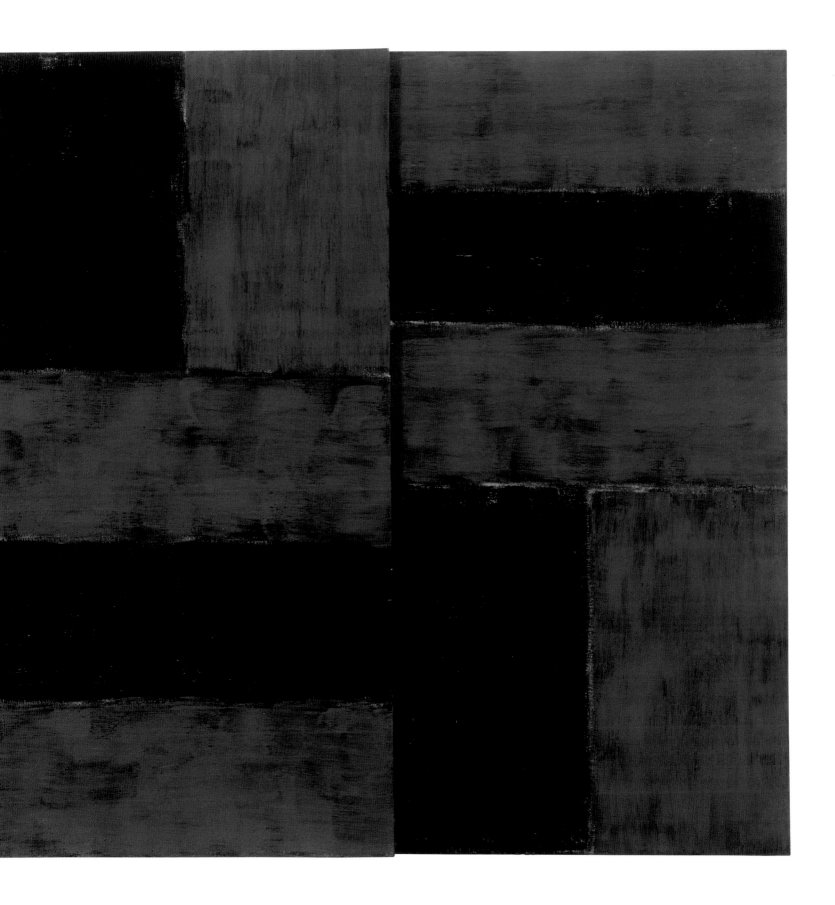

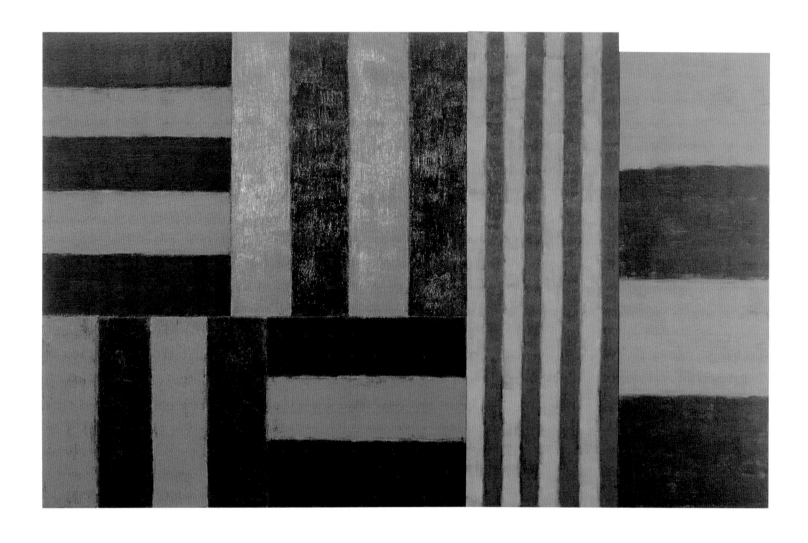

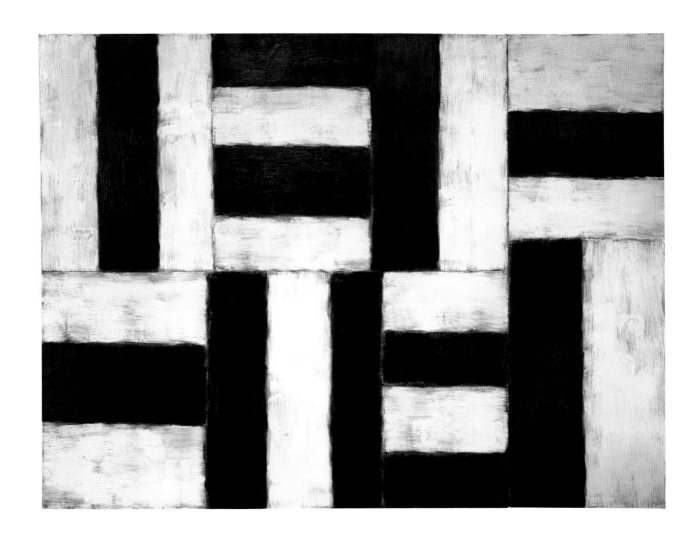

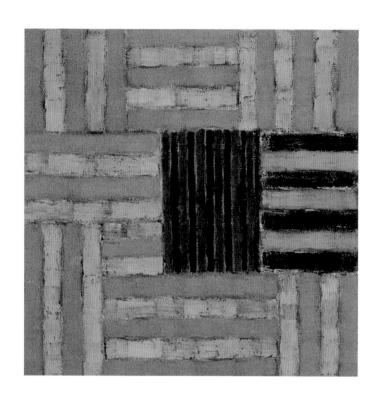

019 Pink Insert 1991

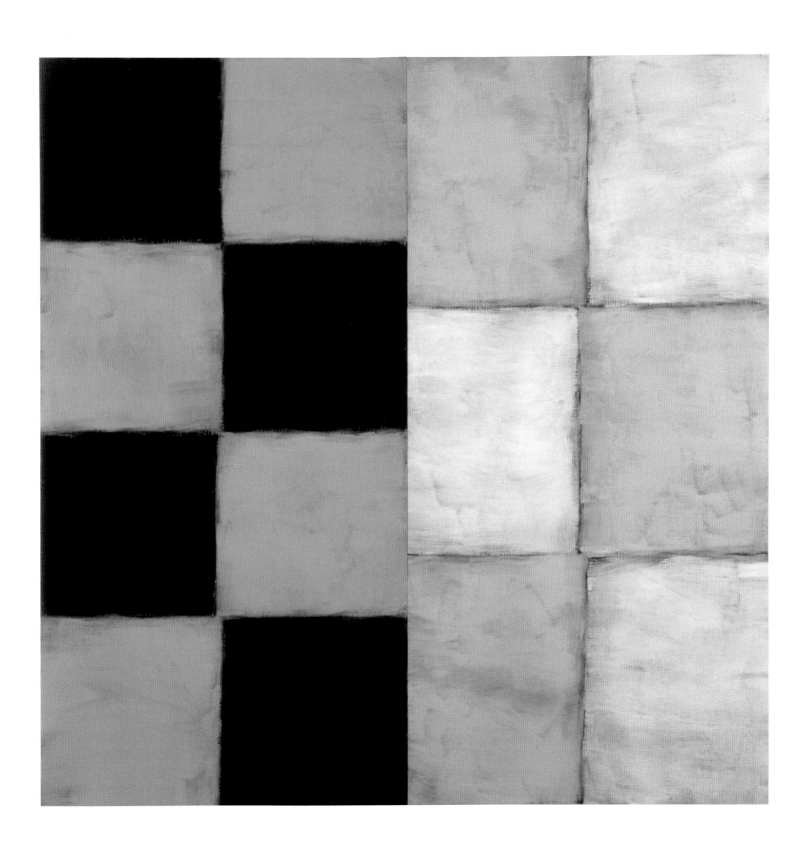

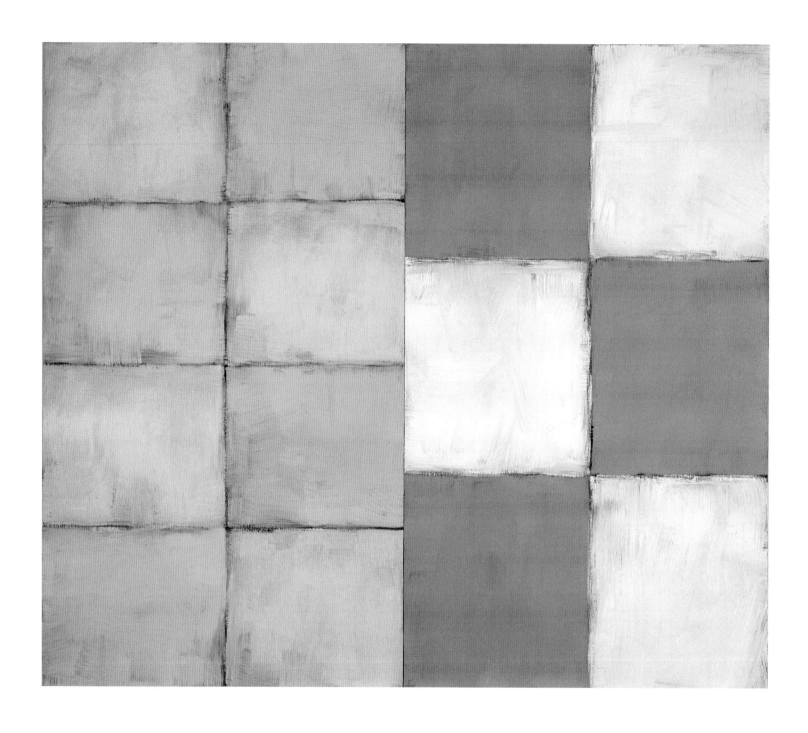

021 Union Yellow 1994

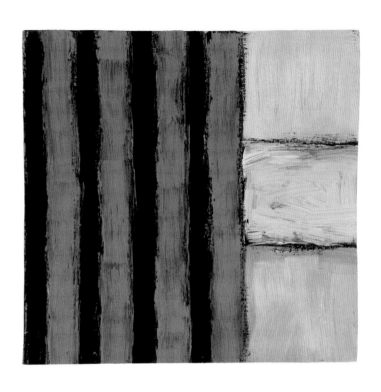

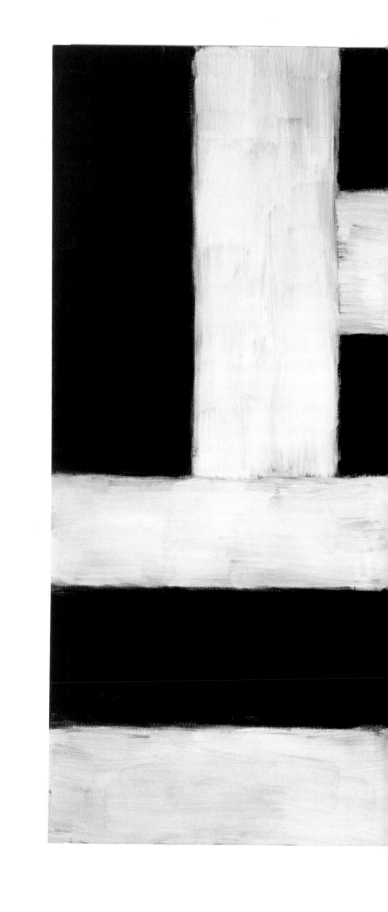

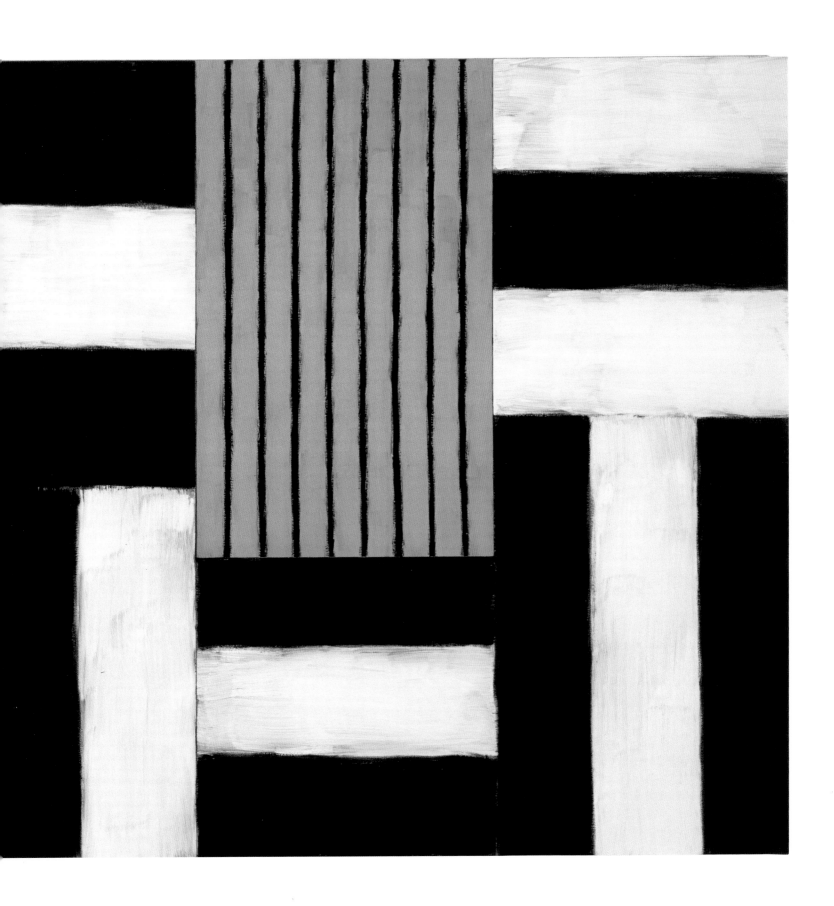

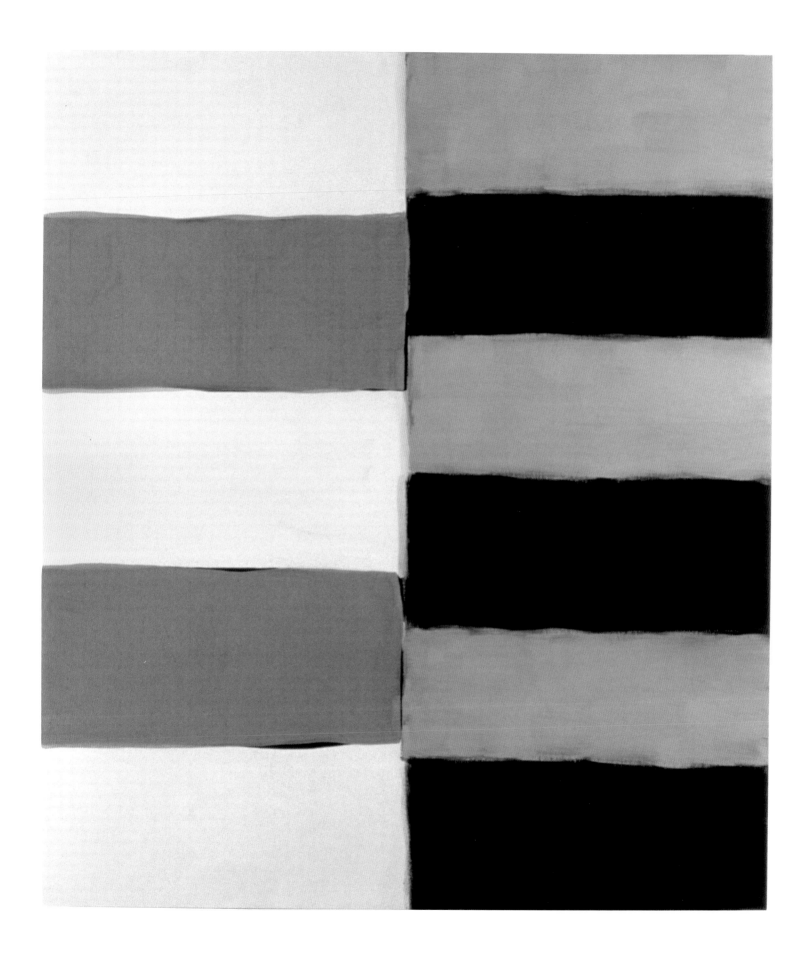

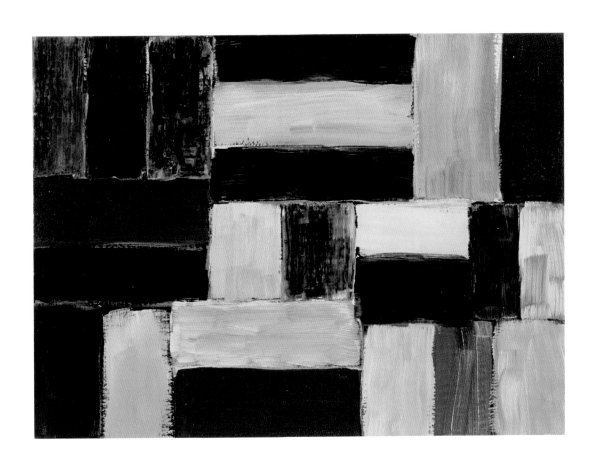

025 Small Barcelona Painting 9.15.99 1999

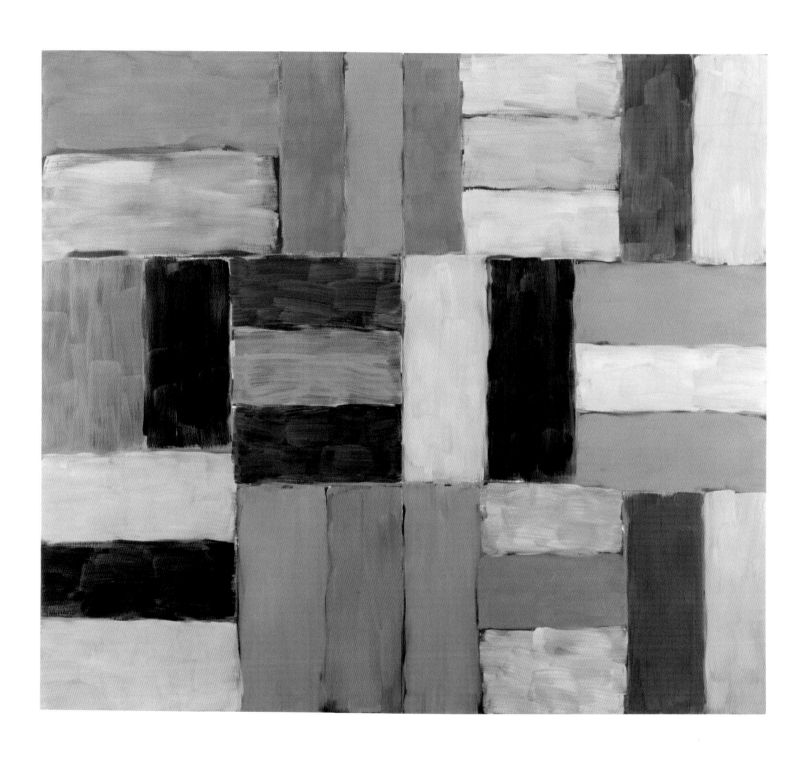

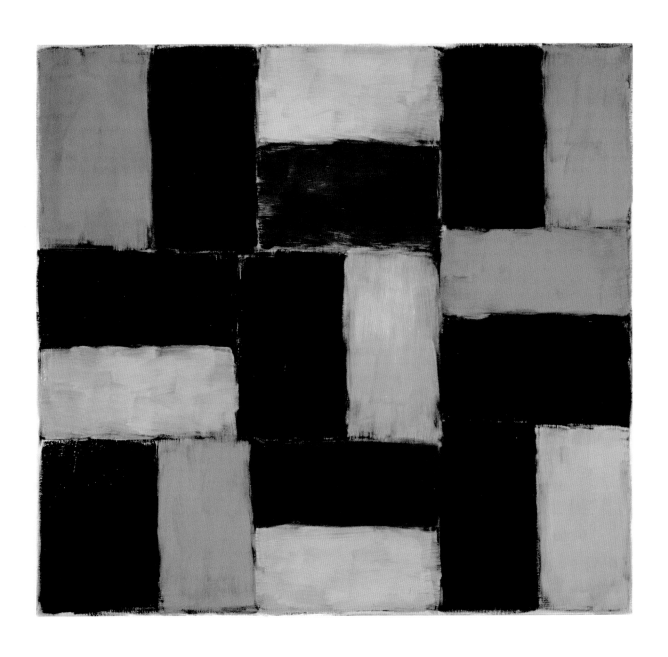

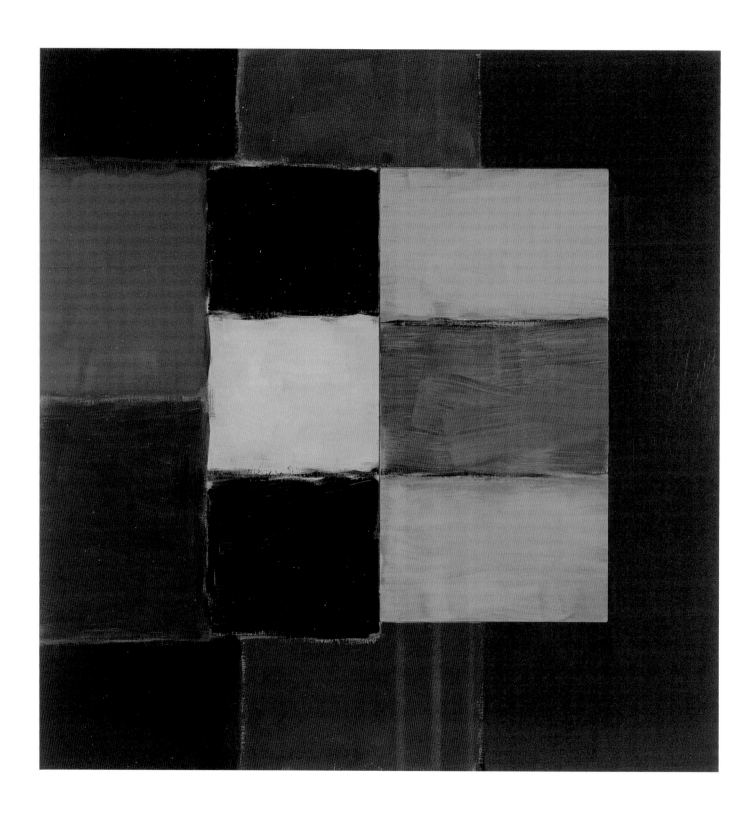

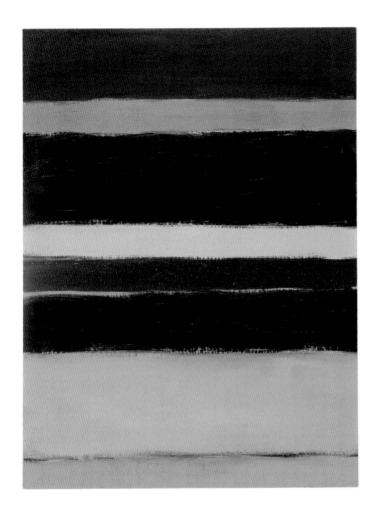

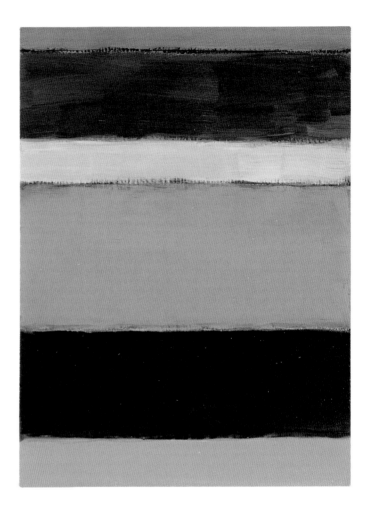

029 Colored Landline 2003 **030** Landline Sand 2003

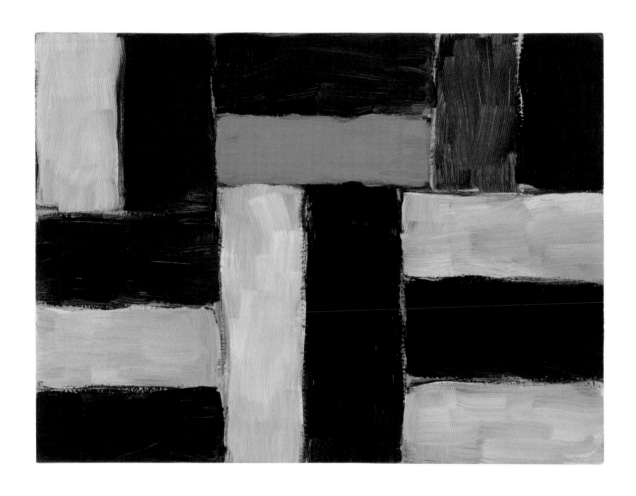

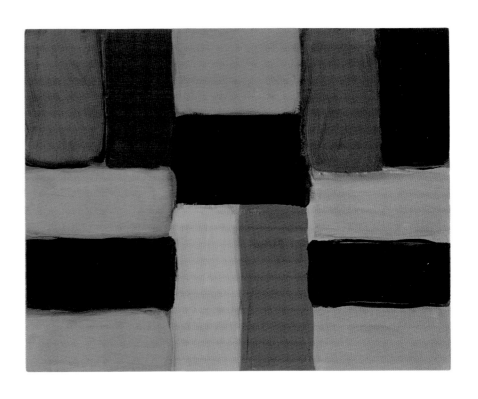

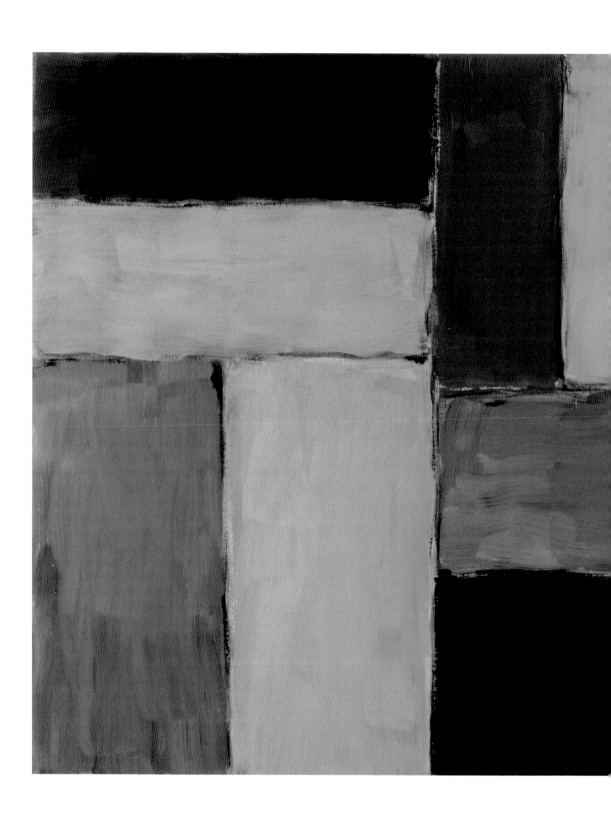

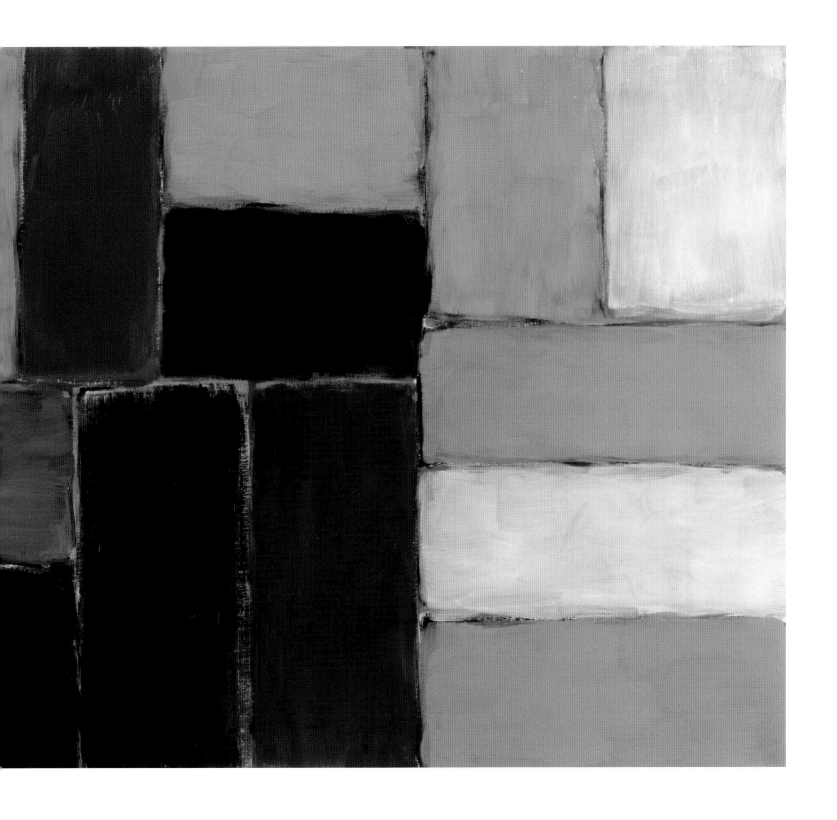

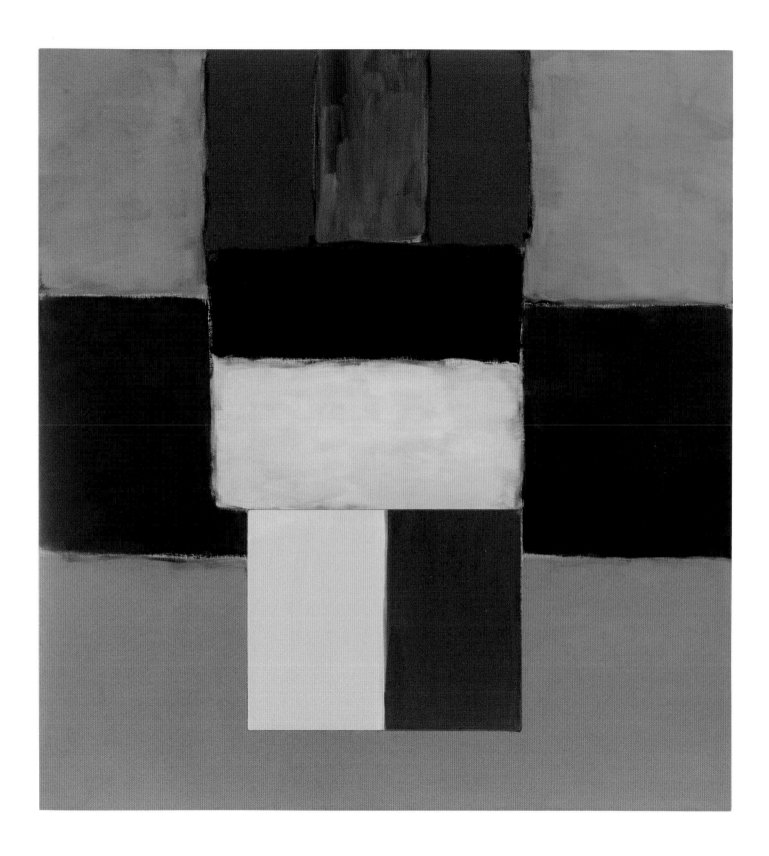

034 Figure in Blue 2003

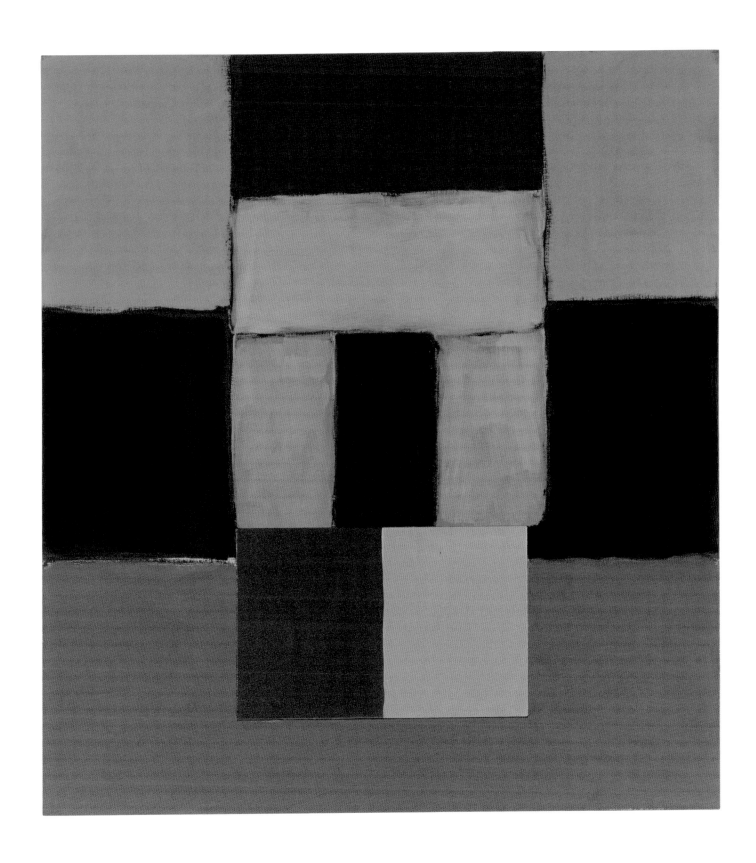

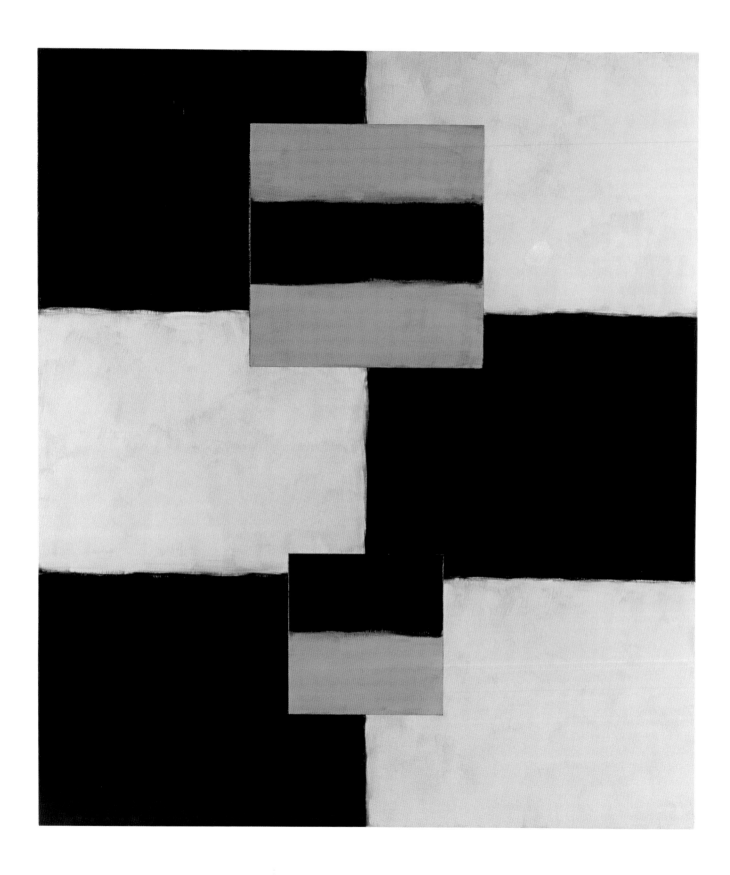

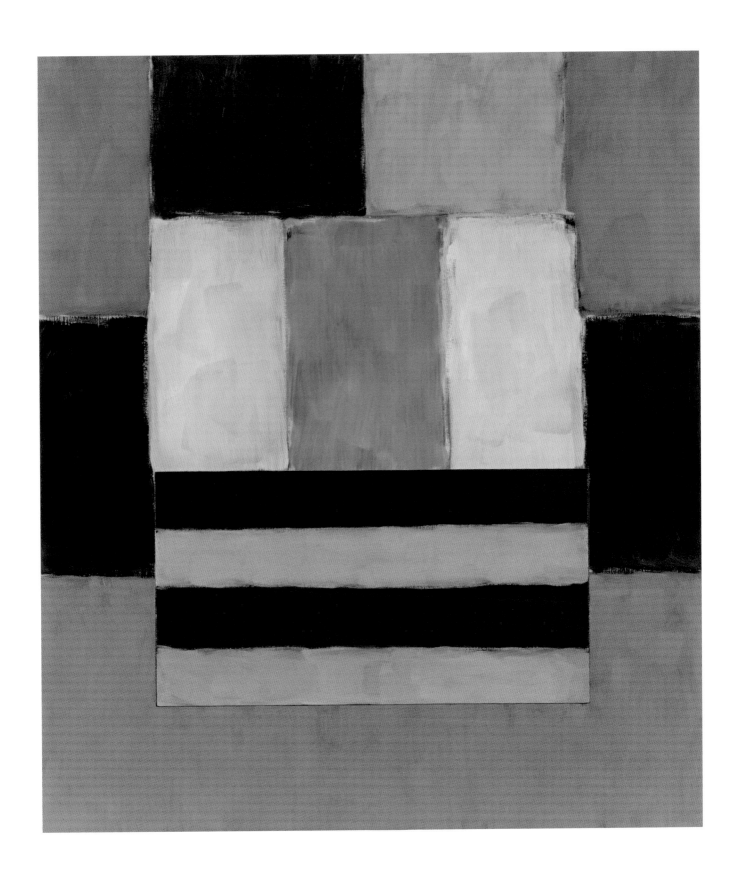

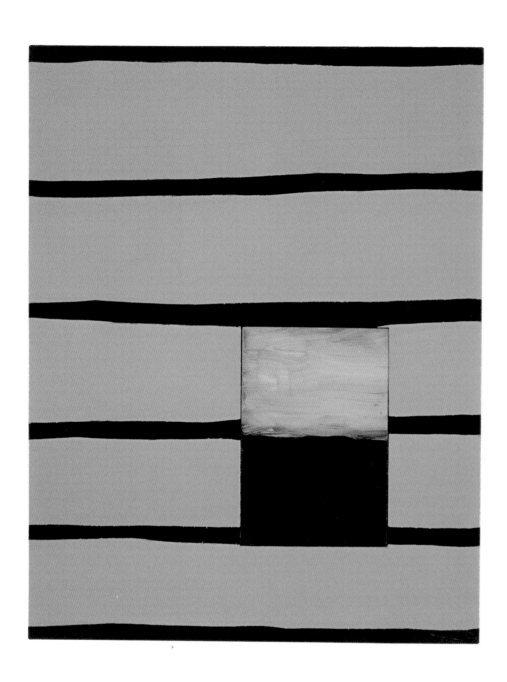

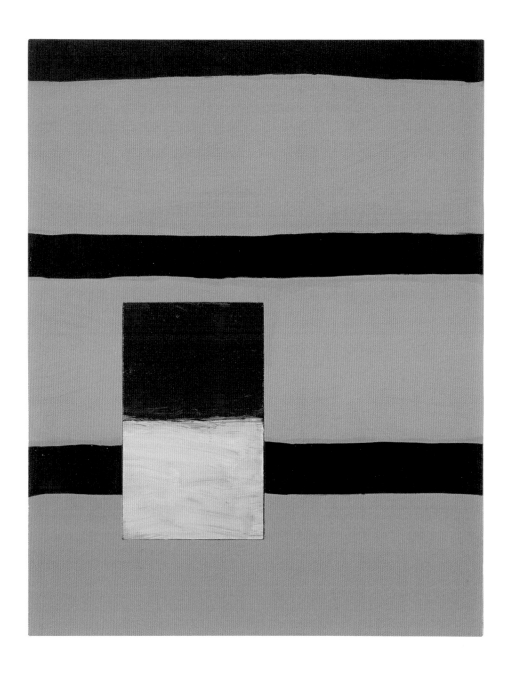

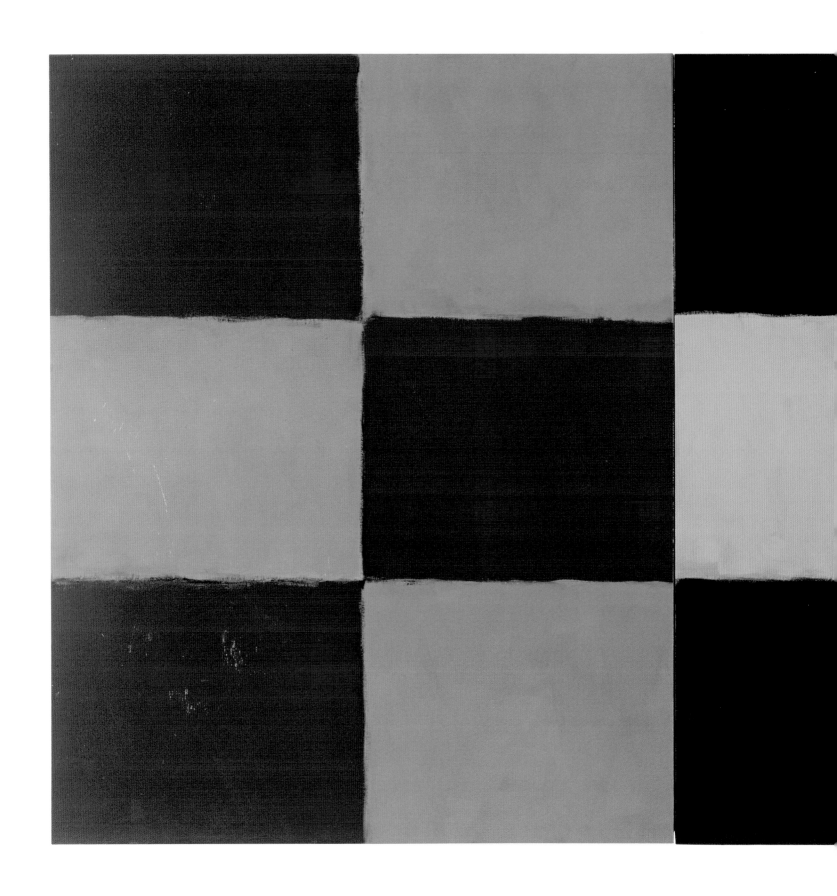

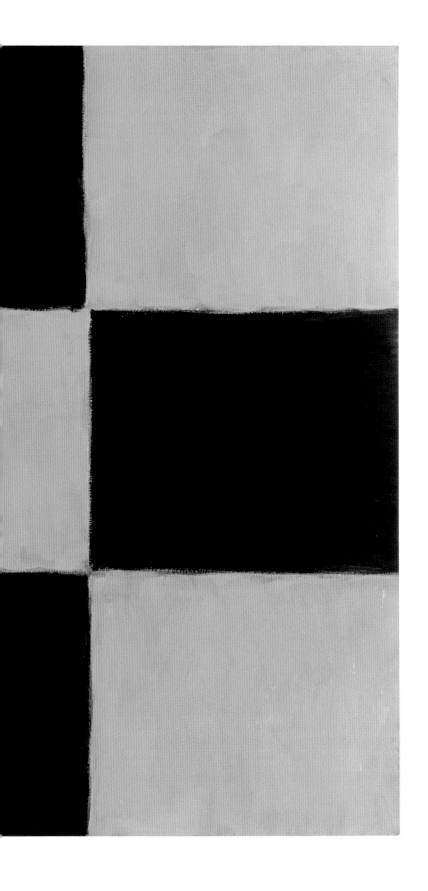

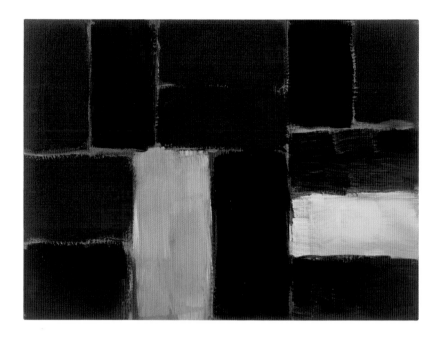

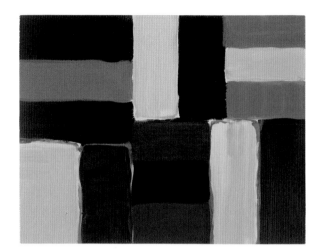

041 Barcelona Red Blue 2004 **042** Dark Blue 8.05 2005

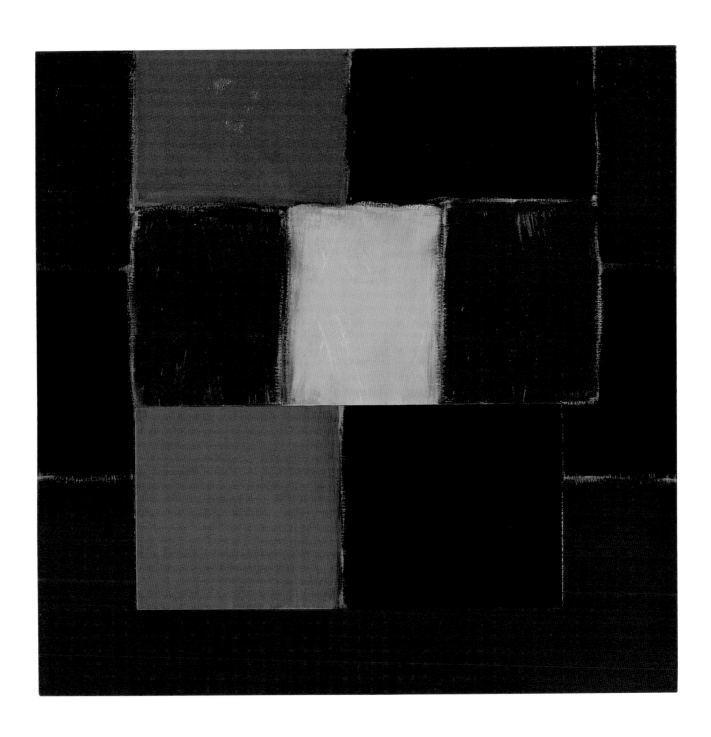

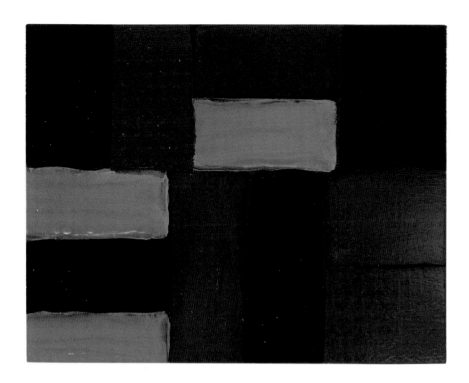

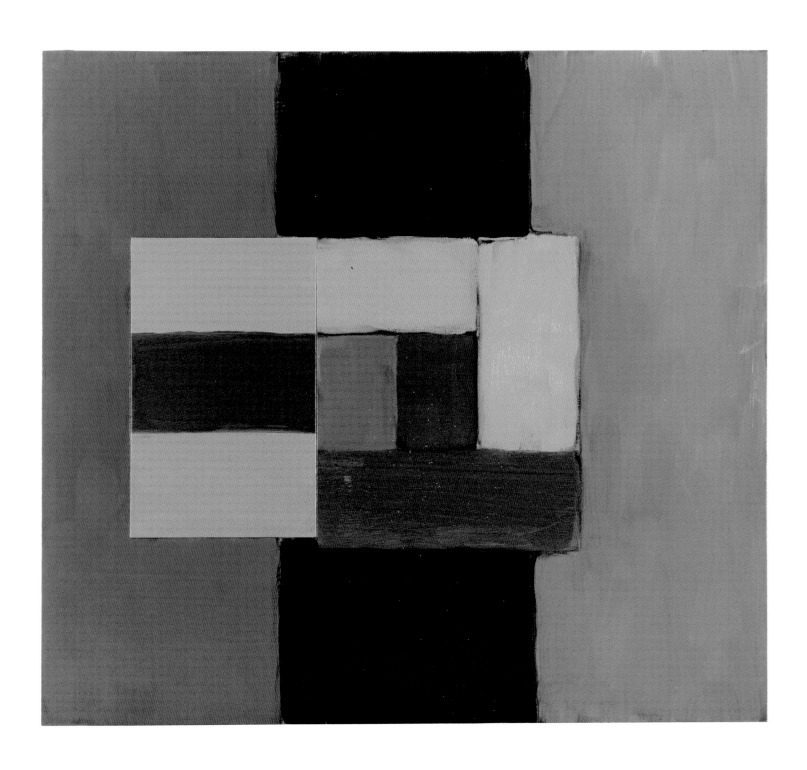

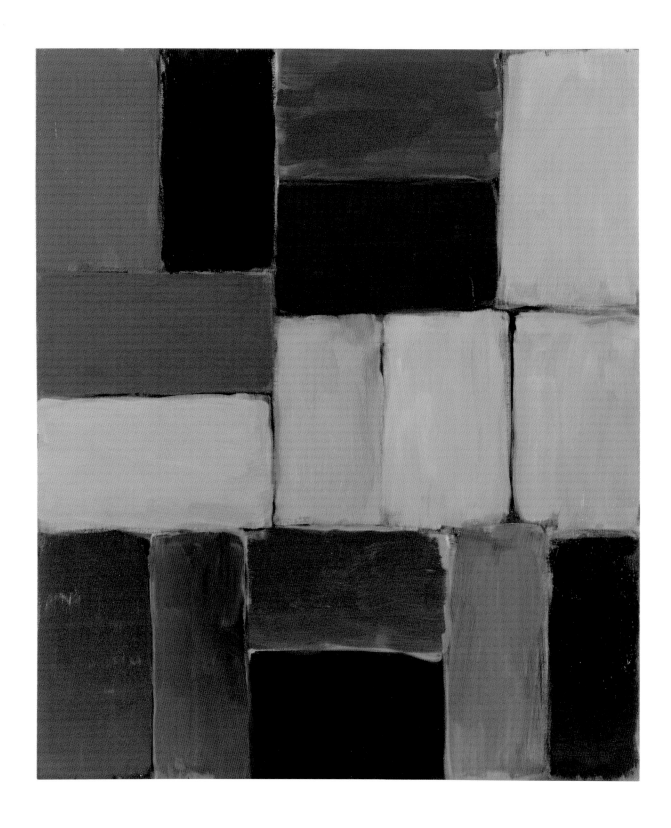

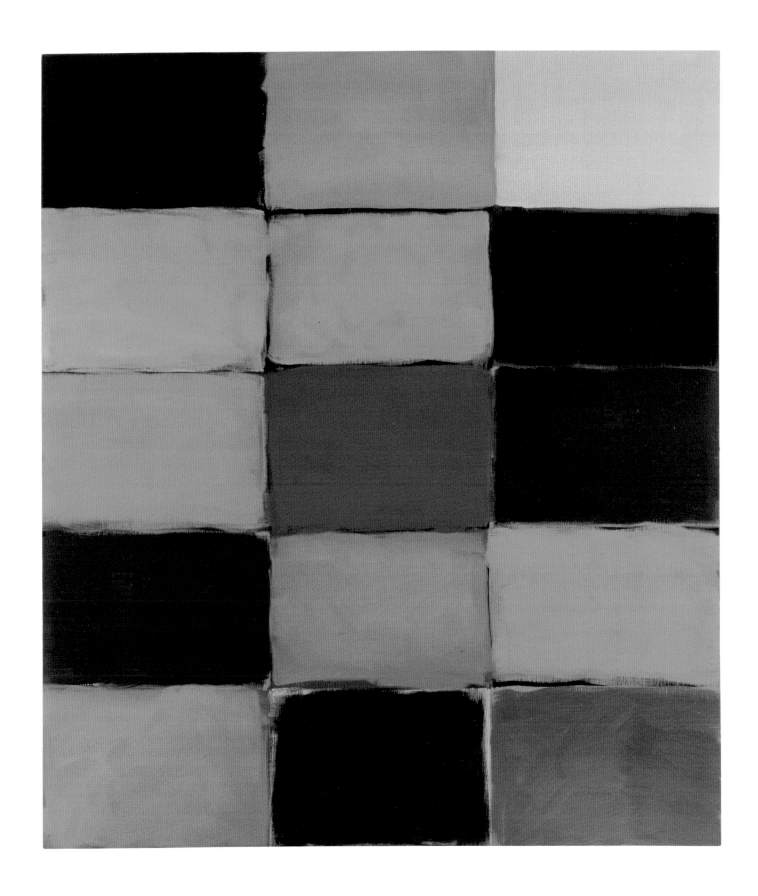

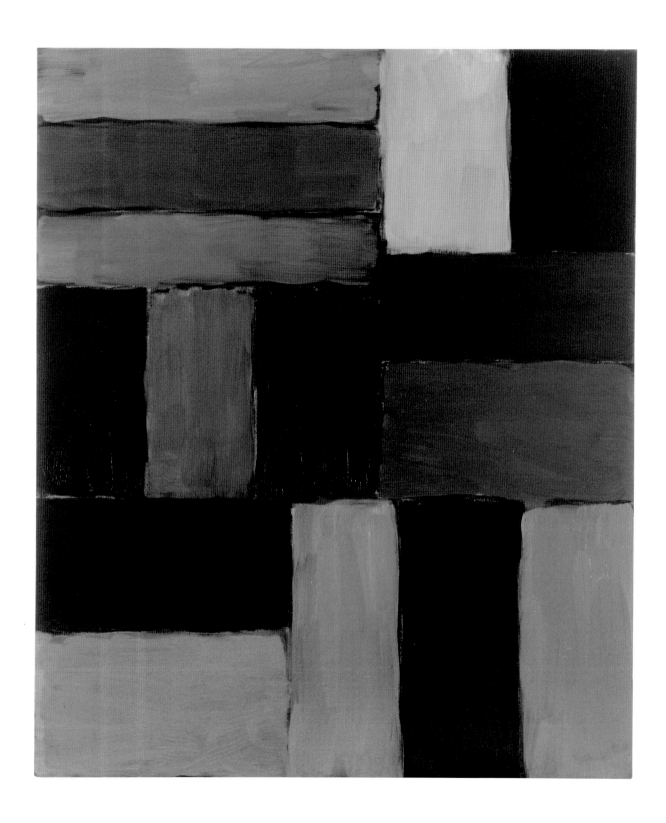

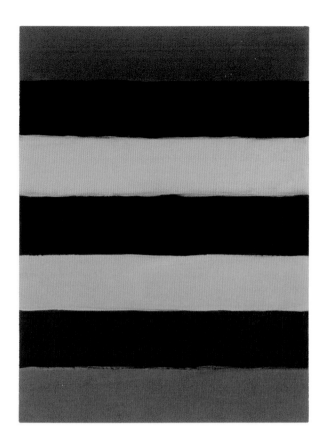

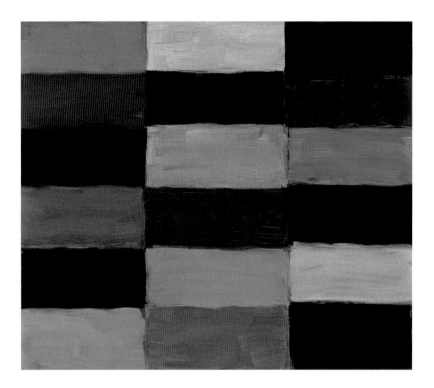

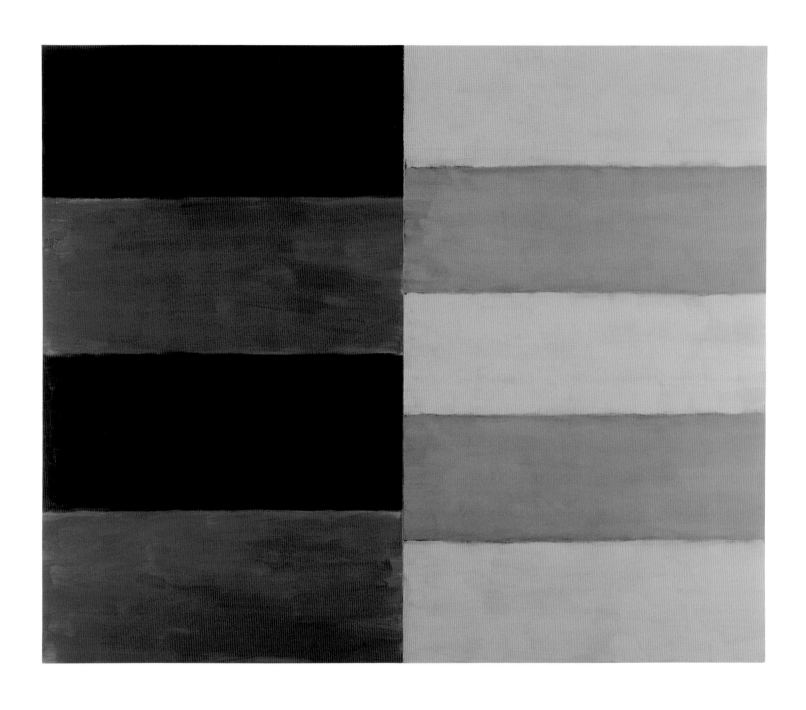

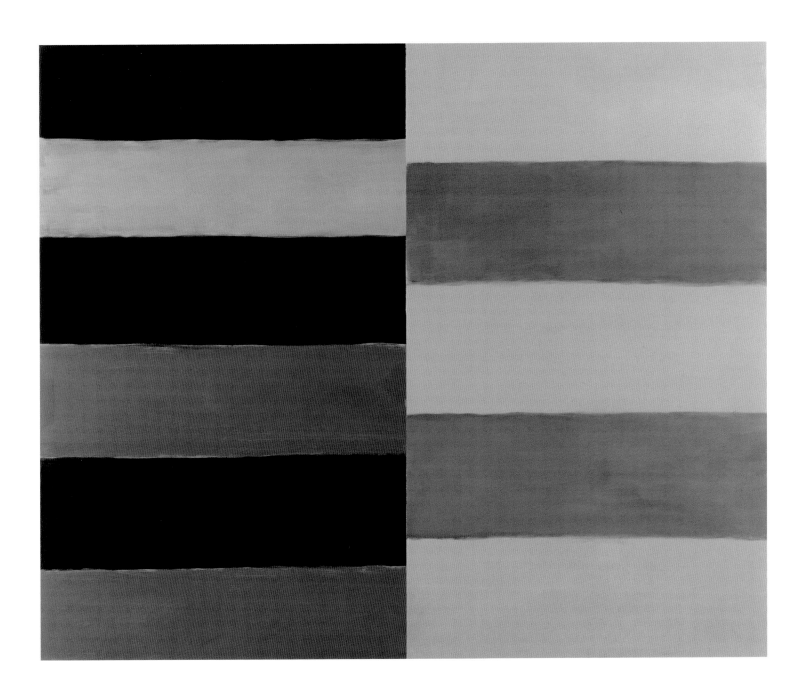

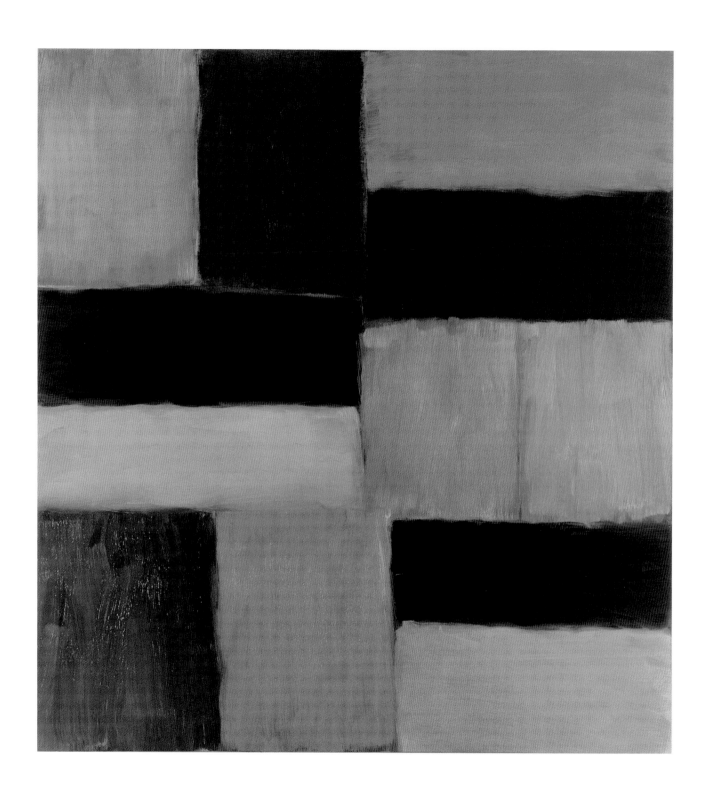

053 Wall of Light Yellow Plain 2007

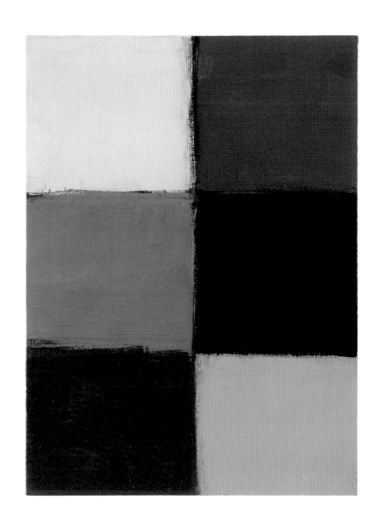

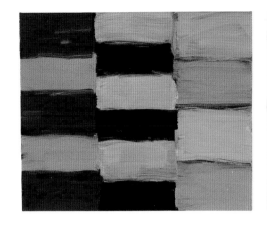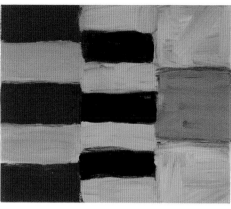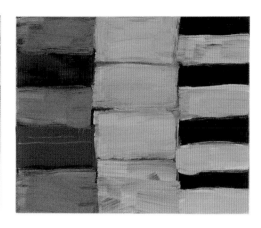

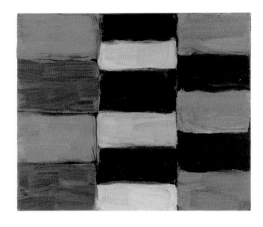 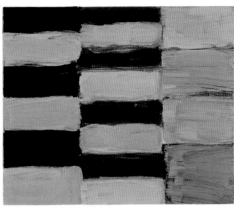 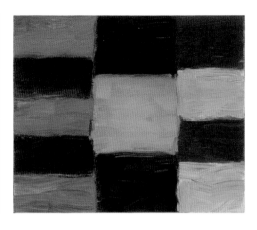

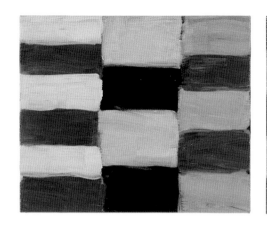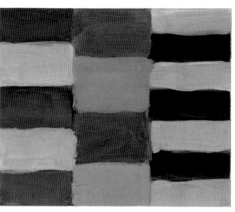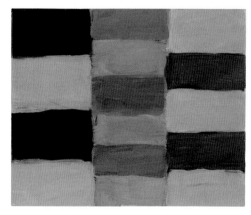

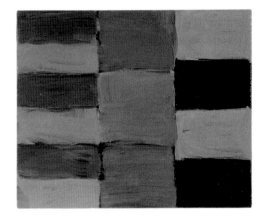 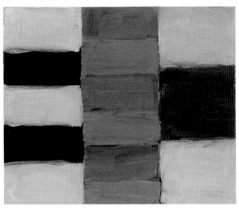 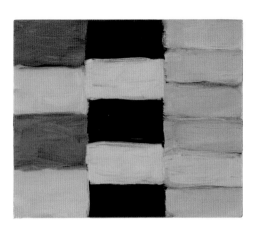

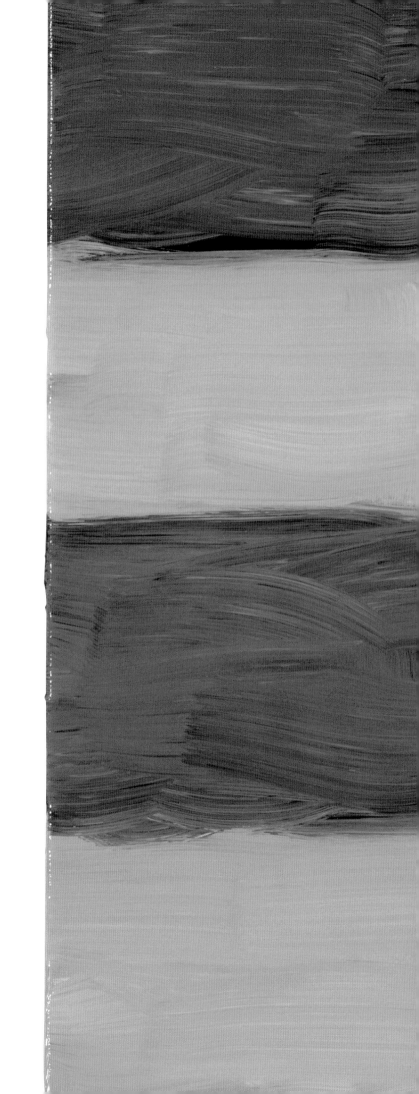

DETAIL OF 12 Triptychs #12 2008

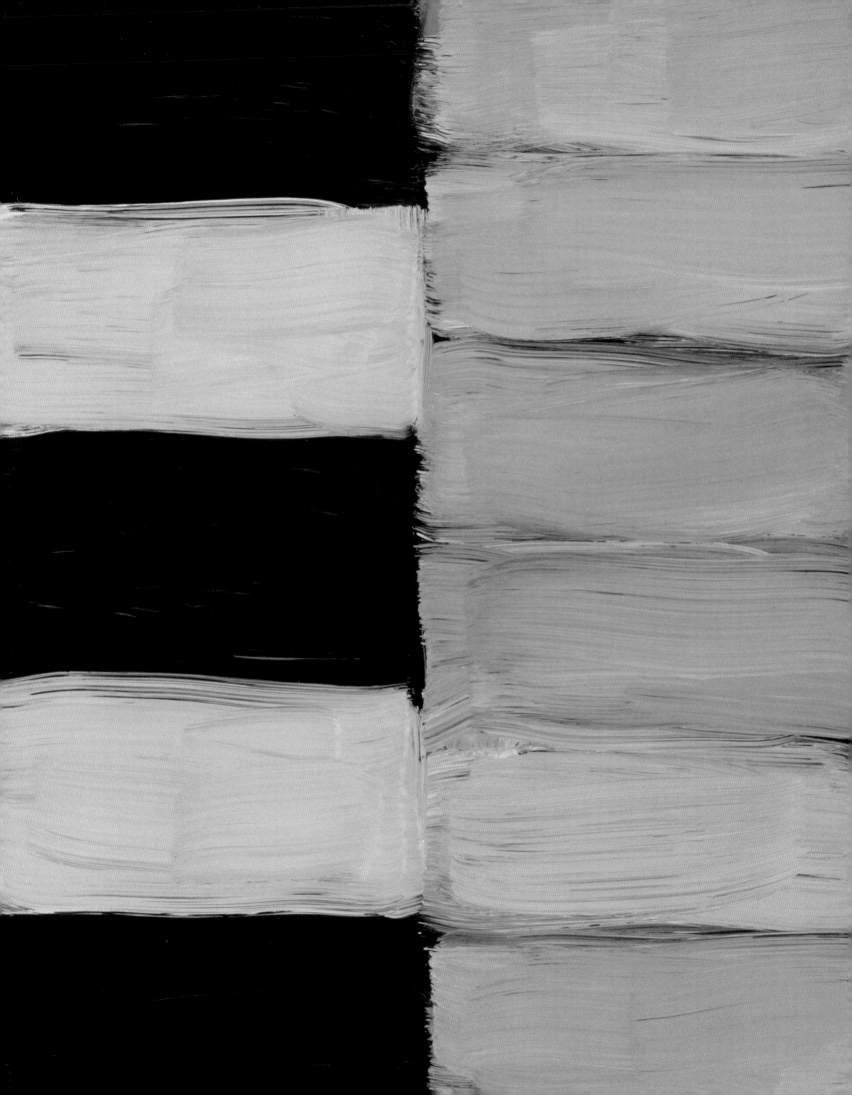

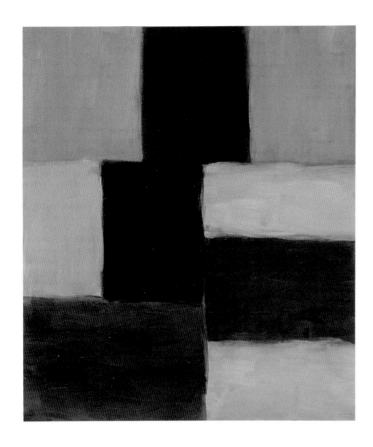

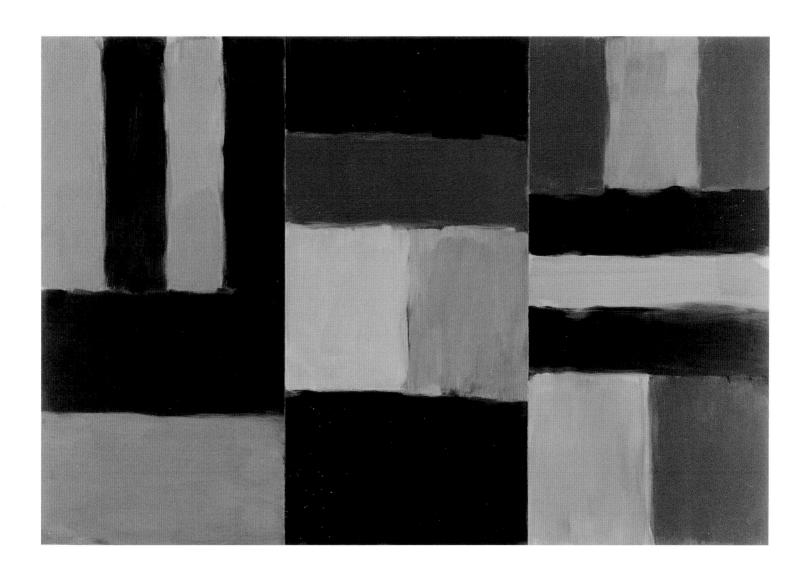

057 Cut Ground Colored Triptych 6.08 2008

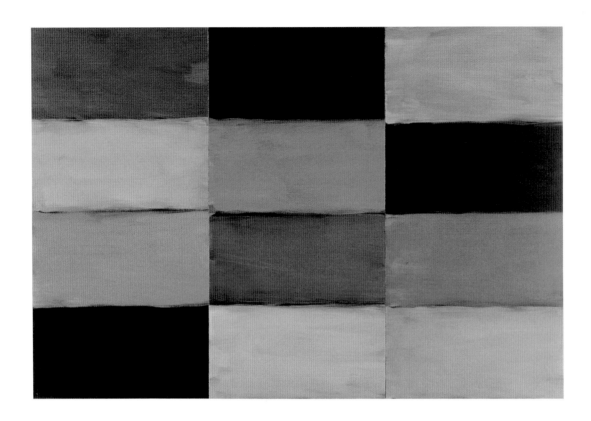

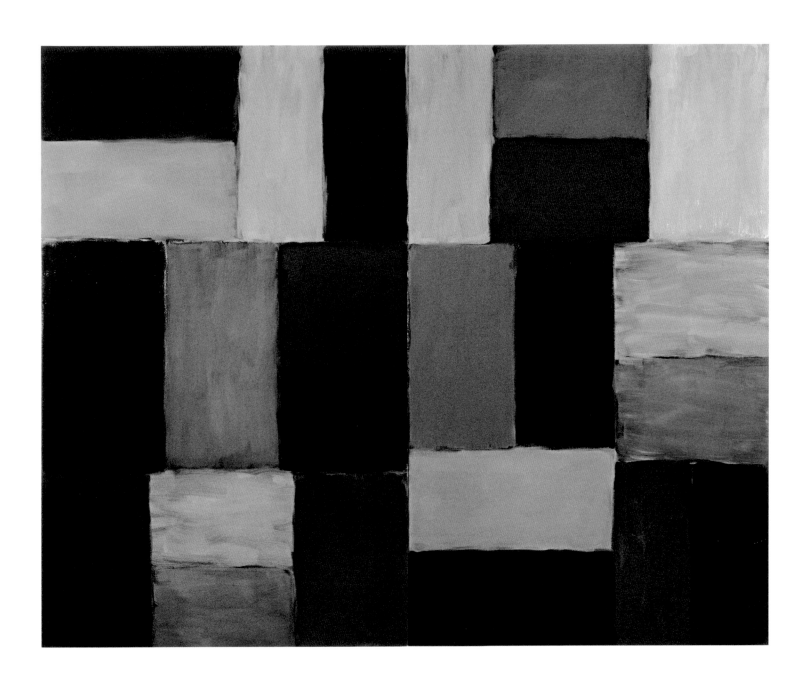

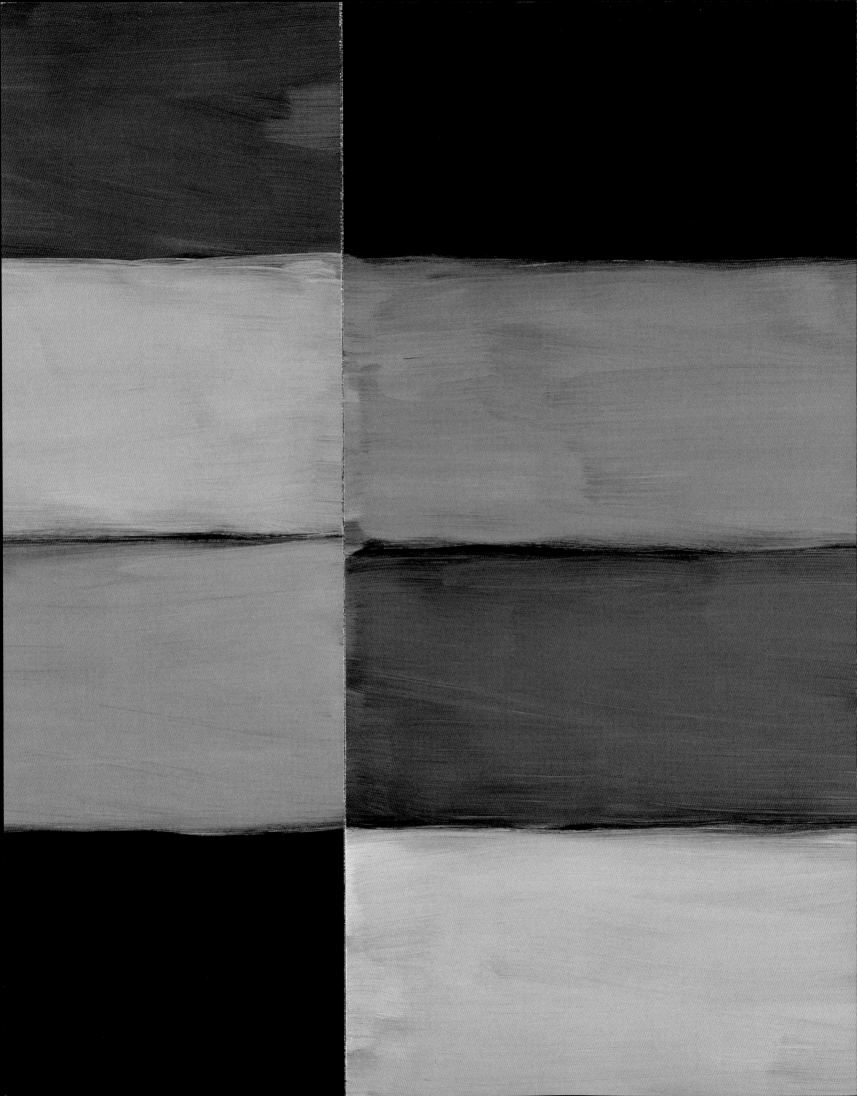

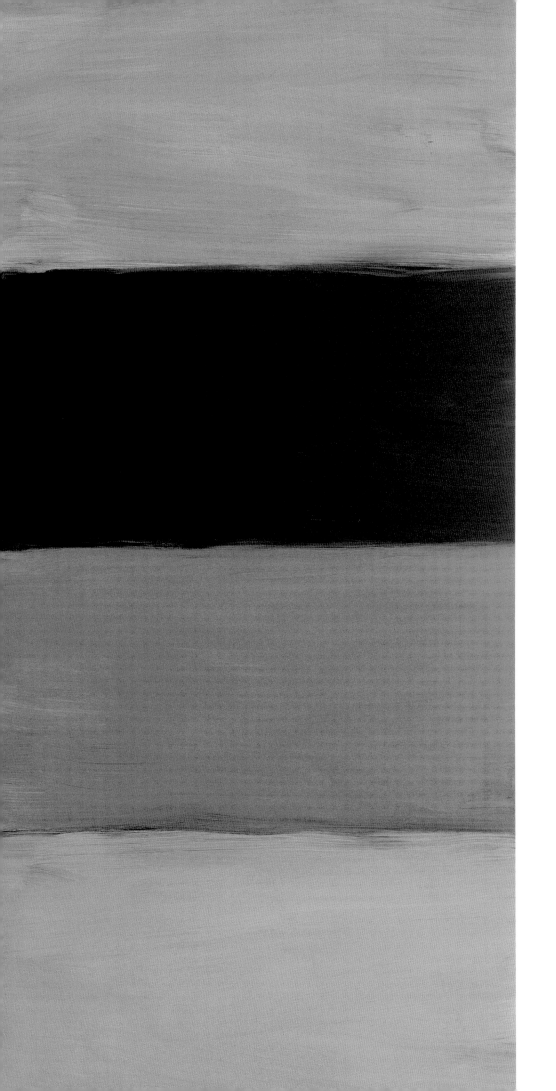

DETAIL OF Barcelona Robe 7.08 2008

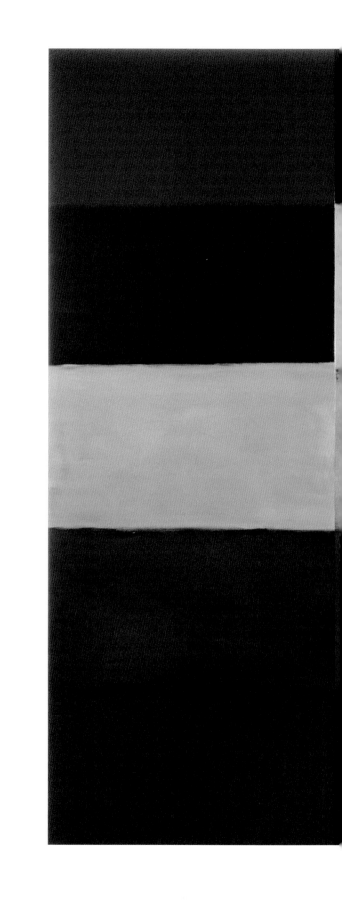

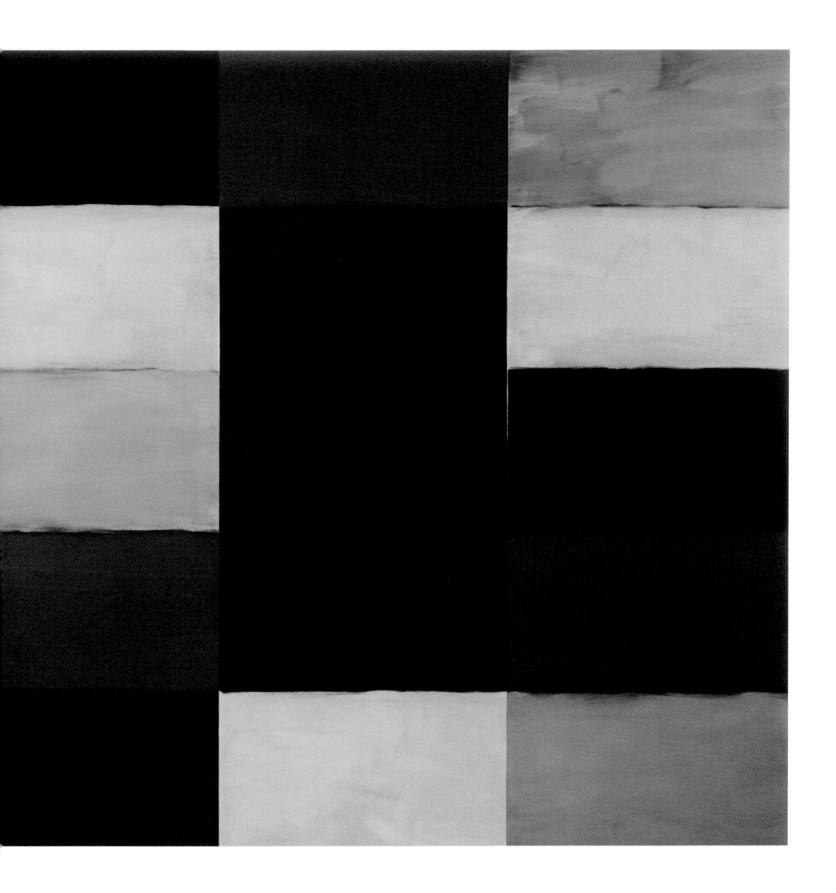

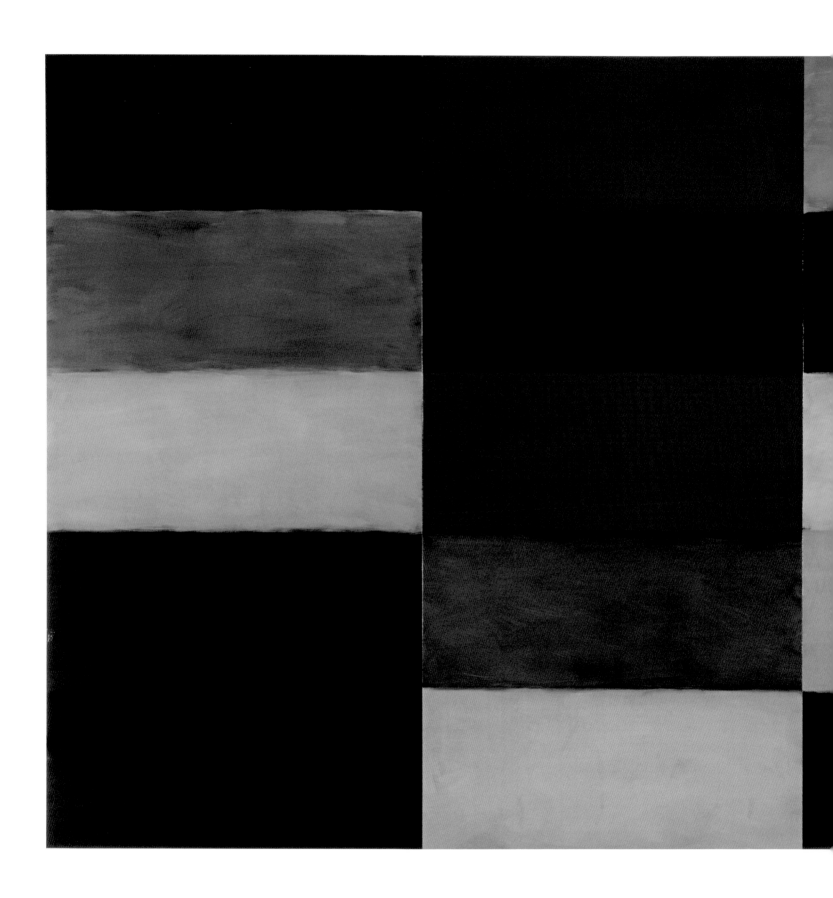

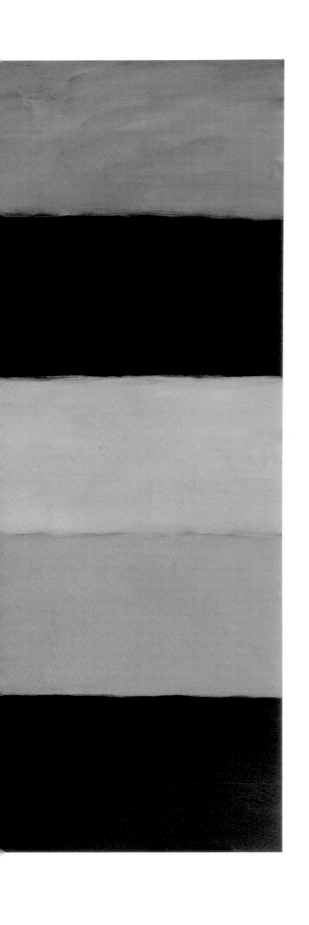

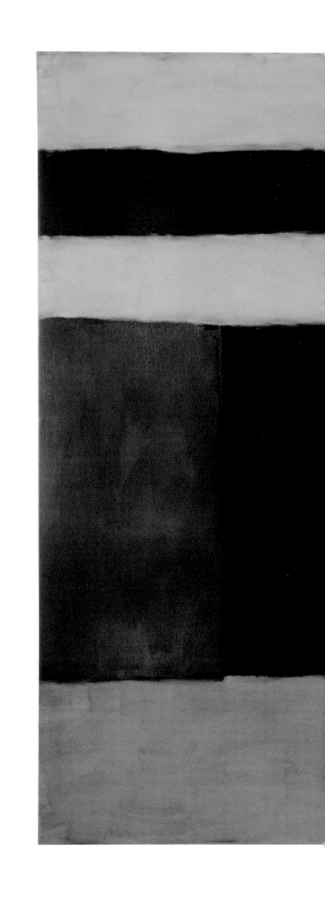

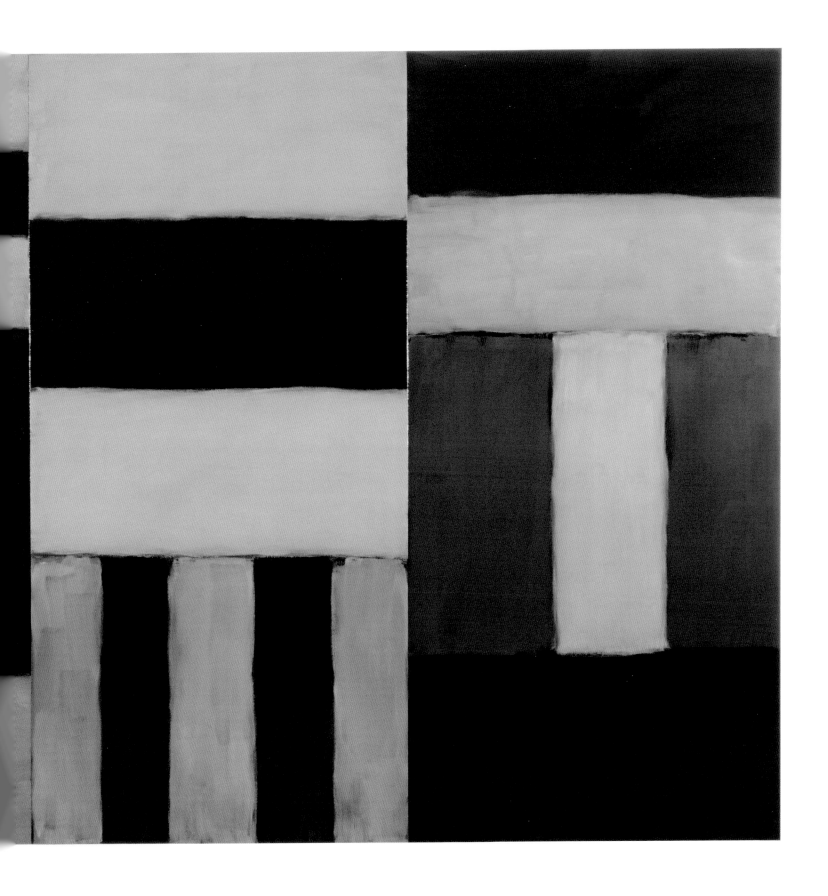

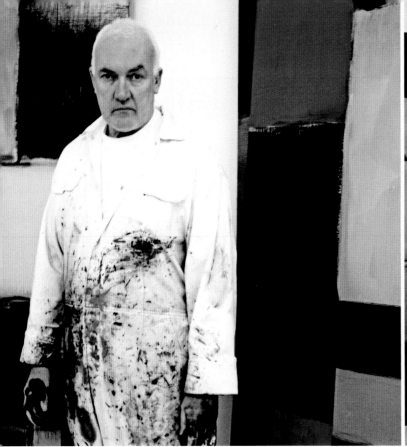
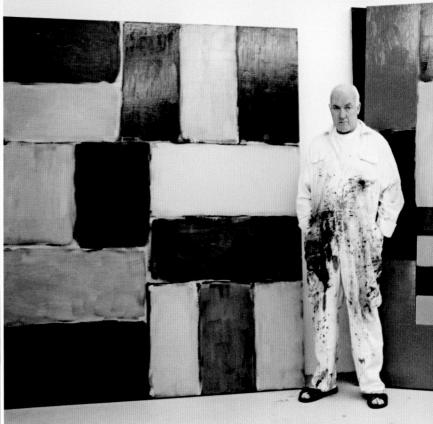

Sean Scully

1945 Born in Dublin, Ireland.

1949–59 Family moves to London. Grows up in a working-class area of south London and attends local convent schools.

1960–62 Apprenticed at a commercial printing shop in London.

1962–65 Attends evening classes at the Central School of Art, London.

1965 Decides to dedicate himself entirely to art studies. Studies at the Croydon College of Art, London, until 1968.

1968–72 Attends Newcastle University, Newcastle-upon-Tyne, England. Visits Morocco in 1969. The stripes and colours of local textiles and carpets and the southern light make an impression.

1972–73 Awarded the John Knox Fellowship. Makes his first visit to the United States. Attends Harvard University.

1973 Returns to England. Has his first solo exhibition at the Rowan Gallery, London.

1973–75 Teaches at the Chelsea College of Art and Design and Goldsmith's College of Art and Design, London.

1975 Awarded the Harkness Fellowship for two years. Moves to New York.

1977 Has his first solo exhibition in New York at the Duffy-Gibbs Gallery.

1978–82 Teaches at Princeton University, New Jersey.

1981 Has first retrospective at the Ikon Gallery, Birmingham, England. The exhibition travels within the United Kingdom under the auspices of the Arts Council of Great Britain.

1981–84 Professor at the Parsons School of Art, New York.

1983 Becomes American citizen. Receives the Guggenheim Fellowship.

1984 International break-through. Receives the National Endowment for the Arts Fellowship.

1985 Has his first solo exhibition in an American museum the Museum of Art, Carnegie Institute, Pittsburgh, Pennsylvania. The exhibition travels to the Museum of Fine Arts, Boston, Massachusetts.

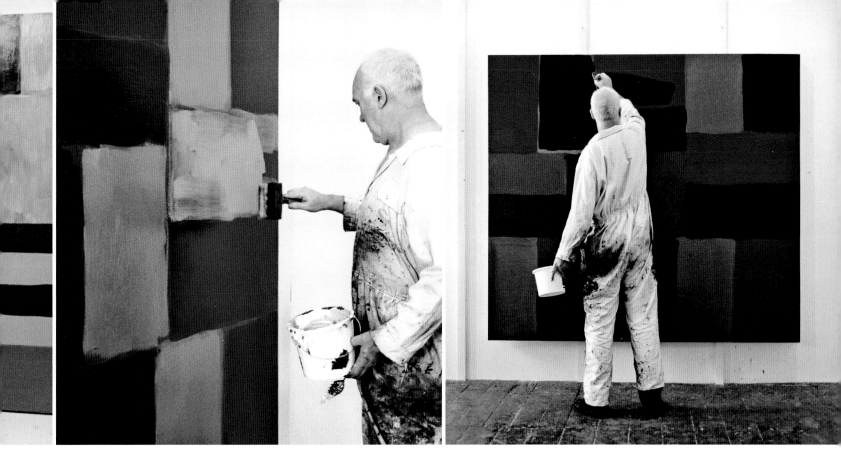

Sean Scully

1945 Geboren in Dublin, Irland.

1949 – 1959 Die Familie zieht nach London um. Scully wächst in einem Arbeiterviertel im Süden Londons auf und besucht dort eine Klosterschule.

1960 – 1962 Lehre in einer Londoner Druckerei.

1962 – 1965 Besuch von Abendkursen an der Central School of Art, London.

1965 Scully beschließt, sich ganz der Kunst zu widmen. Aufnahme am Croydon College of Art, wo er bis 1968 studiert.

1968 – 1972 Studium an der Newcastle University, Newcastle-upon-Tyne, England. 1969 erste Reise nach Marokko. Die Streifen und Farben der marokkanischen Textilien und Teppiche und das Licht des Südens hinterlassen einen tiefen Eindruck.

1972 – 1973 Erhält ein John-Knox-Stipendium. Erste Reise in die USA. Studienaufenthalt an der Harvard University.

1973 Rückkehr nach England. Erste Einzelausstellung in der Rowan Gallery, London.

1973 – 1975 Unterrichtet am Chelsea College of Art and Design und dem Goldsmith's College of Art and Design in London.

1975 Erhält ein Harkness-Stipendium für zwei Jahre. Geht nach New York.

1977 Erste Einzelausstellung in New York, in der Duffy-Gibbs Gallery.

1978 – 1982 Unterrichtet an der Princeton University, New Jersey.

1981 Erste Retrospektive in der Ikon Gallery, Birmingham, England. Die Ausstellung steht unter der Schirmherrschaft des Arts Council of Great Britain und wandert anschließend durch Großbritannien.

1981 – 1984 Lehrauftrag an der Parsons School of Art, New York.

1983 Erwirbt die amerikanische Staatsbürgerschaft. Guggenheim-Stipendium.

1984 Internationaler Durchbruch. Erhält ein Künstlerstipendium des National Endowment for the Arts.

1985 Erste Einzelausstellung in einem amerikanischen Museum, dem Museum of Art, Carnegie Institute, Pittsburgh, Pennsylvania. Die Ausstellung wird anschließend im Museum of Fine Arts, Boston, Massachusetts, gezeigt.

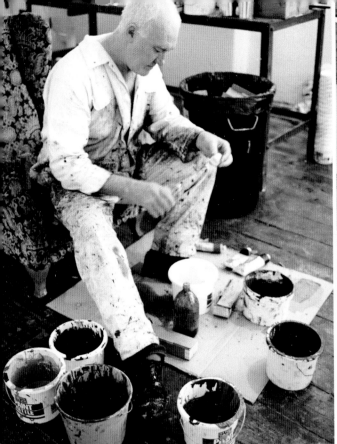
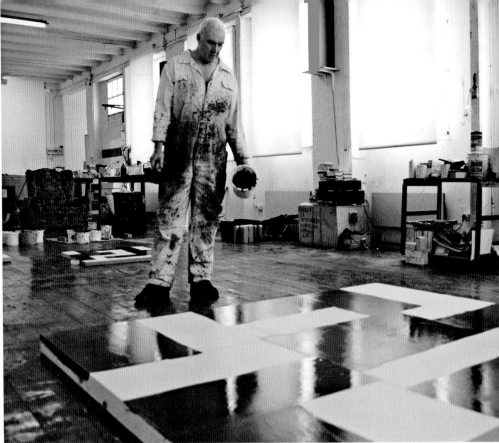

1989 Has his first solo exhibition in a European museum at the Whitechapel Art Gallery, London. The exhibition travels to Palacio Velázquez, Madrid and to the Städtische Galerie im Lenbachhaus, Munich.

1990 Maurice Poirier's monograph is published by Hudson Hills Press, New York.

2002 Starts working as a part-time professor of painting at Akademie der Bildenden Künste, Munich, Germany.

2003 Receives the degree of an Honourary Doctor of Fine Arts from the Massachusetts College of Art, the United States, and the National University of Ireland.

2004 Retrospective exhibition opens at Sara Hildén Art Museum Tampere, Finland, and travels to Stiftung Weimarer Klassik, Weimar and National Gallery of Australia, Canberra.

2005 *Wall of Light* exhibition opens at The Phillips Collection, Washington DC and travels to Modern Art Museum of Fort Worth, Texas, Cincinnati Art Museum, Ohio and the Metropolitan Museum of Art, New York.

2006 Hugh Lane Municipal Gallery, Dublin opens a room exclusively for paintings of Sean Scully. Exhibition of Prints at the Bibliothèque nationale de France.

2007–8 Retrospective exhibition opens at Miro Foundation, Barcelona travels to Musée d'Art Moderne, Stainte-Etienne, and The Museo d'Arte Contemporanea Roma.

Sean Scully lives and works in New York, Barcelona and Munich.

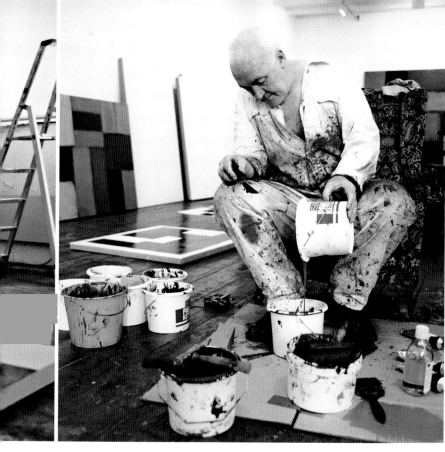

1989 Erste Einzelausstellung in einem europäischen Museum, der Whitechapel Art Gallery in London. Weitere Stationen der Ausstellung sind der Palacio Velázquez, Madrid, und die Städtische Galerie im Lenbachhaus, München.

1990 Bei Hudson Hills Press, New York, erscheint eine Monographie von Maurice Poirier.

2002 Beginn seiner Lehrtätigkeit als Professor für Malerei an der Akademie der Bildenden Künste, München.

2003 Erhält die Ehrendoktorwürde vom Massachusetts College of Art, USA, und der National University of Ireland.

2004 Retrospektive im Sara Hildén Art Museum in Tampere, Finnland, die später in der Stiftung Weimarer Klassik, Weimar, und in der National Gallery of Australia, Canberra, gezeigt wird.

2005 Die Ausstellung *Wall of Light* wird in The Phillips Collection, Washington DC, eröffnet. Weitere Stationen sind das Modern Art Museum of Fort Worth, Texas, das Cincinnati Art Museum, Ohio, und das Metropolitan Museum of Art, New York.

2006 Das Dubliner Museum Hugh Lane Municipal Gallery richtet einen eigenen Saal für Sean Scullys Gemälde ein. Ausstellung von Drucken in der Bibliothèque nationale de France.

2007 – 2008 Retrospektive in der Fundació Joan Miró, Barcelona. Weitere Stationen sind das Musée d'Art Moderne, Saint-Etienne, und das Museo d'Arte Contemporanea di Roma.

Sean Scully lebt und arbeitet in New York, Barcelona und München.

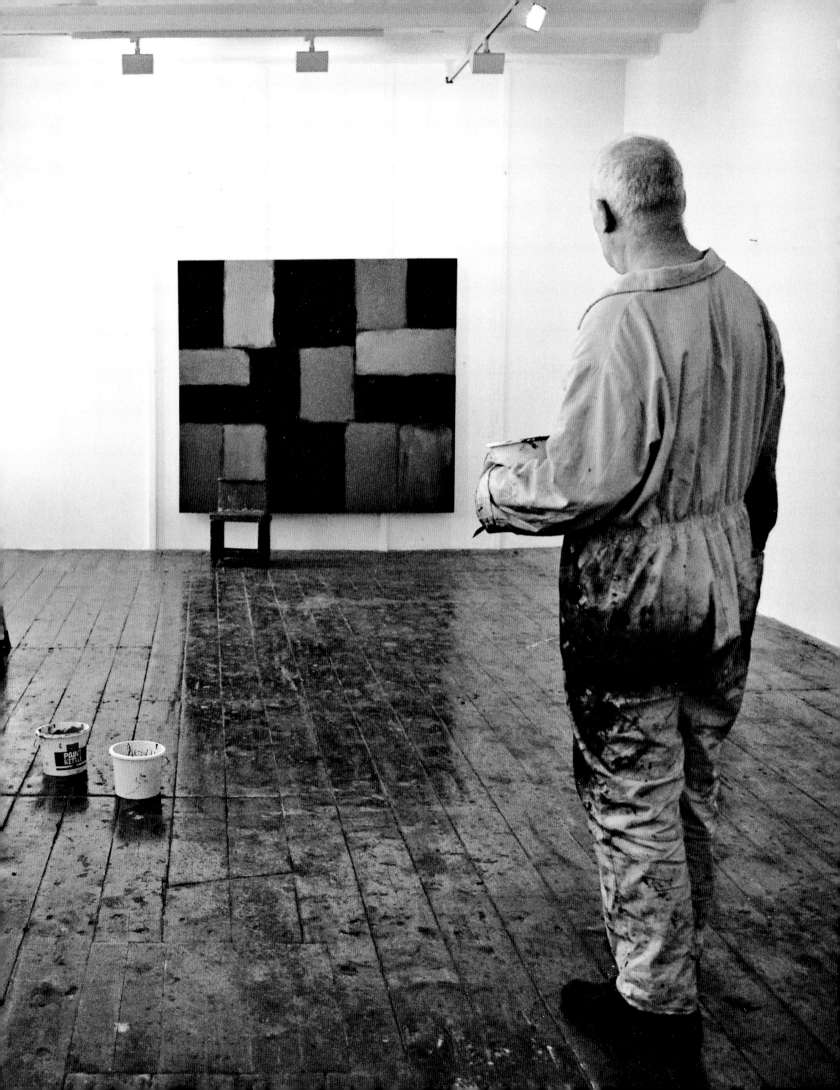

Ausgewählte Gruppenausstellungen · Selected Group Exhibitions *(c) verweist auf einen Ausstellungskatalog · (c) denotes that a catalogue was published*

1970

1970 Northern Young Contemporaries, Whitworth Art Gallery, University of Manchester, Manchester, England, Nov 14 – Dec 19, 1970 (c)

Young Contemporaries, Royal Academy, London, England. Traveled under the auspices of the Arts Council of Great Britain

1971

Art Spectrum North, Laing Art Gallery, Newcastle-upon-Tyne; Leeds City Art Gallery, Leeds; Whitworth Art Gallery, Manchester, England

Annual Students' Summer Exhibition, Hatton Gallery, University of Newcastle, Newcastle-upon-Tyne, UK

1972

John Moores Liverpool Exhibition 8, Walker Art Gallery, Liverpool, England (Prize Winner)

Northern Young Painters, Stirling University, Stirling, Scotland

1973

La Peinture Anglaise Aujourd'hui, Musée d'Art Moderne de la Ville de Paris, Paris, France, Feb 7 – Mar 11, 1973 (c)

Critics Choice, curated by William Varley, Gulbenkian Gallery, People's Theatre, Newcastle upon Tyne, England, 1973

1974

Dixieme Biennale Internationale D'Art De Menton, Palais De L'Europe, Menton, France, July – Sept, 1974 (c)

British Painting, Hayward Art Gallery, London, England; Rowan Gallery, London, England

John Moores Liverpool Exhibition 9, Walker Art Gallery, Liverpool, England (Prize Winner) (c)

1975

Contemporary Art Society Art Fair, Contemporary Art Society, Mall Galleries, London, England

The British Art Coming. Contemporary British Art, De Cordova Museum, Lincoln, MA, Apr 12 – June 8, 1975 (c); Rowan Gallery, London, England; The Arts Club, London, England

1976

Invitational, John Weber Gallery, New York, NY

7 Artists from the Rowan Gallery, Sunderland Arts Centre, Sunderland, England; Rowan Gallery, London, England

Invitational Exhibition, Susan Caldwell Gallery, New York, NY

1977

Post Minimal Works, curated by Per Jensen, Nobe Gallery, New York, NY, Feb 7 – Feb 25, 1977

British Painting 1952 – 1977, The Royal Academy of Arts, London, England, Sept 24 – Nov 20, 1977

Works on Paper – The Contemporary Art Society's Gifts to Public Galleries 1952 – 1977, Diploma Galleries, The Royal Academy of Arts, London, England; Rowan Gallery, London, England

1978

Certain Traditions: Recent British and Canadian Art, Edmonton Art Gallery, Edmonton, Canada. Traveled (1979) to Art Gallery of Hamilton, Ontario; Regional Art Gallery, London, Ontario; Memorial University of Newfoundland, St Johns, Newfoundland, Canada; Mostyn Art Gallery, Llandudno, Wales (c); Rowan Gallery, London, England

Small Works, Newcastle Polytechnic Art Gallery, Newcastle-upon-Tyne, England

1979

New Wave Painting, curated by Per Jensen, The Clocktower, New York, NY, Mar 7 – 31, 1979

Fourteen Painters, Lehman Gallery, CUNY, New York, NY, Apr 3 – 25, 1979

First Exhibition, Toni Birkhead Gallery, Cincinnati, OH

The British Art Show, curated by William Packer, Mappin Art Gallery, Sheffield, Dec 1979. Traveled (1980) to Laing Art Gallery and Hatton Gallery, The University of Newcastle, Newcastle-upon-Tyne; Arnolfini, Bristol and Royal West of England Academy, UK; Susan Caldwell Gallery, New York, NY

Tolly Cobbold Eastern Arts 2nd National Exhibition, Fitzwilliam Museum, Cambridge. Traveled (1980) to Norwich Art Gallery, Norwich; Ipswich, London and Sheffield.

1980

Marking Black, Bronx Museum of the Arts, Bronx, NY, Jan 24 – Mar 9, 1980 (c)

New Directions, Princeton University Art Museum. Princeton, NJ

The Newcastle Connection, curated by Mary-Helen Wood, Polytechnic Art Gallery, Newcastle upon Tyne, England, 1980 (c)

The International Connection, Sense of Ireland Festival, Roundhouse Gallery, London, England

Growing Up with Art, Leicestershire Collection for Schools and Colleges, Whitechapel Art Gallery, London, England (c)

ROSC, University College Gallery and National Gallery of Ireland, Dublin, Ireland

Irish Art 1943 – 1973, Crawford Municipal Art Gallery, Cork, Ireland, Aug 24 – Nov 7, 1980 and Ulster Museum, Belfast, Ireland, Jan – Feb, 1981 (c)

1981

Arabia Felix, curated by William Zimmer, Art Galaxy Gallery, New York, NY

Catherine Porter Scully/Sean Scully. Arbeiten und Wandmalerei, Museum für (Sub-) Kultur, Berlin, Germany, Mar 22, 1981

New Directions, curated by Sam Hunter, Sidney Janis Gallery, New York, NY

Art for Collectors, Museum of Art, Rhode Island School of Design, Providence, RI

New Directions: Contemporary American Art from the Commodities Corporation Collection, Museum of Art, Fort Lauderdale, FL, Dec 9, 1981 – Jan 24, 1982; Oklahoma Museum of Art, Oklahoma City, OK, Feb 8 – Mar 28, 1982; Santa Barbara Museum of Art, Santa Barbara, CA, Apr 17 – May 30, 1982; Grand Rapids Art Museum, Grand Rapids, MI, July 11 – Sept 6, 1982; Madison Art Center, Madison, WI, Oct 3 – Nov 28, 1982; Montgomery Museum of Fine Arts, Montgomery, AL, Jan 14 – Mar 13, 1983 (c)

1982

Critical Perspectives, curated by Joseph Masheck, P.S.1 The Institute for Art & Urban Resources, New York, NY, Jan 17 – March 14, 1982 (c)

Recent Aspects of All-Over, curated by Theodore Bonin, Harm Bouckaert Gallery, New York, NY, Sept 9 – Oct 2, 1982

Pair Group. Current and Emerging Styles in Abstract Painting, curated by William Zimmer, Jersey City Museum, Jersey City, NJ, Sept 15 – Oct 16, 1982

Workshop F, Chelsea School of Art, London, England

Group Invitational, Sunne Savage Gallery, Boston, MA

Art for A New Year, organized by Art Lending Service, Museum of Modern Art, New York, NY

1983

Three Painters: Sean Scully, David Reed, Ted Stamm, Zenith Gallery, Pittsburgh, PA, Jan 8 – Feb 2, 1983

American Abstract Artists, Weatherspoon Art Gallery, University of North Carolina, Greensboro, NC, Jan 16 – Feb 20 / Moody Gallery of Art, University of Alabama, AL, Mar 6 – Apr 6, 1983 (c)

Nocturne, curated by Michael Walls, Siegel Contemporary Art, New York, NY

Contemporary Abstract Painting", Muhlenberg College Center for the Arts, Allentown, PA, Sept 12 – Oct 23, 1983 (c); David McKee Gallery, New York, NY

New work New York (Newcastle Salutes New York), Newcastle Polytechnic Art Gallery, Newcastle-upon-Tyne, England (c)

Student's Choice Exhibition, Yale University Art Gallery, New Haven, CT

1984

From Color Surface: Painting About Itself, Barbara Krakow Gallery, Boston, MA, Feb 11 – Mar 29, 1984

An International Survey of Recent Painting and Sculpture, Museum of Modern Art, New York, NY (c)

Four Painters: Pat Steir, Sean Scully, Robert Mangold, Robert S. Zakanitch, McIntosh/Drysdale Gallery, Houston, TX

Part 1: Twelve Abstract painters, Siegel Contemporary Art, New York, NY

ROSC '84. The Poetry of Vision, The Guinness Hop Store, St. James's Gate, Dublin, Ireland, August 24 – November 17, 1985 (c)

Currents #6, Milwaukee Art Museum, Milwaukee, WI

Small Works: New Abstract painting, Lafayette College and Muhlenberg College, Allentown, PA

Group Exhibition, Susan Montezinos Gallery, Philadelphia, PA, Sept – Oct 6, 1984

Hassam & Speicher Purchase Fund Exhibition, Academy of Arts and Letters – New York, NY

Contemporary Paintings and Sculpture, William Beadleston Fine Art Inc., New York, NY, Oct 25 – Nov 20, 1984

Art on Paper, Galerij S65, Aalst, Belgium

1985

Abstract Painting as Surface and Object, curated by Judith Van Wagner, Hillwood Art Gallery, C.W Post Center, Long Island University, Brookville, NY, 1985

An Invitational, curated by Tiffany Bell, Condeso/Lawler Gallery, New York, NY

Decade of Visual Arts at Princeton: Faculty 1975 – 1985, Princeton University Museum of Art, Princeton, NJ

Abstraction/Issues, Tibor de Nagy Gallery, New York, NY; Oscarsson Hood Gallery, New York, NY and Sherry French Gallery, New York, NY, Sept 6 – 28, 1985

Art on Paper, Weatherspoon Art Gallery, University of North Carolina at Greensboro, Greensboro, NC

Masterpieces of the Avant-Garde, Annely Juda Fine Art / Juda Rowan Gallery, London, England

Painting 1985, Pam Adler Gallery, New York, NY, Jan – Feb 2, 1985

An Invitational, Condeso/Lawler Gallery, New York, NY

Small Works, Juda Rowan Gallery, London, England

1986

After Matisse, guest curator Tiffany Bell, a traveling exhibition organized by Independent Curators Inc., New York, NY (c): Queens Museum, Flushing, NY, Mar 30 – May 25, 1986; Chrysler Museum, Norfolk, VA, Sept 11 – Nov 9, 1986; Portland Museum of Art, Portland, MA, Dec 9, 1986 – Feb 9, 1987; Bass Museum of Art, Miami Beach, FL, Mar 17 – May 17, 1987; The Phillips Collection, Washington, D.C., June 19 – Aug 14, 1987, Dayton Art Institute, Dayton, OH, Sept 12 – Nov 8, 1987; Worcester Art Museum, Worcester, MA, Dec 9, 1987 – Feb 7, 1988

An American Renaissance in Art: Painting and Sculpture since 1940, Fort Lauderdale Museum of Fine Art, Fort Lauderdale, FL

Public and Private: American Prints Today, Brooklyn Museum of Art, Brooklyn, NY

Catherine Lee & Sean Scully, Cava Gallery, Philadelphia, PA, Mar 6 – Apr 5, 1986

CAL Collects 1, University Art Museum, The University of California, Berkeley, CA

The Heroic Sublime, Charles Cowles Gallery, New York, NY, 1986

Structure/Abstraction, Hill Gallery, Birmingham, MI Courtesy of

Courtesy David McKee, David Mckee Gallery, New York, NY and Pamela Auchincloss Gallery, Santa Barbara, CA

Detroiters Collect: New Generation, Meadow Brook Art Gallery, Oakland University, Rochester, MI

Recent Acquisitions, Contemporary Arts Center, Honolulu, HI

Group Drawing Show, Barbara Krakow Gallery, Boston, MA, Nov 29, 1986 – Jan 7, 1987

25 Years: Three Decades of Contemporary Art, Juda Rowan Gallery, London, England

1987

The Fortieth Biennial Exhibition of Contemporary American Painting, curated by Ned Rifkin, The Corcoran Gallery of Art, Washington, D.C., Apr 11 – June 21, 1987 (c)

Large Scale Prints, Barbara Krakow Gallery, Boston, MA, July – Aug, 1987

Harvey Quaytman and Sean Scully, Two person exhibition, Ateneum, Helsinki Festival, Helsinki, Finland, Aug 19 – Sept 20, 1987 (c)

Drawing from the 80's – Chatsworth Collaboration, Carnegie Mellon University Art Gallery, Pittsburgh, PA

Drawn-Out, Kansas City Art Institute, Kansas City, MO

Magic in the Minds Eye: Part 1 & 2, Meadow Brook Art Gallery, Rochester, MI

Logical Foundations, curated by the Advisory Services, Museum of Modern Art, New York, NY

Works on Paper, Nina Freundenheim Gallery, Buffalo, NY

Winter, Museum of Modern Art, New York, NY

Large Works by Rowan Artists, Mayor Rowan Gallery, London, England

Monotypes by Catherine Lee, John Walker, Sean Scully, Rubin Gallery, New York, NY, through Oct 10, 1987

1988

17 Years at the Barn, Rosa Esman Gallery, New York, NY, Feb 5 – Mar 5, 1988

In Side, Barbara Krakow Gallery, Boston, MA, Apr 2 – 27, 1988

Works on Paper: Selections from the Garner Tullis Workshop, Pamela Auchincloss Gallery, New York, NY

New Editions, Crown Point Press, San Francisco, CA and New York, NY

Large Works on Paper, Mayor Rowan Gallery, London, England

Sightings: Drawings with Color, curated by Max Gimblett and Eleanor Moretta, Pratt Manhattan Gallery, Pratt Institute, New York, NY. Traveled to Instituto de Etudios Nordamericanos, Barcelona, Spain (c)

Sean Scully & Jose Maria Sicilia. New Editions, Crown Point Press, San Francisco, CA & New York, NY, Oct 7 – Nov 12, 1988

The Presence of Painting. Aspects of British Abstraction 1957–1988, Mappin Art Gallery, Sheffield. Traveled to Laing Art Gallery & Hatton Gallery, Newcastle-upon-Tyne; Ikon Gallery, Birmingham; Harris Museum & Art Gallery, England (c)

1989

The Elusive Surface. Painting in Three Dimensions, The Albuquerque Museum, Albuquerque, NM

Drawings and Related Prints, Castelli Graphics, New York, NY

Essential Painting: Kelly, LeWitt, Mangold, Scully, curated by Deborah Leveton, Nelson Atkins Museum, Kansas City, MO, May 5 – June 25, 1989

The 1980's: Prints from the Collection of Joshua P. Smith, National Gallery of Art, Washington, D.C. (c)

The Linear Image: American Masterworks on Paper, curated by Sam Hunter, Marisa del Re Gallery, New York, NY, Apr 25 – May 27, 1989 (c)

1990

Stripes, Barbara Krakow Gallery, Boston, MA, Mar 10 – Apr 4, 1990

Drawing: Joseph Beuys, Paul Rotterdam, Sean Scully, Arnold Herstand & Company, New York, NY, Feb 1 – Mar 10, 1990 (c)

Sean Scully/Donald Sultan: Abstraction/Representation, curated by Michelle Meyers, Stanford University Art Gallery, Stanford, CA, Feb 20 – Apr 22, 1990 (c)

Geometric Abstraction, Marc Richards Gallery, Santa Monica, CA

Artists in the Abstract, Weatherspoon Art Gallery, University of North Carolina at Greensboro, Greensboro, NC (c)

1991

Small Format Works on Paper, John Berggruen Gallery, San Francisco, CA

Post modern Prints, Victoria and Albert Museum, London, England

Moses Richter Scully, Louver Gallery, New York, NY, Mar 16 – Apr 20, 1991

La Metafisica Della Luce, curated by Demetrio Paparoni, John Goode Gallery, New York, NY

Large Scale Works on Paper, John Berggruen Gallery, San Francisco, CA

1992

Surface to Surface, Barbara Krakow Gallery, Boston, MA, Jan 11 – Feb 12, 1992

Four Series of Prints. Donald Judd, Brice Marden, Sean Scully, Terry Winters, John Berggruen Gallery, San Francisco, CA, Feb 6 – 29, 1992

Recent Abstract Painting: Ross Bleckner, Kenneth Dingwall, Susan Laufer, Ken Nevadomi, Sean Scully, curated by David S. Rubin, Cleveland Center for Contemporary Art, Cleveland, OH, Feb 28 – Apr 15, 1992 (brochure)

Collaborations in Monotype from the Garner Tullis Workshop, Sert Gallery, Carpenter Center for the Visual Arts, Harvard University, Cambridge, MA, Dec 13 – Feb 3, 1992

Geteilte Bilder. Das Diptychon in der neuen Kunst, Museum Folkwang Essen, Essen, Germany, Mar 15 – May 3, 1992 (c)

Behind Bars, curated by Meg O'Rourke, Thread Waxing Space, New York, NY, Mar 17 – Apr 25, 1992 (c)

Color Block Prints of the 20th Century, Associated American Artists, New York, NY, Mar 18 – Apr 18, 1992 (c)

Whitechapel Open, Whitechapel Art Gallery, London, England

Painted on Press: Recent Abstract Prints, Madison Art Center, Madison, WI

Monotypes, Woodcuts, Drawings, Europaische Akademie Für Bildende Kunst, Trier, Germany

Garner Tullis Monotype Survey, SOMA Gallery, San Diego, CA, Aug 28 – Oct 4, 1992

44th Annual Academy-Institute Purchase Exhibition, American Academy of Arts and Letters, New York, NY

Verso Bisanzio con disincanto, Galeria Sergio Tossi, Prato, Italy (c)

1993

Tutte le Strade Portano A Roma, The Exhibition Center of Rome, Rome, Italy (c)

Beyond Paint, curated by Maurice Poirier, Tibor de Nagy Gallery, New York, NY, Mar 5 – Apr 1, 1993

Drawing in Black and White, The Museum of Modern Art, The New York Grolier Club, New York, NY (c)

American and European Prints, Machida City Museum of Arts, Tokyo, Japan (c)

American and European Works on Paper, Gallery Martin Wieland, Trier, Germany

Italia-America L'astrazione ridefinita, curated by Demetrio Paparoni, Dicastero Cultura, Galleria Nazionale d'Arte Moderna, Repubblica di San Marino, Italy, June 16 – Sept 16, 1993 (c)

Partners, Annely Juda Fine Art, London, England (c)

25 Years, Cleveland Center for Contemporary Art, Cleveland, OH (c)

New Moderns, Baumgartner Galleries Inc., Washington, D.C., Sept 11 – Oct 9, 1993

5 One Person Shows, Galerie Jamileh Weber, Zürich, Switzerland

The Turner Prize 1993, Tate Gallery, London, England, Nov 3 – 28, 1993 (c)

Ausgewählte Druckgraphik, Galerie Bernd Klüser, Munich, Germany

1994

Paper Under Pressure. Work in Collaboration with Garner Tullis, Sun Valley Center Gallery, Ketchum, ID, July 1 – July 31, 1994

Recent Painting Acquisitions, Tate Gallery, London, England

Contemporary Watercolors: Europe and America, curated by Diana Block, University of North Texas Art Gallery, Denton, TX, 1994

For 25 Years Brooke Alexander Editions, Museum of Modern Art, New York, NY

Recent Acquisitions: Paintings from the Collection, IMMA – The Irish Museum of Museum Art, Dublin, Ireland

L'Incanto e la Trascendenza, Galleria Civica de Arte Contemporanea, Trento, Italy, July 10 – Aug 28, 1994

British Abstract Art. Part 1: Painting, Flowers East, London, England, Aug 5 – Sept 11, 1994 (c)

Recent Acquisitions: Prints, Drawings and Photographs, The Cleveland Museum of Art, Cleveland, OH

1995

Seven From the Seventies, Knoedler & Company, New York, NY, Feb 8 – Mar 4, 1995

New Publications, Brooke Alexander Editions, New York, NY

New York Abstract, curated by Lew Thomas, Contemporary Arts Center, New Orleans, LA, May 29 – June 25, 1995 (c)

US Prionts, Retretti Art Center, Punkaharju, Finland

Color + Structure: Mangold, De Maria, Scully, Swanger, Thursz, Tusek, Tuttle, Galerie Lelong, New York, NY

1996

XV Salon des los 16, Museo de Antropologia, Madrid, Spain

Balancing Act, Room Gallery, New York, NY

nuevas abstracciones, Museo Nacional Centro de Arte Reina Sofia, Madrid, Spain, Apr 25 – June 23, 1996. Traveled to Kunsthalle Bielefeld, Bielefeld, Germany, July 28 – Sept 8, 1996; Museu d'Art Contemporani de Barcelona, Barcelona, Spain, Oct 10 – Nov 30, 1996 (c)

Bare Bones, TZ Art, New York, NY

Festival de Culture Irlandaise Contemporaine, Ecoles des Beaux-Arts, Paris France

Thinking Print, Museum of Modern Art, New York, NY

Holländisches Bad: Radierungen zur Renaissance einer Technik, Kunsthaus, Hamburg, Germany. Traveled to Brecht-Haus-Weissensee, Berlin, Germany

1997

Without trembling, Galerie Fortlaan 17, Gent, Belgium, Mar 8 – Apr 20, 1997

After the Fall. Aspects of Abstract Painting Since 1970, curated by Lilly Wei, Newhouse Center for Contemporary Art, Snug Harbor Cultural Center, Staten Island, NY, Mar 27 – Sept 7, 1997 (c)

British Arts Council Collection, Royal Festival Hall, London, England

The Pursuit of Painting, IMMA – Irish Museum of Modern Art, Dublin, Ireland, June 26 – Oct 31, 1997

Prints, Galerie Lelong, New York, NY

Prints, Galerie Lelong, Paris, France

A Century of Irish Paintings; Selections from the Collection of the Hugh Lane Municipal Gallery of Modern Art, Dublin, The Hugh Lane Municipal Gallery of Modern Art, Dublin, Ireland. Traveled to: The Hokkaido Museum of Modern Art-Sapporo, Japan; The Mitaka City Gallery of Art, Mitaka, Tokyo, Japan; Yamanashi Perfectural Museum of Art, Yamanashi, Japan (c)

The View From Denver: Contemporary American Art from the Denver Art Museum, Museum Moderner Kunst Stiftung Ludwig Wien, Vienna, Austria (c)

Thirty Five Years at Crown Point Press: Making Prints, Doing Art, The National Gallery of Art, Washington D.C. USA and the Fine Arts Museum of San Francisco, San Francisco, CA (c)

Singular Impressions: The Monotype in America, The National Museum of American Art, Washington D.C.

1998

Zeit und Materie, Baukunst, Cologne, Germany, Feb 12 – Apr 15, 1998

The Edward R. Broida Collection: A Selection of Works, Orlando Museum of Art, Orlando, FL, Mar 12 – June 21, 1998 (c)

Arterias: Collection of Contemporary Art Fundacio la Caixa, Malmö Konsthall, Malmö, Sweden, Apr 25 – June 7, 1998

45th Corcoran Biennial, Corcoran Gallery of Art, Washington, D.C., July 17 – Sept 28, 1998 (c)

Sarajevo 2000, curated by Lorand Heygi, Museum Moderner Kunst Stiftung Ludwig Wien, Palais Liechtenstein, Vienna, Austria, Oct 27, 1998 – Jan 10, 1999 (c)

Lawrence Carroll and Sean Scully, Lawing Gallery, Houston, TX, Oct 30 – Dec 31, 1998 (c)

Cleveland Collects Contemporary Art, The Cleveland Museum of Art, Cleveland, OH, Nov 8, 1998 – Jan 10, 1999

Contemporary Art: The Janet Wolfson de Botton Gift, Tate Gallery, London, England (c)

Photographies, Galerie Lelong, Paris, France

On a Clear Day, Graphische Sammlung, Staatsgalerie Stuttgart, Stuttgart, Germany

Large Scale Works on Paper: Le Va, LeWitt, Mangold, Scully, Serra, Winters, Danese Gallery, New York, NY

Jan Dibbets/Sean Scully fotografias, Galeria Estiarte, Madrid, Spain

Group Exhibition, Kerlin Gallery, Dublin, Ireland

Acquisitions 1997, Le Conseil General du Val-de-Marne FDAC exhibited at Hotel du Departement, Creteil, France

Matrix Berkeley 1978 – 1998, University of California, Berkeley Art Museum and Pacific Film Archive, Berkeley, CA (c)

En Norsk Samling Au Europeisk kunst, Trondheim Kunstmuseum, Norway

1999

Signature Pieces: Contemporary British Prints and Multiples, Alan Christea Gallery, London, England, Jan 5 – Feb 6, 1999 (c)

Unlocking the Grid. Concerning the Grid in Recent Painting, Main Gallery, University of Rhode Island, Kingston, RI, Jan 22 – Feb 28, 1999 (brochure)

Side by Side, Knoedler & Company, New York, NY, Feb 4 – 27, 1999

Geometrie als Gestalt. Strukturen der modernen Kunst von Albers bis Paik. Werke der Sammlung DaimlerChrysler, Neue Nationalgalerie Berlin, Germany, Apr 30 – July 11, 1999 (c)

Drawing in the Present Tense, curated by Roger Shephard and George Negroponte, Parsons School of Design, New York, NY, Oct 13 – Dec 3, 1999. Traveled to: Eastern Connecticut State University, Willimantic, CT, 2000; North Dakota Museum of Art, Grand Forks, ND, 2000

Tore A. Holm's Collection of Contemporary European Art - An Encounter between North and South, Centro Cultural del Conde Duque, Madrid, Spain,1999

The Essl Collection: The First View, curated by Rudi Fuchs, Sammlung Essl, Klosterneuburg/Vienna, Austria, Nov 6, 1999 – Oct 31, 2000 (c)

25 Jahre – 25th anniversary, Galerie Jamileh Weber, Zürich, Switzerland, Nov 9, 1999 – Jan 29, 2000

Pars Pro Toto, Galerie Lelong, Zürich, Switzerland, Nov 27, 1999 – Jan 15, 2000

1999 Drawings, Alexander + Bonin, New York, NY, Dec 11, 1999 – Jan 22, 2000

Zeitschnitt 1900 – 2000. 100 Jahre, 100 Werke, Lentos Kunstmuseum Linz, Linz, Austria, Dec 16, 1999 – Feb 20, 2000

2000

Works on Paper, Timothy Taylor Gallery, London, England, Jan 11 – Feb 12, 2000

Sean Scully/Edwardo Chillida, Alan Cristea Gallery, London, England, Feb 8 – Mar 11, 2000

On Canvas: Contemporary Painting from the Collection, curated by J. Fiona Ragheb, Solomon R. Guggenheim Museum, New York, NY

Art Moves To Benefit The Cure, Benefiting the Christopher Reeve Paralysis Foundation, Bergdorf Goodman, New York, NY, Apr 14 – 25, 2000. Auction: May 8, 2000, Sotheby's New York, NY, May 8, 2000 (c)

L'Ombra Della Ragione. L'Idea Del Sacro Nell'Identita Europa Nel XX Secolo, Galleria D'Arte Moderna Bologna, Bologna, Italy, May 13 – Oct 29, 2000 (c)

Colleccion MMKSLW: Viena, de Warhol a Cabrita Reis, CGAC – Centro Galego de Arte Contemporanea, Santiago de Compostela, Spain, May 24 – Aug 31, 2000

September Selections, Knoedler & Company, New York, NY, Sept 2000

Group Show, Timothy Taylor Gallery, London, England, Sept 7 – Oct 7, 2000

Une Ville - Une Collection, Centre de la Gravure et de l'Image imprimee, La Louviere, Belgium, Sept 22 – Dec 17, 2000

New Works, Galerie Jamileh Weber, Zürich, Switzerland, Sept 30 – Nov 18, 2000

Import, curated by Catherine Marshall and Marguerite O'Molloy, IMMA – Irish Museum of Modern Art, Dublin, Ireland, Oct 19, 2000 – Mar 25, 2001

Shifting Ground. Selected Works of Irish Art 1950 – 2000, Irish Museum of Modern Art, Dublin, Ireland, Nov 9, 2000 – Feb 18, 2001

2001

Group Show, McKee Gallery, New York, NY, Jan 4 – Mar 10, 2001

Group Show, McKee Gallery, New York, NY, Apr 26 – May 2, 2001

Watercolor: In the Abstract, curated by Pamela Auchincloss, traveling exhibition: The Hyde Collection Art Museum, Glen Falls, NY, Sept 30 – Dec 9, 2001; Michael C. Rockefeller Arts Center Gallery, SUNY College at Fredonia, NY, Jan 18 – Feb 22, 2002; Butler Institute of American Art, Youngstown, OH, Mar 10 – Apr 28, 2002; Ben Shahn Gallery, William Patterson University, Wayne, NJ, Sept 6 – Oct 11, 2002; Sarah Moody Gallery of Art, University of Alabama, Tuscaloosa, AL, Nov 3 – Dec 14, 2002 (brochure)

Content is a Glimpse, Timothy Taylor Gallery, London, England, Nov 7 – Dec 21, 2001

A Century of Drawing: Works on Paper from Degas to LeWitt, The National Gallery of Art, Washington, D.C., Nov 18, 2001 – Apr 7, 2002 (c)

2002

Selected Works – A Collection, Galerie Jamileh Weber, Zurich, Switzerland, Jan 19 – Mar 23, 2002

Profile of a Collection: The Gordon Lambert Trust Collection at IMMA, IMMA – Irish Museum of Modern Art, Dublin, Ireland, Jan 22 – June 23, 2002

The Rowan Collection: Contemporary British and Irish Art, IMMA – Irish Museum of Modern Art, Dublin, Ireland, Feb 13 – June 3, 2002

Augenblick, Foto/Kunst, Sammlung Essl, Klosterneuburg/Vienna, Austria, Feb 15 – June 30, 2002 (c)

Choose your partner – An International Drawing Show, Nusser & Baumgart Contemporary, Munich, Germany, Mar 1 – Apr 20, 2002

abstraction, Ingleby Gallery, Edinburgh, Scotland, 2002 (c)

25° Bienal De São Paulo, Fundação Bienal De São Paulo, São Paulo, Brazil, Mar 23 – June 2, 2002 (c)

Epic Paintings from the Luther W. Brady Collection, Luther W. Brady Art Gallery, The George Washington University, Washington D.C., Mar 25 – Apr 5, 2002 (brochure)

Eight New Paintings, Kerlin Gallery, Dublin, Ireland, Apr 25 – May 25, 2002

Extranjeros – Los otros artistas españoles, Museo de Arte Contemporaneo Esteban Vicente, Segovia, Spain, May 24 – Sept 15, 2002

Margins of Abstraction, curated by Robert Knafo, Kouros Gallery, New York, NY, July 10 – Sept 7, 2002

177th Annual Exhibition, National Academy of Design, New York, NY, May 1 – June 9, 2002

No Object, No Subject, No Matter... Abstraction in the IMMA Collection, Irish Museum of Modern Art, Dublin, Ireland, May 9 – Sept 1, 2002 (brochure)

Independent Visions, John Berggruen Gallery, San Francisco, CA, July 11 – Aug 31, 2002

Watercolor, curated by David Cohen, New York Studio School, New York, NY, Oct 15 – Nov 16, 2002

Color/Concept, National Gallery of Australia, Canberra, Australia, Sept 7 – Dec 1, 2002 (brochure)

110 Years: The Permanent Collection of the Modern Art Museum of Fort Worth, Modern Art Museum of Fort Worth, TX, Dec 2002 – Mar 2003 (c)

2003

Abstraction in Photography, Von Lintel Gallery, New York, NY, Feb 6 – Mar 22, 2003

Human Stories – Photographs and paintings from the Essl Collection, Ludwig Museum, Museum of Contemporary Art, Budapest, Hungary, Mar 14 – June 10, 2003

Inaugural Group Show, Timothy Taylor Gallery, London, England, May 21 – June 11, 2003

Avantgarde und Tradition, Lentos Kunstmuseum Linz, Linz, Austria, May 18 – Nov 22, 2003

The Museum Store Collects, Arizona State University Art Museum, Nelson Fine Arts Center, May 31 – Sept 13, 2003, Tempe, AZ

Divergent, Galerie Lelong, New York, NY, June 26 – Aug 1, 2003

Streifzüge, Galerie Lelong, Zürich, Switzerland, June 28 – Aug 30, 2003

Nachbarschaften – Arbeiten auf Papier, Galerie Dittmar, Berlin, Germany, Sept 5 – Oct 22, 2003

Drawing Modern: Works from the Agnes Gund Collection, Cleveland Art Institute, Cleveland, Ohio, Oct 26, 2003 – Jan 11, 2004

The Eighties – Part II: USA, Galerie Bernd Klüser, Munich, Germany, Nov 13, 2003 – Jan 31, 2004

Grafiikkaa ja piirustuksia, Forum Box, Helsinki, Finland, Nov 21 – Dec 21, 2003

2004

Masterprints, Sundsvalls Museum, Sundsvall, Sweden, Feb 7 – Apr 18, 2004

Picasso to Thiebaud, Cantor Center for Visual Arts, Stanford University, Stanford, CA, Feb 18 – June 20, 2004 (c)

A Vision of Modern Art, In Memory of Dorothy Walker, Irish Museum of Modern Art, Dublin, Ireland, Feb 24 – June 27, 2004

Pop Art to Minimalism. The Serial Attitude, Albertina, Vienna, Austria, Mar 10 – Aug 29, 2004 (c)

Bearings: Landscapes from the IMMA Collection, curated by Marguerite O'Molloy, Irish Museum of Modern Art, Dublin, Ireland, Apr 27 – Oct 17, 2004

In the time of shaking. Irish Artists for Amnesty International, Irish Museum of Modern Art, Dublin, Ireland, May 6 – 23, 2004 (c)

Behind Closed Doors, curated by Susan H. Edwards, Katonah Museum of Art, Katonah, NY, May 29 – July 11, 2004

Views from an Island and Representing the Tain, Millennium Monument Museum, Beijing, China, Apr 29 – May 23, 2004 and Shanghai Art Museum, Shanghai, China, June 11 – July 3, 2004

Monocromos. De Malevich al presente, curated by Barbara Rose, Museo Nacional Centro de Arte Reina Sofia, Madrid, Spain, June 15 – Sept 6, 2004 (c)

Matisse to Freud: A Critic's Choice – The Alexander Walker Bequest, British Museum, London, England, June 15, 2004 – Jan 9, 2005

Bloomsday 16 Juni 1904 – 16 Juni 2004, Galerie Bernd Klüser, Munich, Germany, June 29 – Sept 25, 2004

The Gallery selects..., Alexander and Bonin, New York, NY, July 6 – 30, 2004

Sean Scully Jon Groom, Galerie 422, Gmunden, Austria, Aug 15 – Sept 12, 2004 (c)

Nueva tecnologia – nueva iconografia – nueva fotografia, Museu d'Arte Espanyol Contemporani, Palma de Mallorca, Spain, Sept 14 – Dec 4, 2004. Traveled to Museo de Arte Abstracto Español, Cuenca, Spain, Apr 8 – June 26, 2005

Destination Germany, Kunst Galerie Fürth, Fürth, Germany, Sept 19 – Oct 31, 2004 (c)

La Collection, Hotel des Arts, Toulon, France, Oct 31 – Nov 21, 2004

Beneath the sky, Cavan County Museum, Ballyjamesduff, Ireland, Oct 14 – Nov 13, 2004

2005

Von Paul Gauguin bis Imi Knoebel. Werke aus der Hilti art foundation, Kunstmuseum Liechtenstein, Vaduz, Liechtenstein, Jan 18 – May 22, 2005 (c)

Western Biennale of Art: Art Tomorrow, curated by Edward Lucie-Smith, John Natsoulas Center for the Arts, Davis, CA, Feb 2 – Mar 27, 2005

After The Thaw – Recent Irish Art from the AIB Collection, Crawford Municipal Art Gallery, Cork, Ireland, Feb 5 – Apr 2, 2005

The giving person, curated by Lorand Hegyi, Fondazione Culturale Edison, PAN – Palazzo delle Arti di Napoli, Naples, Italy, Mar 26 – Oct 2, 2005

Nueva tecnologia – nueva iconografia – nueva fotografia, Museo de Arte Abstracto Español, Cuenca, Spain, Apr 8 – June 26, 2005

Eye of the Storm: The IMMA Collection, Irish Museum of Modern Art (IMMA), Dublin, Ireland, Apr 26 – Nov 6, 2005

Summer Group Show, McKee Gallery, New York, NY, June 8 – July 29, 2005

Fotografia, Galeria Estiarte, Madrid, Spain, June 28 – July 30, 2005

Minimalism and After IV, Daimler Contemporary, Berlin, Germany, July 29, 2005 – Mar 26, 2006

Points of View: Landscapes and Photography, Galerie Lelong, New York, NY

Summer Group Show, Kerlin Gallery, Dublin, Ireland, Aug 12 – Sept 3, 2005

Sean Scully, Stephan Girard, Nicolas Ruel, Galerie Orange Art Contemporain, Montreal, Canada, Sept 12 – Oct 5, 2005. Traveled to Galerie Lacerte Art Contemporain, Quebec City, Canada, Nov 16, 2005 – Jan 13, 2006

Soltanto Un Quadro Al Massimo, Accademia Tedesca Roma Villa Massimo, Rome, Italy, Sept 14 – Oct 21, 2005

Pairings II. Discovered Dialogues in Postwar Abstraction, Hackett-Freedman Gallery, San Francisco, CA, Nov 3 – Dec 31, 2005 (c)

SIAR 50, curated by Campbell Bruce and Catherine Marshall, IMMA – Irish Museum of Modern Art, Dublin, Ireland, Nov 16, 2005 – Feb 19, 2006

2006

Nomaden im Kunstsalon – Begegnungen mit der Moderne von Bayer bis Sol LeWitt, Lentos Kunstmuseum Linz, Linz, Austria, Jan 26 – Sept 10, 2006

Homage to Chilida, curated by Cosme de Barañano, Guggenheim Museum Bilbao, Bilbao, Spain, Apr 5 – June 11, 2006

The Unknown Masterpiece, ARTIUM Centro – Museo Vasco de Arte Contemporaneo, Vitoria-Gasteiz, Spain, Mar 9 – May 28, 2006 (c)

Kunst und Photographie, Photographie und Kunst, Galerie Bernd Klüser, Munich, Germany, May 24 – July 29, 2006

Against the Grain, Contemporary Art from the Ed Broida Collection, The Museum of Modern Art, New York, NY (c)

The Collector's Collection, Ormeau Baths Gallery, Belfast, Northern Ireland, June 9 – 22, 2006

Sammlung Essl – Kunst der Gegenwart, Kunstverein Villa Wessel, Iserlohn, Germany, Oct 21, 2006 – Jan 7, 2007

Big Juicy Paintings (and more): Selections from the Permanent Collection, curated by Peter Boswell, Miami Art Museum, Miami, Florida, June 16 – Sept 17, 2006

Einzelausstellungen · One-person Exhibitions

2007

Klasse Scully, whiteBOX e.V., Kultfabrik, Munich, Germany, Jan 25 – Feb 25, 2007 (c)

Radharc, Galway Arts Centre, Galway, Ireland, Feb 2 – Mar 3, 2007

Beckett, Centre Georges Pompidou, Paris, France, Mar 14 – June 25, 2007 (c)

(I'm Always Touched) By Your Presence, Dear. New Acquisitions, IMMA Irish Museum of Modern Art, Dublin, Ireland, Apr 24, 2007 – Nov 11, 2007

Before and After Minimalism. A Century of Abstract Tendencies in the Daimler Chrysler Collection, Museu d"Art Espanyol Contemporani Fundacion Juan March, Palma de Mallorca, Spain, May 22 – Dec 1, 2007

Große Malerei, Lentos Kunstmuseum Linz, Linz, Austria, June 28 – Oct 28, 2007

Collecting the Past, Present, Future – Highlights of British Art From Turner to Freud, Abbot Hall Art Gallery, Kendal, Cumbria, England, July 13 – Oct 27, 2007

Themes and Variations in Painting and Sculpture, MFAH – Museum of Fine Arts, Houston, TX, July 30 – Sept 23, 2007

frisch gestrichen, Museum Franz Gertsch, Burgdorf, Switzerland, Aug 4 – Oct 28, 2007

DE-Natured. Painting, Sculpture and Work on Paper from the Anderson Collection + the Anderson Graphic Arts Collection, curated by Heather Pamela Green, San Jose Museum of Art, San Jose, CA, Oct 13, 2007 – Jan 6, 2008 (c)

No answer is also an answer - Recent acquisitions 2005 - 2007, IMMA – Irish Museum of Modern Art, Dublin, Ireland, Oct 25, 2007 – Mar 2, 2008

La vida privada - Coleccion Josep Civit, CDAN – Centro de Arte y Naturaleza – Fundacion Beulas, Huesca, Spain, Nov 16, 2007 – Mar 2, 2008

2008

Masterpieces of Modern British Art: Selected works from the Derek Williams Trust and Amgueddfa Cymru National Museum Wales, Osborne Samuel Gallery, London, England, Jan 9 – Feb 9, 2008

Art is for the Spirit: Works from The UBS Art Collection, Mori Art Museum, Tokyo, Japan, Feb 2 – Apr 6, 2008 (c)

MAXImin, Maximum Minimization in Contemporary Art, Fundacion Juan March, Madrid, Spain, Feb 8 – May 25, 2008

Degas to Diebenkorn: The Phillips Collections, The Phillips Collection, Washington D.C., Feb 9 – May 25, 2008

Monet - Kandinsky - Rothko und die folgen Wege der abstrakten Malerei, BA-CA Kunstforum Wien, Palais Ferstel, Vienna, Austria, Feb 28 – June 29, 2008 (c)

Unique Act. Five Abstract Painters, curated by Barbara Dawson, Dublin City Gallery, The Hugh Lane Gallery, Dublin, Ireland, Mar 13 – May 25, 2008 (c)

New Horizons: the collection of the Ishibashi Foundation, Bridgestone Museum of Art, Ishibashi Foundation, Tokyo, Japan

Rhythmus 21 - Positionen des Abstrakten, Städtische Galerie im Lenbachhaus, Munich, Germany, Apr 12 – Sept 14, 2008

Paper Trail II: Passing Through Clouds, The Rose Art Museum, Brandeis University, Waltham, MA, May 8 – July 8, 2008

The 183rd Annual: An Invitational Exhibition of Contemporary American Art, National Academy Museum & School of Fine Arts, New York, NY, May 29 - Sept 7, 2008 (c)

A Year in Drawing, Galerie Lelong, New York, NY, June 12 – Aug 1, 2008

Reflections on Light. 30 Years Galerie Bernd Klüser, Galerie Bernd Klüser, Munich, Germany, Sept 16 – Nov 15, 2008

Camouflage II, curated by Helmut Friedel and Giovanni Iovane, Galleria Gentili, Prato, Italy, Oct 4 – Dec, 2008 (c)

Hugh Lane Centenary Print Collection, The Hugh Lane Gallery, Dublin, Ireland, Nov 20, 2008 – Feb 8, 2009

Made in Munich, Haus der Kunst, Munich, Germany, Nov 21, 2008 – Feb 22, 2009

Fifty Percent Solitude, Kerlin Gallery, Dublin, Ireland, Nov 27, 2008 – Jan 10, 2009

Color into Light, Museum of Fine Arts, Houston, TX (Dec 13, 2008 – Mar 22, 2009)

2009

Drei. Das Triptychon in der Moderne, Kunstmuseum Stuttgart, Stuttgart, Germany, Feb 7 – June 14, 2009

Pop to Present, Pigott Family Gallery, Iris & B. Gerald Cantor Center for Visual Arts, Stanford University, Stanford, CA, March 18 – August 16, 2009

Historias del Confin, IVAM – Institut Valencia d'Art Modern, Valencia, Spain, May 28 – Nov 15, 2009

1972

Sean Scully. Bookshop Gallery, Ceolfrith Art Centre, Sunderland, UK, July – Aug 13, 1972

1973

Recent Paintings. Sean Scully, Rowan Gallery, London, UK, Nov 9 – Dec 6, 1973

1975

Sean Scully. Paintings 1974, La Tortue Gallery, Santa Monica, CA, Feb 11 – Apr 4, 1975 (c)

Sean Scully. Recent Paintings, Rowan Gallery, London, UK, Apr 4 – May 1, 1975

1976

Sean Scully. Works on Paper, La Tortue Gallery, Santa Monica, CA

1977

Sean Scully, Duffy/Gibbs Gallery, New York, NY, 1977

Sean Scully. Paintings & Drawings, Rowan Gallery, London, UK, Nov 4 – Dec 1, 1977

1979

Painting for One Place, Peter Nadin's Space, New York, NY, Feb 1 – Mar 27, 1979

Sean Scully. Recent Paintings, Rowan Gallery, London, UK, Aug 10 – Sept 14, 1979

Sean Scully. Paintings 1975 - 1979, The Clocktower, New York, NY, Nov 28 – Dec 22, 1979

1980

Sean Scully, Susan Caldwell Inc, New York, NY, Jan 5 – 26, 1980

1981

Sean Scully, Susan Caldwell Inc, New York, NY, Jan 10 – 31, 1981

Sean Scully. Recent Paintings, Rowan Gallery, London, UK, Mar 27 – Apr 23, 1981

Sean Scully. seven drawings, a wall painting: Spider *to the people of Berlin - dedicated to Blinky Palermo*, Museum für (Sub-) Kultur, Berlin, Germany, Apr 8 – 29, 1981

Sean Scully. Paintings 1971 - 1981, Ikon Gallery, Birmingham, UK, Sept 5 – 30, 1981 (c) Traveled under the auspices of the Arts Council of Great Britain to: Ceolfrith Gallery, Sunderland Arts Centre, Sunderland, UK, Oct 6 - 31, 1981; Douglas Hyde Gallery, Dublin, Ireland, Nov 16, 1981 – Jan 9, 1982; Warwick Arts Trust, London, UK, July – Aug 7, 1982 (c)

Sean Scully. Recent Paintings, McIntosh/Drysdale Gallery, Washington D.C., Oct 10 – Nov 3, 1981

1982

Sean Scully. Recent Paintings, William Beadleston Inc., New York, NY, Dec 1, 1982 – Jan 8, 1983

1983

Sean Scully, David McKee Gallery, New York, NY, Sept 13 – Oct 5, 1983

1984

Sean Scully. Recent Paintings and Drawings, Juda Rowan Gallery, London, UK, Nov 2 – Dec 15, 1984

Sean Scully. schilderijen - tekeningen, Galerij S65 – Aalst, Belgium, Oct 26 – Dec 2, 1984

1985

Sean Scully. New Paintings, David McKee Gallery, New York, NY, Feb 1 – Mar 2, 1985

Sean Scully. Paintings and Drawings, Barbara Krakow Gallery, Boston, MA, Apr 13 – May 16, 1985

Sean Scully, Museum of Art, Carnegie Institute, Pittsburgh, PA, May 4 – June 30, 1985 and the Museum of Fine Arts, Boston, MA, July 17 – Oct 13, 1985 (c)

Sean Scully. Neue Arbeiten, Galerie Schmela, Düsseldorf, Germany, Nov 8 – Dec 31, 1985

1986

Sean Scully. Paintings. 1985 - 1986, David McKee Gallery, New York, NY, Oct 1 - 28, 1986 (c)

1987

Sean Scully. Monotypes from the Garner Tullis Workshop, Pamela Auchincloss Gallery, Santa Barbara, CA, Apr 3 – May 6, 1987 (c)

Sean Scully. Monotypes, David McKee Gallery, New York, NY, June 1987

Sean Scully. Recent Monotypes and Drawings, Flanders Contemporary Art, Minneapolis, MN, July 16 – Aug 15, 1987

Sean Scully, Mayor Rowan Gallery, London, UK, Oct 9 – Nov 12, 1987 (c)

Sean Scully, Galerie Schmela, Düsseldorf, Germany, Oct 16 – Nov 25, 1987 (c)

Sean Scully. Matrix/Berkeley 112, University Art Museum, University of California at Berkeley, Berkeley, CA, Oct 10 – Dec 13, 1987 (c)

Sean Scully, curated by Neal Benezra, The Art Institute of Chicago, Chicago, IL, Dec 15, 1987 – Feb 7, 1988 (c)

1988

Sean Scully, Fuji Television Gallery, Tokyo, Japan, Oct 7 – 29, 1988 (c)

1989

Sean Scully. New Paintings, David McKee Gallery, New York, NY, Jan 31 – Feb 25, 1989 (c)

Sean Scully: Paintings and Works on Paper 1982 – 1988, Whitechapel Art Gallery, London, UK, May 5 – June 25, 1989. Traveled to Centro de Arte Reina Sofia – Palacio de Velazquez, Parque del Retiro, Madrid, Spain, Sept 14 – Nov 12, 1989 and Städtische Galerie im Lenbachhaus, Munich, Germany, July 12 – Aug 27, 1989 (c)

Sean Scully. Pastel Drawings, Grob Gallery, London, UK, Dec 6, 1989 – Jan 27, 1990

Sean Scully. Bilder und Zeichnungen, Galerie Karsten Greve, Cologne, Germany, Dec 8, 1989 – Feb 10, 1990

1990

Sean Scully. Prints, M. Art, Tokyo, Japan, Apr 9 – 21, 1990

Sean Scully, Galerie de France, Paris, France, Oct 18 – Nov 24, 1990 (c)

Sean Scully. Monotypes from the Garner Tullis Workshop, Pamela Auchincloss Gallery, New York, NY, Nov 23 – Dec 22, 1990 (c)

Sean Scully. New Paintings, McKee Gallery, New York, NY, Nov 28 – Dec 31, 1990 (c)

1991

Sean Scully. Paintings and Works on Paper, Galerie Jamileh Weber, Zürich, Switzerland, Sept 20 – Nov 9, 1991 (c)

1992

Sean Scully. New Graphic Works, Weinberger Gallery, Copenhagen, Denmark

Sean Scully. Woodcuts, Pamela Auchincloss Gallery, New York, NY, Feb 8 – Mar 11, 1992

Sean Scully. Prints and Related Works, Brooke Alexander Editions, New York, NY, Feb 28 – Apr 11, 1992

Sean Scully. New Prints, Bobbie Greenfield Fine Art, Inc., Venice, CA, Jan 31 – Mar 7, 1992

Sean Scully. Woodcuts, Stephen Solovy Fine Art, Chicago, IL, Apr 3 – May 5, 1992

Sean Scully, Daniel Weinberg Gallery, Santa Monica, CA, May 12 – June 13, 1992

Sean Scully. Paintings 1973 – 1992, Sert Gallery, Carpenter Center for the Visual Arts, Harvard University, Cambridge, MA, Oct 9 – Nov 15, 1992

Sean Scully, Waddington Galleries, London, UK, Nov 4 – Dec 23, 1992 (c)

1993

Sean Scully, Mary Boone Gallery, New York, NY, May 1 – June 26, 1993

Sean Scully. The Catherine Paintings, Modern Art Museum of Fort Worth, TX, May 16 – July 25, 1993 (c)

Sean Scully. Heart of Darkness, Waddington Galleries, London, UK, May 18 – June 5, 1993 (c)

Sean Scully. Paintings. Works on Paper", Galerie Bernd Klüser, Munich, Germany, Nov 16, 1993 – Jan 15, 1994 (c)

1994

Sean Scully. The Light in the Darkness, Fuji Television Gallery, Tokyo, Japan, Mar 18 – Apr 28, 1994 (c)

Sean Scully. Works on Paper, Knoedler & Co., New York, NY, Apr 30 – May 21, 1994

Sean Scully. Paintings, Butler Gallery, Kilkenny Castle, Kilkenny, Ireland, July 9 – Aug 14, 1994

Sean Scully, Kerlin Gallery, Dublin, Ireland, Nov 4 – Dec 5, 1994

Sean Scully. Obra graphica 1991 – 1994, Galeria DV, San Sebastian, Spain, Dec 17, 1994 – Feb 10, 1995 (c)

Sean Scully. La forma e lo spirito/The Form and the Spirit, Galleria Gian Ferrari Arte Contemporanea, Milano, Italy, Nov 24, 1994 – Jan 14, 1995 (c)

1995

Galeria De L'Ancien College, Châtellerault, France (c)

Sean Scully, Waddington Galleries, London, UK, June 7 – July 8, 1995 (c)

Sean Scully. The Beauty of the Real, Galerie Bernd Klüser, Munich, Germany, Dec 5, 1995 – Jan 31, 1996 (c)

Sean Scully: Twenty Years, 1976 – 1995, Hirshhorn Museum and Sculpture Garden, Smithsonian Institution, Washington, D.C. June 14 – Sept 10, 1995; High Museum of Art, Atlanta, GA, Oct 10, 1995 – Jan 7, 1996; Fundacio "la Caixa," Centre Cultural, Barcelona, Spain, Feb 5 – Apr 7, 1996; Irish Museum of Modern Art (IMMA), Dublin, Ireland, May 29 – Aug 25, 1996; Schirn Kunsthalle Frankfurt, Frankfurt am Main, Germany, Sept 21 – Dec 1, 1996 (c)

Sean Scully. The Catherine Paintings, Kunsthalle Bielefeld, Bielefeld, Germany, July 30 – Sept 24, 1995; Palais des Beaux-Arts, Charleroi, Belgium, Apr 28 – June 18, 1995 (c)

Sean Scully, Mary Boone Gallery, New York, NY, Oct 28 – Dec 16, 1995

1996

Sean Scully. The Catherine Paintings (1979 – 1995) & Watercolours, Casino Luxembourg, Forum d'art contemporain, Luxembourg, May 23 – July 14, 1996 (c)

Sean Scully. Obra grafica recent, Edicions T Galeria D'Art, Barcelona, Spain, Feb – Apr, 1996 (c)

Sean Scully. Paintings and Works on Paper, Galerie nationale du Jeu de Paume, Paris, France, Oct 7 – Dec 1, 1996. Traveled to Neue Galerie der Stadt Linz, Linz, Austria, Jan 23 – Mar 14, 1997; Culturgest, Lisbon, Portugal, 1997 (c)

Sean Scully, curated by Danilo Eccher, Galleria d'Arte Moderna – Villa Delle Rose, Bologna, Italy, May 31 – September 1, 1996 (c)

Sean Scully, Galeria Carles Tache, Barcelona, Spain, 1996 (c)

Sean Scully. New Pastels, Galerie Lelong, New York, NY, Sept 12 – Nov 2, 1996

Sean Scully. Graphische Arbeiten, Galerie Angelika Harthan, Stuttgart, Germany, Sept 14 – Nov 2, 1996 (c)

Sean Scully. Works on Paper 1975 – 1996, Staatliche Graphische Sammlung, Neue Pinakothek, Munich, Germany, Sept 26 – Nov 24, 1996. Traveled to Museum Folkwang Essen, Essen, Germany, Dec 1, 1996 – Jan 26, 1997; Henie-Onstad Kunstsenter, Hovikodden, Norway, 1997; Whitworth Art Gallery, Manchester, UK; Hugh Lane Municipal Gallery of Art, Dublin, Ireland; *Sean Scully. Works on Paper 1984 – 1996*, Herning Kunstmuseum, Herning, Denmark, 1997; Milwaukee Art Museum, Milwaukee, WI; Denver Art Museum, Denver, CO, 1998; Carpenter Center for the Visual Arts, Harvard University, Cambridge, MA, Nov 30 – Dec 31, 1998; Albright-Knox Art Gallery, Buffalo, NY, Jan 8 – Mar 2, 2000 (c)

1997

Sean Scully. Seven Unions, Timothy Taylor Gallery, London, UK, Jan 14 – Feb 28, 1997

Sean Scully 1989 – 1997, La Sala de Exposiciones REKALDE, Bilbao, Spain, Mar 13 – May 11, 1997. Traveled to Salas del Palacio Episcopal, Plaza del Obispo, Malaga, Spain; Fundacio "la Caixa", Palma de Mallorca, Spain (c)

Sean Scully 1982 – 1996, City Art Galleries & The Whitworth Art Gallery, Manchester, UK, June 7 – July 13, 1997 (c)

Sean Scully. Recent Paintings, Galerie Lelong, Paris, France, Mar 20 – May 24, 1997 (c)

Sean Scully, Kerlin Gallery, Dublin, Ireland, May 25 – June 23, 1997

Sean Scully. Floating Paintings and Photographs, Galerie Lelong, New York, NY, Sept 9 – Nov 1, 1997

Sean Scully. Obra Reciente: Pinturas, Acuarelas, Pasteles y Obra Grafica, Galeria DV, San Sebastian, Spain, Sept – Oct, 1997 (c)

Sean Scully, Mary Boone Gallery, New York, NY, Sept 6 – Oct 18, 1997

Sean Scully. Paintings & Works on Paper, Galerie Jamileh Weber, Zürich, Switzerland, Nov 22, 1997 – Feb 28, 1998

Sean Scully. Prints and Watercolors, John Berggruen Gallery, San Francisco, CA, Dec 10, 1997 – Jan 3, 1998

1998

Sean Scully. Paintings and Works on Paper, Galerie Bernd Klüser, Munich, Germany, Feb 17 – Mar 28, 1998 (c)

Sean Scully. Mirror Images. Paintings & Works on Paper, Timothy Taylor Gallery, London, UK, June 24 – Aug 1, 1998

Sean Scully, Bawag Foundation, Vienna, Austria, June 4 – Aug 29, 1998 (c)

Sean Scully, Galerie Haas & Fuchs, Berlin, Germany, Feb 3 – Mar 7, 1998

Sean Scully. Seven Mirrors. Harris and Lewis Stacks, Mira Godard Gallery, Toronto, Canada, Feb 28 – Mar 14, 1998

Sean Scully. New Paintings and Works on Paper, Galleri Weinberger, Copenhagen, Denmark, Oct 9 – Nov 14, 1998

Sean Scully, Galeria Antonia Puyo, Zaragoza, Spain, Nov 1998 (c)

Sean Scully. Pastels, Watercolors, Prints and Photos, Galerie Le Triangle Blue Art Contemporain, Stavelot, Belgium, Dec 13, 1998 – Jan 31, 1999

1999

Sean Scully, Galerie Lelong Paris, Paris, France, Mar 4 – Apr 17, 1999 (c)

Sean Scully. Prints 1968 – 1999, Graphische Sammlung Albertina, Vienna, Austria, Apr 16 – May 30, 1999; Musee du Dessin et de l'Estampe Originale, Gravelines, Gravelines, France, July 4 – Oct 3, 1999 (catalogue raisonne)

Sean Scully New Paintings and Works on Paper, Danese Gallery and Gallery Lelong, New York, NY, Apr 29 – June 11, 1999 (c)

Sean Scully. New Paintings, South London Gallery, London, UK, June 16 – Aug 1, 1999 (c)

Sean Scully. Monotypes and Color Woodcuts 1987 – 1993 from the Garner Tullis Workshop, New York, Galerie Kornfeld, Zürich, Switzerland, Mar 14 – Apr 24, 1999

Sean Scully, Kerlin Gallery, Dublin, Ireland, Oct 15 – Nov 15, 1999 (c)

Sean Scully. Ten Barcelona Paintings, Galerie Bernd Klüser, Munich, Germany, Dec 14, 1999 – Feb 14, 2000 (c)

2000

Sean Scully on Paper, The Metropolitan Museum of Art, New York, NY, Jan 11 – Mar 12, 2000

Sean Scully. Prints 1994 - 1998, Alan Cristea Gallery, London, UK, Feb 8 – Mar 11, 2000

Sean Scully, Galeria Carles Tache, Barcelona, Spain, 2000 (c)

Sean Scully. Estampes 1983 – 1999, Musee des Beaux-Arts de Caen, Caen, France, June 30 – Sept 11, 2000 (c)

Sean Scully. Photographies, Galerie de l'ancien college, Ecole municipale d'Arts

plastiques, Chatellerault, France, May 20 – June 29, 2000

Sean Scully. Graphics, A+A Galleria D'Arte, Venice, Italy, 2000

2001

Barcelona Etchings for Frederico Garcia Lorca, Instituto Cervantes, London, England

Sean Scully. Light + Gravity: Recent Wall of Light Paintings, Knoedler & Company, New York, NY, Mar 8 – Apr 28, 2001 (c)

Sean Scully. New Works on Paper, Galerie Lelong, New York, NY, Mar 10 – Apr 21, 2001

Sean Scully. The 90's - Paintings Pastels Watercolors Photographs, Kunstsammlung Nordrhein-Westfalen, Düsseldorf, Germany, Mar 17 – June 4, 2001. Traveled to: Haus der Kunst, Munich, Germany, June 14 – Sept 16, 2001; Instituto Valencia d'Arte Modern (IVAM), Valencia, Spain (c)

Sean Scully Work on Paper, Rex Irwin Gallery, Woollahra, Australia, Mar 6 – Mar 31, 2001. Traveled to Dickerson Gallery, Melbourne, Australia, Apr 18 – May 13, 2001

Sean Scully, Ingleby Gallery, Edinburgh, UK, Aug 1 – Sept 15, 2001

Sean Scully: Light to Dark, Galerie Lelong, Paris, France (c)

Sean Scully: walls windows horizons, David Winton Bell Gallery, List Art Center, Brown University, Providence, RI, Sept 8 – Oct 28, 2001

Sean Scully, Musée Jenisch, Vevey, Switzerland, Sept 22, 2001 – Jan 6, 2002

"*Sean Scully. Wall of Light,* curated by Michael Auping, Museo De Arte Contemporaneo De Monterrey, Monterrey, Mexico, 2001. Traveled to Museo de Arte Moderno, Mexico City, Mexico, 2002 (c)

2002

Sean Scully, Camara de Comercio, Industria Y Navegacion de Cantabria, Santander, Spain, Jan – Feb, 2002. Traveled to Ayuntamiento de Pamplona, Polvorin de la Cindadela (c)

Sean Scully, Galerie Neue Meister, Staatliche Kunstsammlungen Dresden, Dresden, Germany, Apr 19 – June 26, 2002 (c)

Sean Scully: Wall of Light, Figures, Timothy Taylor Gallery, London, UK, June 11 – July 12, 2002 (c)

Sean Scully, L.A. Louver Gallery, Venice, CA, Oct 25 – Nov 30, 2002

Sean Scully. Wall of Light, Centro de Arte Helio Oiticica, Rio de Janeiro, Brazil, Aug 22 – Oct 27, 2002 (c)

2003

Sean Scully, Hotel des Arts, Toulon, France, Apr 26 – June 15, 2003 (c)

Sean Scully, Galeria Carles Tache, Barcelona, Spain, May 8 – July 31, 2003 (c)

Sean Scully. Photographs, Galerie Jamileh Weber, Zürich, Switzerland, Oct 11 – Nov 22, 2003 (Monograph: The Color of Time)

Sean Scully. Works 1990 – 2003, Sara Hilden Art Museum, Tampere, Finland, Sept 13, 2003 – Feb 15, 2004. Traveled to: Neues Museum Weimar, Weimar, Germany, Mar 13 – May 31, 2004 (c)

Sean Scully. Photographs, L.A. Louver Gallery, Venice, CA, Nov 21, 2003 – Jan 3, 2004 (Monograph: The Color of Time)

Sean Scully. Prints and Photographs, Alexander and Bonin Gallery, New York, NY, Dec 2, 2003 – Jan 10, 2004 (Monograph: The Color of Time)

2004

Sean Scully. Photographs, Galerie Bernd Klüser, Munich, Germany, Feb 5 – Apr 24, 2004 (Monograph: The Color of Time).

Sean Scully. Photographs, Kerlin Gallery, Dublin, Ireland, Mar 31 – Apr 30, 2004

Sean Scully. España-Spain-Spanien, Kunsthalle Weimar, Harry Graf Kessler, Weimar, Germany, Mar 13 – Apr 18, 2004

Sean Scully. Fotografias, Galeria Estiarte, Madrid, Spain, Mar 15 – Apr 12, 2004

Sean Scully. Winter Robe, Galerie Lelong, Paris, France, May 13 – July 10, 2004 (c)

Sean Scully. Estampes 1983 – 2003, Centre Culturel Irlandais, Paris, France, May 12 – July 10, 2004

Sean Scully. Paintings from the 70's, Timothy Taylor Gallery, London, UK, Mar 31 – Apr 8, 2004

tigres en el jardin. Jose Guerrero & Sean Scully, Centro Jose Guerrero, Granada, Spain, May 6 – July 4, 2004 (c)

Sean Scully, Etchings for Federica Garcia Lorca, Huerta de San Vicente, Casa - Museo Federico Garcia Lorca Foundation, Granada, Spain, 2004 (c)

Holly Series, Kunstverein Aichach, Aichach, Germany, May 16 – June 13, 2004

Sean Scully: body of light, National Gallery of Australia, Canberra, Australia, July 23 – Oct 10, 2004 (c)

Sean Scully Photographs, Anne Reed Gallery, Ketchum, Idaho

2005

Faith Hope Love, Augustinerkloster, Erfurt, Germany, Mar – Apr, 2005

Sean Scully. Graphic Works, Fenton Gallery, Cork, Ireland, Mar 16 – Apr 9, 2005

Sean Scully. Paintings and Works on Paper, Abbot Hall Art Gallery at Lakeland Artists Trust, Kendal, UK, Mar 21 – June 25, 2005 (c)

Sean Scully. Malerie: kleine Formate, Staatliche Museen Kassel, Neue Galerie, Kassel, Germany, Apr 14 – Sept 4, 2005 (c)

Sean Scully. New Work, Galerie Lelong, New York, NY, May 12 – June 25, 2005 *Sean Scully,* Ingleby Gallery, Edinburgh, UK, May 25 – July 22, 2005 (c)

Mirrors 1982 – 2004 prints, editions & photographs, La Louviere Museum, La Louviere, Belgium, May 14 – Aug 14, 2005

Sean Scully. Photographs, Galeria Carles Tache, Barcelona, Spain (c)

Sean Scully. para Garcia Lorca, Sala de Exposiciones Acala 31, Madrid, Spain, Oct 27 – Dec 11, 2005 (c)

Sean Scully. Wall of Light, curated by Stephen Phillips, The Phillips Collection, Washington D.C., Oct 22, 2005 – Jan 8, 2006. Traveled to: The Modern Art Museum of Fort Worth, Fort Worth, TX, Feb 12 – May 28, 2006, Cincinnati Art Museum, Cincinnati, OH, June 24 – Sept 3, 2006, The Metropolitan Museum of Art, New York, NY, Sept 25, 2006 – Jan 14, 2007 (c)

2006

Sean Scully. The Architektur der Farbe / The Architecture of Color, Kunstmuseum Liechtenstein, Vaduz, March 10 – May 21, 2006 (c)

Sean Scully, Bibliothèque Nationale de France, Paris, France

Sean Scully. Recent Paintings, L.A. Louver Gallery, Venice, CA, May 12 – June 30, 2006 (c)

Sean Scully, Timothy Taylor Gallery, London, UK, Nov 22, 2006 – Jan 20, 2007 (c)

Sean Scully, Scottish National Gallery of Modern Art, Edinburgh, UK, Nov 18, 2006 – Mar 4, 2007

2007

Sean Scully: Dedicate a Garcia Lorca, Instituto Cervantes Dublin, Dublin, Ireland

Sean Scully. A Retrospective, curated by Danilo Eccher, Miró Foundation, Barcelona, Spain, June 28 – Sept 30, 2007; Musee d'art moderne, St. Etienne, France, Feb 9 – Apr 6, 2008; MACRO al Mattatoio, Rome Italy, May 10 – Aug 31, 2008 (c)

Sean Scully. Walls of Aran, Kerlin Gallery, Dublin, Ireland, May 4 – June 2, 2007 (c)

Sean Scully. Aran Islands. A Portfolio of Photographs, Galerie Lelong, New York, NY, June 28 – Aug 3, 2007 (c)

Sean Scully. Walls of Aran, Ingleby Gallery, Edinburgh, UK, July 14 – 21, 2007 (c)

The Prints of Sean Scully, curated by Joann Moser, SAAM Smithsonian American Art Museum, Washington D.C., May 18 – Oct 8, 2007. Traveled to: Naples Museum of Art, Naples, FL; Minneapolis Institute of Arts, Minneapolis, MN, Mar 1 – May 4, 2008; Hyde Collection, Glens Falls, NY, Sept 7 – Nov 2, 2008

Sean Scully. New Painting, Galerie Jamileh Weber, Zürich, Switzerland, Oct 5 – Dec 7, 2007

2008

Sean Scully: The Art of the Stripe, Hood Museum of Art, Dartmouth College, Hanover, NH, Jan 12 – Mar 9, 2008 (c)

Sean Scully. La surface peinte, Galerie Lelong, Paris, France, May 16 – July 5, 2008 (c)

Sean Scully, Galeria Carles Tache, Barcelona, Spain, Nov 27, 2008 – Jan 31, 2009

2009

Sean Scully. Paintings from the 80s, Timothy Taylor Gallery, London, UK, Jan 8 – Feb 14, 2009

Konstantinopel oder die versteckte Sinnlichkeit. Die Bilderwelt von Sean Scully (Constantinople or the Sensual Concealed. The imagery of Sean Scully), curated by Susanne Kleine, MKM Museum Küppersmühle für Moderne Kunst, Duisburg, Germany, Feb 20 – May 3, 2009. Travels to: Belfast, Bremen and Chemnitz (c)

Sean Scully, Galerie Lelong, New York, NY, Apr – June, 2009

2010 – 11

Sean Scully. The 1980s, curated by Tanja Pirsig Marshall, National Gallery of Wales, Cardiff, UK & Leeds Art Gallery, Leeds, UK (c)

Sean Scully. A Retrospective, curated by Enrique Juncosa & Susanne Kleine, IMMA – Irish Museum of Modern Art & Dublin City Gallery, The Hugh Lane, Dublin, Ireland; Kunst und Ausstellungshalle der Bundesrepublik Deutschland, Bonn, Germany; Kunstmuseum Bern, Bern, Switzerland (c)

Bibliografie · Bilbliography

Adams, Brooks. "The Stripe Strikes Back," ART IN AMERICA, October 1985, p. 118–123

Aguilare, Luis. "Torno exigente o arcaismo de la abstraccion?" DIARIO DE MONTERREY, October 10, 2001. p. 46

Aukeman, Anastasia. "Sean Scully at Bernd Klüser," ARTNEWS, April 1994

Baker, Kenneth. "Abstract Gestures," ARTFORUM INTERNATIONAL, September 1989, pp. 135–138

Balbona, Guillermo. "Las últimas miradas fotográficas de Sean Scully, primera cita de 2002 en el Palacete.," EL DIARIO MONTAÑÉS. January 13, 2002.

Barrett, Cyril. "Exhibitions. ROSC, 84," ART MONTHLY, October 1984, p. 11–14

Barringer, Felicity. "Matisse: 'He's Kind of Cast a Spell on Me.'" ARTNEWS, April 1993

Bass, Ruth. "Sean Scully," ARTNEWS, March 1991

Batchelor, David. "Sean Scully," ARTSCRIBE INTERNATIONAL, September/October 1989, pp. 72

Bell, Tiffany. "Responses to Neo-Expressionism," FLASH ART, May 1983, pp. 40–46

Benezra, Neal. "Sean Scully," SEAN SCULLY, The Art Institute of Chicago, 1987

Bennett, Ian. "Sean Scully," FLASH ART, January/February 1980, pp. 53

Bennett, Ian. "Modern Painting and Modern Criticism in England," FLASH ART, March/April 1980, pp. 24–26

Bennett, Ian. "Sean Scully," FLASH ART, Summer 1989, p. 157

Bennett, Ian. "Sean Scully," TEMA CELESTE, January/March 1992, p. 104

Berryman, Larry. "Abstraction of Opposites," ARTS REVIEW, December 1992

Bevan, Roger. "Scully's Decade," ANTIQUE AND NEW ART, Winter 1990

Roger Bevan. Controversy over the Turner Prize, THE ART NEWSPAPER, November 1991

Bonaventura, Paul. "Sean Scully: 'Hay que ligar la abstracción a la vida'" RS, October 1989, pp. 26–34

Bonaventura, Paul. "Interview with Sean Scully," EXHIBITION GUIDE TO SEAN SCULLY: PAINTINGS AND WORKS ON PAPER 1982–88, Whitechapel Art Gallery, London 1989

Bonaventura, Paul. "It is all a Question of Intensity," SEAN SCULLY, Waddington Galleries, London 1992

Bromberg, Craig. "The Untitled Orbit," ART AND AUCTION, October 1991

Bromberg, Craig. "Gefühl ist wieder angesagt. Die Renaissance der abstrakten Malerei in New York," ARTIS, February 1992, pp. 44–49

Burr, James. "Round the Galleries – People and Patterns," APOLLO, November 1984, p. 354

Burr, James. "Sean Scully at the Whitechapel," APOLLO, June 1989, pp. 432

Caldwell, John. "The New Paintings," SEAN SCULLY, Museum of Art, Carnegie Institute, Pittsburgh 1985, pp. 17–21 (Reprinted in THE COLLECTED WRITINGS OF JOHN CALDWELL, San Francisco Museum of Modern Art, 1996)

Campbell-Johnson, Rachel. "A Mere Stripe of a Thing," THE LONDON TIMES. June 16, 1999.

Cappuccio, Elio. "Interview with Arthur Danto," SEGNO, November 1992

Carrier, David. "Theoretical Perspectives on the Arts, Sciences and Technology," LEONARDO, Vol. 18, No. 2, 1985, pp. 108–113

Carrier, David. "Color in the Recent Work," SEAN SCULLY, Museum of Art, Carnegie Institute, Pittsburgh 1985, pp. 22–27 (Reprinted in Carrier, David, THE AESTHETE IN THE CITY: THE PHILOSOPHY AND PRACTICE OF AMERICAN ABSTRACT PAINTING IN THE 1980S, University Park, Pennsylvania 1994)

Carrier, David. "Corcoran Gallery 40th Biennial," BURLINGTON MAGAZINE, July 1987, pp. 483

Carrier, David. "Spatial Relations," ART INTERNATIONAL, Autumn 1989, p. 81

Carrier, David. "Art Criticism and Its Beguiling Fictions," ART INTERNATIONAL, Winter 1989, pp. 36–41

Carrier, David. "Piet Mondrian and Sean Scully: Two Political Artists," ART JOURNAL, Spring 1991 (Reprinted in SEAN SCULLY. PRINTS FROM THE GARNER TULLIS WORKSHOP, Garner Tullis, New York 1991, and Carrier, David, THE AESTHETE IN THE CITY: THE PHILOSOPHY AND PRACTICE OF AMERICAN ABSTRACT PAINTING IN THE 1980S, University Park, Pennsylvania 1994)

Carrier, David. "Abstract Painting and Its Discontents," TEMA CELESTE, Autumn 1991, pp. 77–79

Carrier, David. "Afterlight. Exhibiting Abstract Painting in the Era of its Belatedness," ARTS MAGAZINE, March 1992, pp. 60

Carrier, David. "Sean Scully: New York and Fort Worth," BURLINGTON MAGAZINE, July 1993

Carrier, David. "Italia/America: L'Astrazione ridefinita," SEGNO, Autumn 1993

Carrier, David. "Sean Scully. Il pittore della vita moderna/The Painter of Modern Life," SEAN SCULLY, Galleria d'Arte Moderna, Villa delle Rose, Bologna 1996, pp. 16

Carrier, David. "review," TEMA CELESTE, NY. May-June 2001, p. 85.

Castaneda, Jessica. "Presenta su muro de luz y color," EL NORTE. October 10, 2001. p. 10.

Combalia, Victoria. "Sean Scully: Against Formalism," SEAN SCULLY. TWENTY YEARS. 1976–1995, High Museum of Art, Atlanta 1995, pp. 31

Combalia, Victoria. "La Importancia y el Lugar de la Pintura de Scully/The Importance and the Place of Scully's Paintings," SEAN SCULLY, Galeria Carles Taché, Barcelona 1996

Cone, Michele C. "review," ART NEWS. Summer 2001, p. 174.

Cooke, Lynne. "Sean Scully," GALERIES MAGAZINE, August/September 1989, pp. 60–63

Cooke, Lynne. "Sean Scully. Taking a Stand, Taking up a Stance," SEAN SCULLY. TWENTY YEARS. 1976–1995, High Museum of Art, Atlanta 1995, pp. 47

Cotter, Holland. "Sean Scully," FLASH ART, April/May 1985, p. 40

Crichton, Fenella. "Sean Scully at the Rowan," ART INTERNATIONAL, June 15, 1975, p. 58

Crichton, Fenella. "London," ART AND ARTISTS, October 1979, pp. 41–48

Cyphers, Peggy. "Sean Scully," TEMA CELESTE, March/April 1991, pp. 92

Dannatt, Adrian. "Sean Scully: An Interview," FLASH ART, May/June 1992, pp. 103–105

Dannatt, Adrian. "reviews," THE ART NEWSPAPER. March 2001.

Danto, Arthur C. "Astrattismo post-storico," TEMA CELESTE (Italy), April/May 1992

Danto Arthur C. "Art after the End of Art," ARTFORUM INTERNATIONAL, April 1993, pp. 62–69

Danto, Arthur C. "Sean Scully's Catherine Paintings: The Aesthetics of Sequence," SEAN SCULLY. THE CATHERINE PAINTINGS, Modern Art Museum of Fort Worth, 1993, pp. 30–46

Danto, Arthur C. "Between the Lines: Sean Scully on Paper/Zwischen den Linien: Sean Scully auf Papier," SEAN SCULLY. WORKS ON PAPER 1975–1996, Staatliche Graphische Sammlung, Munich 1996, pp. 9ff.

Danto, Arthur C. "The Catherine Paintings de Sean Scully: l'esthétique de la séquence," SEAN SCULLY, Galerie Nationale du Jeu de Paume, Paris 1996, pp. 67ff.

Danto, Arthur C. "Painting Earns its Stripes," THE NATION. February 21, 2000.

de Circasia, Victor. "Fade into Paint, Sean Scully speaks with critic and curator, Victor de Circasia," LABEL MAGAZINE #7. Autumn 2002.

Decter, Joshua. "Sean Scully," ARTS MAGAZINE, December 1986, pp. 123ff.

Del Renzio, Toni. "London," ART AND ARTISTS, December 1974, pp. 33–35

Denvir, Bernard/Packer, William. "A Slice of Late Seventies Art," ART MONTHLY, March 1980, pp. 3–5

Draper, Francis. "Sean Scully," ARTS REVIEW, November 25, 1977, p. 714

Dunne, Aidan. "Breaking the Rules," THE IRISH TIMES. October 6, 1999.

Dunne, Aidan. "The Painter's Painter; Defender of the Faith," THE IRISH TIMES. Sunday, August 3, 2002.

Durand, Regis. "Sean Scully: Une abstraction ancrée dans le monde," ART PRESS, Februrary 1991

Eccher, Danilo. "Astrazione trascendente e pauperismo cromatico/Transcendent Abstraction and Chromatic Impoverishment," SEAN SCULLY, Galleria d'Arte Moderna, Villa delle Rose, Bologna 1996, pp. 10ff.

Faure-Walker, James. "Sean Scully," STUDIO INTERNATIONAL, May/June 1975, pp. 238

Faust, Gretchen. "Herstand Group Show," ARTNEWS, Summer 1990

Feaver, William. "London Letter: Summer," ART INTERNATIONAL, November 1972, p. 39

Feaver, William. "Sean Scully," ART INTERNATIONAL, November 1973, pp. 26, 32, 75

Feaver, William. "Sean Scully," ARTNEWS, January 1978, p. 133

Feaver, William. "Sean Scully," ARTNEWS, September 1989, p. 191

Fisher, Susan. "Catherine Lee/Sean Scully," NEW ART EXAMINER, June 1986, p. 52

Frank, Peter. "reviews, Sean Scully at L.A. Louver," ARTNEWS. February 2003.

Frémon, Jean. "Sean Scully: la matière de l'âme," SEAN SCULLY "PLACE", Galerie de l'ancien collège, Châtellerault/Galerie Lelong, Paris, 1995

Frémon, Jean. "Blasons du Corps/Blazons of the Body," SEAN SCULLY (Repères/Cahiers d'art contemporain, Nr. 91), Galerie Lelong, Paris 1997, pp. 3

Friedel, Helmut. "Sean Scully – Dark Light," SEAN SCULLY, Bawag Foundation, Vienna 1998, pp. 18–23

Gardner, Paul. "Waking Up and Warming Up," ARTNEWS, October 1992, p. 116

Garlake, Margaret. "Double Scully," GALLERY MAGAZINE, November 1987

Garlake, Margaret. "Sean Scully," ART MONTHLY, No. 127, June 1989, p. 23

124

Girard, Xavier. "Affection du tableau," SEAN SCULLY, Galerie Nationale du Jeu de Paume, Paris 1996, pp. 41

Glazebrook, Mark. "Sean Scully: Summarising Living and Painting," SEAN SCULLY. PAINTINGS, Manchester City Art Galleries, Manchester 1997, pp. 6–15

Glazebrook, Mark. "The Star of the Stripes,"ROYAL ACADEMY MAGAZINE. June 1999.

Glazebrook, Mark. "Positive Approach,"THE SPECTATOR. July 24, 1999.

Glover, Michael. "A Glimpse of the Light Fantastic," THE INDEPENDENT. June 29, 1999.

Godfrey, Tony. "Exhibition Reviews," BURLINGTON MAGAZINE, December 1987, pp. 822–824

Gold, Sharon. "Sean Scully," ARTFORUM INTERNATIONAL, Summer 1977, p.9

Gooding, Mel. "Scully. Startup. Leverett," ART MONTHLY, December 1987/January 1988, pp. 21–23

Goodrich, John. "Sean Scully," REVIEW. May, 15, 1999.

Grant, Daniel. "Strong Sales for Scully," ART NEWS. June 1, 2001, p. 7.

Griefen, John. "Sean Scully," ARTS MAGAZINE, February 1980, pp. 35

Gutterman, Scott. "Sean Scully," JOURNAL OF ART, January 1991

Hagen, Charles. "40th Biennial Exhibition of Contemporary American Paintings," ARTFORUM INTERNATIONAL, October 1987, pp. 135

Hartigan, Marianne. "Scully in the Extreme," SUNDAY TRIBUNE. October 24, 1999.

Hartigan, Marianne. "Earning Your Stripes," AER LINGUS'CARA MAGAZINE. August 2001. Vol 34. No.5 pp. 38–44.

Heartney, Eleanor. "Sean Scully at Danese and Lelong," ART IN AMERICA, November 1999, pp. 136

Herzog, Hans-Michael. "The Catherine Paintings at Bielefeld," SEAN SCULLY. THE CATHERINE PAINTINGS, Kunsthalle Bielefeld, 1995, p. 8

Herzog, Hans-Michael. The Beauty of the Real. H.-M. Herzog interviews Sean Scully/Die Schönheit des Realen. Gespräch mit Sean Scully, SEAN SCULLY. THE CATHERINE PAINTINGS, Kunsthalle Bielefeld, 1995, pp. 65–82
Hans-Michael Herzog interviews Sean Scully, Dezember 13, 1998, SEAN SCULLY, South London Gallery, London 1999 (Reprinted in Sean Scully. New Paintings and Work on Paper, Danese/Galerie Lelong, New York 1999, pp. 10ff.)

Higgins, Judith. "Sean Scully and the Metamorphosis of the Stripe," ARTNEWS, November 1985, pp. 104–112

Hill, Andrea. "Sean Scully," ARTSCRIBE INTERNATIONAL, September 1979, p. 60

Hubert, Thomas. "Irish Abroad," ROLAND GARROS CORRESPONDENCE, June 13, 2001.

Hughes, Robert. "Earning His Stripes," TIME MAGAZINE, August 14, 1989, p. 47

Hunter, Sam. "Sean Scully's Absolute Paintings," ARTFORUM, November 1979, pp. 30–34 (Reprinted in SEAN SCULLY PAINTINGS 1971–1981, Ikon Gallery, Birmingham 1981)

Huntington, Richard. "Sean Scully: Works on Paper, 1975–1996," THE BUFFALO NEWS. January 28, 2000.

Jaunin, Francoise. "Une Heraldique Sensuelle,"VAUD-REGION 24 HEURES. Septembre 23, 2001, p. 33.

Januszczak, Waldemar. "A STAR EARNS HIS STRIPES," THE LONDON SUNDAY TIMES. July 18, 1999.

Jarauta, Francisco. "De la geometría a la memoria," SEAN SCULLY. OBRA GRAFICA 1991–1994, Galeria El Diario Vasco, San Sebastian 1994

Jarauta, Francisco. "Sean Scully. Repensar la abstracción/To rethink the Abstraction," SEAN SCULLY, Sala de Exposiciones Rekalde, Bilbao 1997, pp. 9/47ff.

Francisco Jarauta. Variaciones sobre la abstracción/Variations on abstraction, SEAN SCULLY, Galeria Carles Taché, Barcelona 2000

Jeffett, William. "Sean Scully. Reinventing Abstraction," ARTEFACTUM, Summer 1989, pp. 2–6

Jocks, Heinz-Norbert. Sean Scully: "Kunst setzt voraus, daß man nackt ist und dadurch offener wird." (Interview), Kunstforum International, Vol. 141, July/September 1998, p. 268–281

Jones, Ben/Rippon, Peter. "An Interview with Sean Scully," ARTSCRIBE INTERNATIONAL, June 1978, pp. 27–29

Juncosa, Enrique. "Las Estrategias de Apolo," LAPIZ, Vol. 6, No. 60, 1989, p. 26–32

Juncosa, Enrique. "Sean Scully," TEMA CELESTE, Winter 1993

Juncosa, Enrique. "Tigers in the Garden," SEAN SCULLY, Waddington Galleries, London 1995

Juncosa, Enrique. "La Emoción como Lenguaje/Emotion as a Language," SEAN SCULLY, Galeria Carles Taché, Barcelona 1996

Kaido, Kazu. "Sean Scully Interviewed," SEAN SCULLY, Fuji Television Gallery, Tokyo 1988

Kipphoff, Petra. "Kritiker-Umfrage," ART JOURNAL, January 1985, pp. 8ff.

Klüser, Bernd. "Scully und Irland: Drei Assoziationen," SEAN SCULLY. THE BEAUTY OF THE REAL, Galerie Bernd Klüser, Munich 1995

Klüser, Bernd. "Über die Schwierigkeit des Einfachen. Bemerkungen zu den Bildern von S. Scully, M. Rothko und B. Newman/The Difficulties of the Simple. Notes on the Pictures of S. Scully, M. Rothko, B. Newman," SEAN SCULLY. BARCELONA PAINTINGS AND RECENT EDITIONS, Galerie Bernd Klüser, Munich 1999

Korotkin, Joyce B. "Sean Scully," THE NEW YORK ART WORLD. June 8, 1999.

Krauter, Anne. "Sean Scully. Galerie Jamileh Weber," ARTFORUM INTERNATIONAL, Summer 1992, p. 120

Kuspit, Donald. "Sean Scully. Galerie Lelong/Danese," ARTFORUM INTERNATIONAL, September 1999, p. 168

Lamprecht, Susanne. "Zur Malerei von Sean Scully/The Paintings of Sean Scully," SEAN SCULLY, Galerie Schmela, Düsseldorf/Mayor Rowan Gallery, London, 1987

Lehodey, Franck K. "la Griffe d'un Tigre," ROLAND GARROS MAGAZINE. May 2001. pp. 80, 87–89.

Le Parc, Valerie. "Abstraction et volupté de œveres de Sean Scully. VAR-MATIN. May 2003.

Levy, Mark. "The Permutations of the Stripe," SHIFT, Vol. 1, No. 2, 1988, pp. 38–41

Lewallen, Constance. "Sean Scully," SEAN SCULLY, University Museum of Art, Berkeley, 1987/88

Lewallen, Constance. "Interview with Sean Scully," VIEW, Vol. 5, No. 4, Autumn 1988

Lighthill, Amy. "Portrait of the Artist as Lightning Rod," SEAN SCULLY, Museum of Art, Carnegie Institute, Pittsburgh 1985, pp. 6–16

Lingemann, Susanne. "Liebeserklärungen mit der Disziplin von Piet Mondrian," ART. DAS KUNSTMAGAZIN, July 1995, pp. 74–77

Loughery, John. "Sean Scully," Arts Magazine, December 1986, p. 122

Loughery, John. "Affirming Abstraction: The Corcoran Biennial," ARTS MAGAZINE, September 1987, pp. 76–78

Loughery, John. "17 Years at the Barn," ARTS MAGAZINE, April 1988, p. 110

Loughery, John. "Taking Sides: The Paintings of Sean Scully," SEAN SCULLY, Fuji Television Gallery, Tokyo 1988

Lucie-Smith, Edward. "Sean Scully," SEAN SCULLY, South London Gallery, London 1999

Lüttichau, Mario-Andreas von. "'… it has to be about surface and the way it is painted.' Zur Ordnung von Streifen und Farbflächen bei Sean Scully/The Ordering of Stripes and Surfaces in the Work of Sean Scully," SEAN SCULLY. WORKS ON PAPER 1975–1996, Staatliche Graphische Sammlung Munich, 1996, pp. 23ff.

MacAdam, Barbara A. "A Stripe Day/La Metafisica della luce," ARTNEWS, February 1992

Madoff, Steven Henry. "Sean Scully at William Beadleston," ART IN AMERICA, March 1983, p. 157

Madoff, Steven Henry. "A New Generation of Abstract Painters," ARTNEWS, November 1983, p. 78–84

Madoff, Steven Henry. "An Inevitable Gathering," ARTNEWS, September 1987, p. 183

Madoff, Steven Henry. "Wholeness, Partness, and the Gift," SEAN SCULLY. THE CATHERINE PAINTINGS, Modern Art Museum of Fort Worth, 1993, pp. 47–53

Martino, Vittoria. "Aus dem Herzen der Finsternis," SEAN SCULLY. PRINTS. CATALOGUE RAISONNÉ 1968–1999, Graphische Sammlung Albertina, Vienna 1999

McCarron, John. "Conversation. John McCarron with Sean Scully," SHIFT, Vol. 2, No. 3, 1988, pp. 14–19

Masheck, Joseph. "Stripes and Strokes: On Sean Scully's Paintings," SEAN SCULLY PAINTINGS 1971–1981, Ikon Gallery, Birmingham 1981, pp. 4–15

Masheck, Joseph. "Piecing Things Together. A Conversation between Sean Scully and Joseph Masheck," SEAN SCULLY, David McKee Gallery, New York, 1986, (Reprinted in MODERNITIES, Penn State Press, Pennsylvania 1993)

Meyers, Michelle. SEAN SCULLY/DONALD SULTAN. PAINTINGS, DRAWINGS AND PRINTS FROM THE ANDERSON COLLECTION, Stanford University Art Gallery and Museum, 1990

Molina, Anglea. "Sean Scully: Una pintura hecha con amor puede cambiarr el mundo,"ABC CATALUNA. March 17, 2000.

Morgan, Robert C. "Physicality and Metaphor: The Paintings of Sean Scully," ART JOURNAL, Spring 1991, pp. 64–66

Name, Daniela. "No color de Rocinha," O GLOBO (BRAZIL). September 19, 2002.

Naves, Mario. "Heroic Art is Bravura Only," THE NEW YORK OBSERVER. May 31, 1999.

Newman, Michael. "Sean Scully," ART MONTHLY, October 1981, p. 17

Newman, Michael. "New York Reviews," FLASH ART, June/July 1979, p. 52

Nibuya, Takashi. "Touching on the Issue of Panic," SEAN SCULLY, Fuji Television Gallery, Tokyo 1988

Noda, Masaaki. "Sean Scully," SEAN SCULLY. THE LIGHT IN THE DARKNESS, Fuji Television Gallery, Tokyo 1994

Oliver, Georgina, "Sean Scully," CONNAISSEUR, December 1973, p. 302

Ostrow, Saul. "Sean Scully at Mary Boone," FLASH ART, December 1993, p. 113

Pagel, David. "Monumental paintings done with a light touch," LOS ANGELES TIMES. November 22, 2002.

Paparoni, Demetrio. "Sean Scully. A Conversation with Demetrio Paparoni," TEMA CELESTE, April/May 1992, pp. 82ff. (Reprinted in SEAN SCULLY, Edicions T, Barcelona 1996)

Paparoni, Demetrio. "L'Astrazione ridefinita," TEMA CELESTE, 1994

Paparoni, Demetrio. "Beyond Formalism: Sean Scully," SEAN SCULLY. THE LIGHT IN THE DARKNESS, Fuji Television Gallery, Tokyo 1994

Paparoni, Demetrio. "La Forma e lo Spirito," SEAN SCULLY, Galleria Gian Ferrari Arte Contemporanea, Mailand 1994

Peppiatt, Michael. ESPACE ET LUMIÈRE. CONVERSATION AVEC RICHARD MEIER ET SEAN SCULLY, Paris 1999

Poirier, Maurice. "Sean Scully," ARTNEWS, January 1987, p. 160

Poirier, Maurice. SEAN SCULLY, New York 1990

Power, Kevin. "Cantando solo con Scully/Singing along with Scully," SEAN SCULLY, Sala de Exposiciones Rekalde, Bilbao 1997, pp. 17/53ff. (Reprinted in SEAN SCULLY, Kerlin Gallery, Dublin 1999, pp. 3ff.)

Power, Kevin. "Sean Scully sobre la geometira," EL MUNDO: EL CULTURAL. May 8-14, 2002, p. 25-27.

Princenthal, Nancy. "Irrepressible Vigor: Printmaking Expands," ARTNEWS, September 1990

Puvogel, Renate. "Sean Scully. Neue Arbeiten," KUNSTWERK, February 1986, pp. 84f.

Raddo, Elena di. "Sean Scully: Intervista al l'Artiste Irlandese," SEGNO, Autumn 1994

Rantanen, Mari. "An Interview with Sean Scully," HARVEY QUAYTMAN AND SEAN SCULLY, Helsinki Festival, Helsinki 1987

Ratcliff, Carter. "Artist's Dialogue: Sean Scully. A Language of Materials," ARCHITECTURAL DIGEST, February 1988, pp. 54, 62ff.

Ratcliff, Carter. "Sean Scully and Modernist Painting. The Constitutive Image," SEAN SCULLY. PAINTINGS AND WORKS ON PAPER 1982–88, Whitechapel Art Gallery, London 1989, pp. 9–31 (Reprinted in SEAN SCULLY, Galerie Jamileh Weber, Zürich 1991)

Ratcliff, Carter. "Sean Scully und die moderne Malerei. Die Konstitution des Bildes," SEAN SCULLY. GEMÄLDE UND ARBEITEN AUF PAPIER 1982–1988, Städtische Galerie im Lenbachhaus, München 1989, pp. 9ff.

Ratcliff, Carter. "Sean Scully: The Constitutive Stripe," SEAN SCULLY. THE CATHERINE PAINTINGS, Modern Art Museum of Fort Worth, 1993, pp. 8–29

Rifkin, Ned. "Sean Scully: Twenty Years, 1976–1995," SEAN SCULLY. TWENTY YEARS. 1976–1995, High Museum of Art, Atlanta 1995, pp. 11ff.

Rifkin, Ned. "Interview with Sean Scully," SEAN SCULLY. TWENTY YEARS. 1976–1995, High Museum of Art, Atlanta 1995, pp. 57ff.

Roberts, John. "Patterns and Patterns: Sean Scully and Tony Sherman," ART MONTHLY, September 1979, pp. 11ff.

Rosenthal, Adrienne. "Painting by Sean Scully," ARTWEEK, March 29, 1975

Ruane, Medb. "Tales of Scully Duggery, THE IRISH SUNDAY TIMES. October 24, 1999.

Rubenstein, Meyer Raphael. "Books: Sean Scully," ARTS, March 1991

Saltz, Jerry. "Mayday, Mayday, Mayday," ART IN AMERICA, September 1993, p. 44

Sandler, Irving. "Sean Scully interviewed by Irving Sandler (February 1997)," SEAN SCULLY. PAINTINGS, Manchester City Art Galleries, Manchester 1997, pp. 34–47

Sauré, Wolfgang. "Sean Scully," WELTKUNST, January 1994, p. 141

Schefer, Jean Louis. "Corps sans figure," SEAN SCULLY, Galerie Nationale du Jeu de Paume, Paris 1996, pp. 7ff.

Schefer, Jean Louis. "Cuerpos sin figura/Shapeless Bodies," SEAN SCULLY, Sala de Exposiciones Rekalde, Bilbao 1997, pp. 35/67ff.

Schnock, Frieder. "Sean Scully. Bilder und Zeichnungen," NIKE, January 1986, p. 42

Schwabsky, Barry. "Sean Scully. Mary Boone Gallery," ARTFORUM INTERNATIONAL, December 1993, p. 78

Schwarz, Arturo. "Italia/America: L'Astrazione ridefinita," SEGNO, Autumn 1993

Scully, Sean/Paladino, Mimmo. "'In at the Deep End' (A Conversation by Telephone)," MODERN PAINTERS, Summer 1993

Scully, Sean. "Bodies of Light," THE TIMES LITERARY SUPPLEMENT, November 6, 1998, No. 4988 and ART IN AMERICA, July 1999, pp. 67ff. (Reprinted "Against the Dying of his own Light. Mystery and Sadness in Rothko's Work," SEAN SCULLY. BARCELONA PAINTINGS AND RECENT EDITIONS, Galerie Bernd Klüser, Munich 1999, pp. 11/63ff.

Searle, Adrian. "Recent British Painting. Future Space," FLASH ART, March/April 1980, pp. 28f.

Searle, Adrian, "The British Art Show," ARTFORUM INTERNATIONAL, April 1980, pp. 87f.

Semff, Michael. "Die sublime Dialektik des scheinbar immer Gleichen. Pastell und Wasserfarbe bei Sean Scully/The Dialectic's of Sameness: Sean Scully's Pastels and Watercolours," SEAN SCULLY. WORKS ON PAPER 1975–1996, Staatliche Graphische Sammlung, Munich 1996, pp. 31ff.

Shone, Richard. "Sean Scully," BURLINGTON MAGAZINE, January 1963

Silverman, Andrea. "Sean Scully," ARTNEWS, October 1986, pp. 98f.

Smith, Alistair. "Sean Scully," IRISH ARTS REVIEW YEARBOOK, 1994

Sofer, Ken. "Monotypes from the Garner Tullis Workshop," ARTNEWS, November 1987, p. 210

Spalding, Frances. "Unequal Halves," ARTS REVIEW, September 1993

("S.S."). "reviews, Sean Scully at L.A. Louver," THE ART NEWSPAPER. November 2002. No. 130.

Stoddart, Hugh. "Sean Scully," CONTEMPORARY VISUAL ARTS, 23, May 1999, pp. 30–35

Tatransky, Valentin. "Sean Scully," ARTS MAGAZINE, February 1980, pp. 35f.

Tatransky, Valentin. " Sean Scully," ARTS MAGAZINE, February 1981, pp. 35

Tóibín, Colm. "Sean Scully. The Shimmering Richness of the World," SEAN SCULLY, Kerlin Gallery, Dublin 1999, pp. 43ff.

Trepp, Judith. "5 One-Man Shows: Jamileh Weber," ARTNEWS, January 1994

Tschechne, Martin. "Sean Scully. Strenge Form, große Gefühle," ART. DAS KUNSTMAGAZIN, July 1998, pp. 16–27

Uberquoi, Marie-Claire. "Los Juegos de Luz de Sean Scully," EL MUNDO. March 17, 2000.

___. "Exposa murs de llum i color a Tache,"AVUI. March 17, 2000.

___. "Reviews," THE ART NEWSPAPER. April 2001.

___. "El Instituto Cervantes de Londres un Cilclo Sobre Garcia-Loorca," GRANADA. June 2, 2001, p. 44.

Walker, Dorothy. "The 10 Masters of Abstract Art," THE IRISH SUNDAY TIMES, March 18, 1999.

Wei, Lily. "reviews, Sean Scully at Knoedler and Galerie Lelong," ART IN AMERICA. January 2002.

Welish, Marjorie. "Abstraction, Advocacy of," TEMA CELESTE, January/March 1992, pp. 74–79

Westfall, Stephen. "Recent Aspects of All-Over," ARTS MAGAZINE, December 1982, p. 40

Westfall, Stephen. "Sean Scully," ARTS MAGAZINE, November 1983, p. 35

Westfall, Stephen. "Sean Scully," ARTS MAGAZINE, September 1985, p. 40

Westfall, Stephen. "Sean Scully," ART IN AMERICA, September 1989, pp. 208, 210

Winter, Peter. "Shape Is Not Abstract," ART INTERNATIONAL, Summer 1990, pp. 79–81

Yau, John. "Sean Scully. McKee Gallery/Pamela Auchincloss Gallery," ARTFORUM INTERNATIONAL, April 1991, pp. 124f.

Yau, John. "Défis/State of defiance," SEAN SCULLY, Galerie Lelong (repères. Cahiers d'art contemporain No. 101) Paris 1999 (Reprinted SEAN SCULLY. NEW PAINTINGS AND WORK ON PAPER, Danese/Galerie Lelong, New York 1999, pp. 4ff.)

Yoskowitz, Robert. "Sean Scully/Martha Alf," ARTS MAGAZINE, April 1980, p. 24

Zimmer, William. "Heart of Darkness. New Stripe Paintings by and an Interview with Sean Scully," ARTS MAGAZINE, December 1982, pp. 82f.

Zimmer, William. "Sean Scully," ARTNEWS, May 1989, pp. 159f.

Zweite, Armin. "'To Humanize Abstract Painting'. Einige Bemerkungen zu Sean Scullys 'Stone Light'/Reflections on Sean Scully's 'Stone Light'" SEAN SCULLY. PAINTINGS AND WORKS ON PAPER, Galerie Bernd Klüser, Munich 1993

Liste der ausgestellten Werke · List of Exhibited Works

001 *Crossover Painting #1* · 1974 · Acryl auf Leinwand / Acrylic on canvas · 243,8 × 243,8 cm · Privatsammlung / Private collection

002 *Overlay #1* · 1974 · Acryl auf Leinwand / Acrylic on canvas · 243,8 × 243,8 cm · Privatsammlung / Private collection

003 *Overlay #4* · 1974 · Acryl auf Leinwand / Acrylic on canvas · 243,8 × 243,8 cm · Privatsammlung / Private collection

004 *Overlay #5* · 1974 · Acryl auf Leinwand / Acrylic on canvas · 243,8 × 243,8 cm · Privatsammlung / Private collection

005 *Overlay #9* · 1974 · Acryl auf Leinwand / Acrylic on canvas · 243,8 × 243,8 cm · Privatsammlung / Private collection

006 *Araby* · 1981 · Öl auf Leinwand / Oil on canvas · 243,8 × 198 cm · Privatsammlung / Private collection

007 *The Bather* · 1983 · Öl auf Leinwand / Oil on linen · 243,8 × 304,8 cm · Privatsammlung / Private collection, courtesy of Timothy Taylor Gallery, London

008 *Falling Wrong* · 1985 · Öl auf Leinwand / Oil on linen · 243,8 × 274,3 cm · Privatsammlung / Private collection

009 *How Not* · 1985 · Öl auf Leinwand / Oil on linen · 243,8 × 274,3 cm · Privatsammlung / Private collection · Nicht in der Ausstellung / Not in the exhibition

010 *Lost Land* · 1985 · Öl auf Leinwand / Oil on linen · 259,1 × 365,8 cm · Städtische Galerie im Lenbachhaus, München

011 *One Yellow* · 1985 · Öl auf Leinwand / Oil on linen · 182,9 × 284,5 cm · Sammlung / Collection Jamileh Weber Galerie

012 *Two One One* · 1985 · Öl auf Leinwand / Oil on linen · 228,6 × 274,3 cm · museum franz gertsch, Burgdorf (CH)

013 *Dreamland* · 1987 · Öl auf Leinwand / Oil on linen · 228,6 × 297,2 cm · Timothy Taylor Gallery, London

014 *Darkness and Heat* · 1988 · Öl auf Leinwand / Oil on linen · 203,2 × 274,3 cm · Sammlung Ströher / Ströher Collection, Darmstadt

015 *Arran* · 1990 · Öl auf Holz / Oil on wood · 30,5 × 29,2 cm · Privatsammlung / Private collection, courtesy of Timothy Taylor Gallery, London

016 *Day Night* · 1990 · Öl auf Leinwand / Oil on linen · 254 × 381 cm · Privatsammlung / Private collection

017 *Happy Days* · 1991 · Öl auf Leinwand / Oil on linen · 254 × 392 cm · Privatsammlung / Private collection

018 *Light in August* · 1991 · Öl auf Leinwand / Oil on linen · 228,6 × 304,8 cm · ZKM | Zentrum für Kunst und Medientechnologie Karlsruhe / ZKM | Center for Art and Media Karlsruhe

019 *Pink Insert* · 1991 · Öl auf Leinwand / Oil on linen · 60,96 × 60,96 cm · Privatsammlung / Private collection

020 *Union Grey* · 1994 · Öl auf Leinwand / Oil on linen · 243,8 × 243,8 cm · Sammlung Klüser / Klüser Collection, München

021 *Union Yellow* · 1994 · Öl auf Leinwand / Oil on linen · 213,4 × 243,8 cm · Privatsammlung / Private collection

022 *Block* · 1995 · Öl auf Holz / Oil on wood · 30,5 × 30,5 cm · Privatsammlung / Private collection, courtesy of Timothy Taylor Gallery, London

023 *Uriel* · 1997 · Öl auf Leinwand / Oil on linen · 243,8 × 365,8 cm · Lentos Kunstmuseum Linz

024 *Pale Mirror* · 1999 · Öl auf Leinwand / Oil on linen · 250 × 220 cm · Privatsammlung / Private collection

025 *Small Barcelona Painting 9.15.99* · 1999 · Öl auf Leinwand / Oil on linen · 61 × 81,3 cm · Privatsammlung / Private collection

026 *Wall of Light Light* · 1999 · Öl auf Leinwand / Oil on linen · 274,3 × 304,8 cm · Kunstsammlung Nordrhein-Westfalen, Düsseldorf

027 *Wall of Light Dog* · 2000 · Öl auf Leinwand / Oil on linen · 189 × 203 cm · Kassel, Museumslandschaft Hessen Kassel

028 *Red Bar* · 2002 · Öl auf Leinwand / Oil on linen · 147,3 × 139,7 cm · Privatsammlung / Private collection

029 *Colored Landline* · 2003 · Öl auf Leinwand / Oil on linen · 81,3 × 61 cm · Privatsammlung / Private collection

030 *Landline Sand* · 2003 · Öl auf Leinwand / Oil on linen · 81,3 × 61 cm · Privatsammlung / Private collection

031 *Abend* · 2003 · Öl auf Leinwand / Oil on linen · 61 × 81,3 cm · Privatsammlung / Private collection

032 *Princess* · 2003 · Öl auf Leinwand / Oil on linen · 40,5 × 51 cm · Privatsammlung / Private collection

033 *Königin der Nacht* · 2003 · Öl auf Leinwand / Oil on linen · 165 × 330 cm · Privatsammlung / Private collection

034 *Figure in Blue* · 2003 · Öl auf Leinwand / Oil on linen · 200,5 × 185,5 cm · Privatsammlung / Private collection

035 *Blue Yellow Figure* · 2004 · Öl auf Leinwand / Oil on linen · 201 × 185 cm · Walter Storms Galerie, München

036 *Figure Figure* · 2004 · Öl auf Leinwand / Oil on linen · 244 × 214 cm · Privatsammlung / Private collection, courtesy of Jamileh Weber Galerie

037 *Figure in Orange* · 2004 · Öl auf Leinwand / Oil on linen · 243,8 × 213,4 cm · Privatsammlung / Private collection

038 *Passenger Line Pink Blue* · 2004 · Öl auf Leinwand / Oil on linen · 64 × 50,5 cm · Privatsammlung / Private collection

039 *Passenger Line Red White* · 2004 · Öl auf Leinwand / Oil on linen · 64 × 50,5 cm · Privatsammlung / Private collection

040 *Union Blue* · 2004 · Öl auf Leinwand / Oil on linen · 228 × 366 cm · Privatsammlung / Private collection

041 *Barcelona Red Blue* · 2004 · Öl auf Leinwand / Oil on linen · 60 × 80 cm · Privatsammlung / Private collection

042 *Dark Blue 8.05* · 2005 · Öl auf Leinwand / Oil on linen · 40,5 × 51 cm · Privatsammlung / Private collection

043 *Falling Dark* · 2005 · Öl auf Leinwand / Oil on linen · 135 × 135 cm · Privatsammlung / Private collection

044 *Small River Blue* · 2005 · Öl auf Leinwand / Oil on linen · 40,5 × 51 cm · Privatsammlung / Private collection

045 *Window Painting* · 2005 · Öl auf Leinwand / Oil on linen · 184 × 200 cm · Privatsammlung / Private collection

046 *Beckett* · 2006 · Öl auf Leinwand / Oil on linen · 214 × 182 cm · Privatsammlung / Private collection

047 *Big Yellow Robe 2.06* · 2006 · Öl auf Leinwand / Oil on linen · 244 × 214 cm · Privatsammlung / Private collection

048 *Dark Wall 5.06* · 2006 · Öl auf Leinwand / Oil on linen · 214 × 182 cm · Privatsammlung / Private collection

049 *Landline Pale Blue 8.06* · 2006 · Öl auf Leinwand / Oil on linen · 80,5 × 60,5 cm · Privatsammlung / Private collection

050 *Green Robe* · 2007 · Öl auf Aluminum / Oil on Aluminum · 71,2 × 81,4 cm · Privatsammlung / Private collection

051 *Mirror Crimson Black* · 2007 · Öl auf Leinwand / Oil on linen · 254 × 305 cm · Privatsammlung / Private collection

052 *Mirror Silver* · 2007 · Öl auf Aluminum / Oil on Aluminum · 254 × 305 cm · Privatsammlung / Private collection

053 *Wall of Light Yellow Plain* · 2007 · Öl auf Leinwand / Oil on linen · 203 × 190 cm · Privatsammlung / Private collection

054 *Small Red Black Fold* · 2004 – 2007 · Öl auf Leinwand / Oil on linen · 60 × 45 cm · Privatsammlung / Private collection

055 *12 Triptychs #1 – 12* · 2008 · Öl auf Kupfer / Oil on copper · je 32,2 × 38,2 cm · Privatsammlung / Private collection

056 *Crimson Crimson 3.08* · 2008 · Öl auf Aluminum / Oil on aluminum · 101,6 × 88,9 cm · Privatsammlung / Private collection

057 *Cut Ground Colored Triptych 6.08* · 2008 · Öl auf Aluminum / Oil on aluminum · 140 × 203 cm · Privatsammlung / Private collection

058 *Barcelona Robe 7.08* · 2008 · Öl auf Aluminum / Oil on aluminum · 140 × 203 cm · Privatsammlung / Private collection, courtesy of Galeria Carles Taché

059 *Margarita* · 2008 · Öl auf Leinwand / Oil on linen · 274,2 × 335,3 cm · Privatsammlung / Private collection

060 *Titian's Robe Pink 08* · 2008 · Öl auf Aluminum / Oil on aluminum · 279,5 × 406,5 cm · Privatsammlung / Private collection

061 *Big Robe Triptych* · 2008 · Öl auf Aluminum / Oil on aluminum · 279,5 × 406,5 cm · Privatsammlung / Private collection

062 *Cut Grey Ground 08* · 2008 · Öl auf Aluminum / Oil on aluminum · 279,5 × 406,5 cm · Privatsammlung / Private collection ·

Dieser Katalog erscheint anlässlich der Ausstellung *Konstantinopel oder Die versteckte Sinnlichkeit. Die Bilderwelt von Sean Scully* im MKM Museum Küppersmühle für Moderne Kunst, Duisburg, 19. Februar bis 3. Mai 2009
This catalogue is published to accompany the exhibition *Constantinople or The Sensual Concealed. The Imagery of Sean Scully* at MKM Museum Küppersmühle für Moderne Kunst, Duisburg, 19 February to 3 May 2009

Folgestationen / Subsequent venues
Ulster Museum Belfast
Kunstsammlungen Chemnitz
Weserburg | Museum für moderne
Kunst in Bremen

Eine Ausstellung der Stiftung für Kunst und Kultur e.V. Bonn
An exhibition by the Stiftung für Kunst und Kultur e.V. Bonn

Stiftung für Kunst
und Kultur e.V.
Bonn

Wir danken unseren Förderern und Partnern
We would like to thank our sponsors and partners

SAL. OPPENHEIM
Privatbankiers seit 1789

GEBAG
Das Immobilienunternehmen
der Stadt Duisburg

Willis
Insurance Brokers

RUHR.2010
Kulturhauptstadt Europas

Ausstellung · Exhibition

Direktor MKM / Director MKM
Walter Smerling

Kurator / Curator
Susanne Kleine

Geschäftsführung MKM /
Business manager MKM
Marie-Louise Hirschmüller

Projektmanagement und Öffentlichkeitsarbeit / Project manager and public relations
Tina Franke

Installation und Technik /
Installation and technical team
Wojcik & Wojcik

Leihgeber · Lenders

Kassel, Museumslandschaft Hessen Kassel
Kunstsammlung Nordrhein-Westfalen, Düsseldorf
Lentos Kunstmuseum Linz
museum franz gertsch, Burgdorf
Privatsammlung / Private Collection
Sammlung / Collection Jamileh Weber Galerie
Sammlung Klüser / Klüser Collection, München
Sammlung Ströher / Ströher Collection, Darmstadt
Städtische Galerie im Lenbachhaus, München
Timothy Taylor Gallery, London
Walter Storms Galerie, München
ZKM | Zentrum für Kunst und Medientechnologie Karlsruhe /
ZKM | Center for Art and Media Karlsruhe

Katalog · Catalogue

Herausgeber / Publisher
Walter Smerling, Susanne Kleine

Redaktion / Editor
Tina Franke, Susanne Kleine

Übersetzung / Translation
Alexandra Bootz, John Rayner

Herzlichen Dank an / Special thanks to
Nicole Hayes, Arturo Rucci

Fotonachweis / Photographers
Atelier Sean Scully / Sean Scully Studio und / and Städtische Galerie im Lenbachhaus, München (Nr. / No. 010 Lost Land).

Umschlagabbildung / Cover photo
Sean Scully, Two One One, 1985

Seiten / Pages 2–3
Sean Scully, Two One One, 1985

© 2009 Stiftung für Kunst und Kultur e.V. Bonn

© Prestel Verlag, München · Berlin · London · New York 2009

© für die abgebildeten Werke von Sean Scully / for the works of art by Sean Scully: der Künstler / the artist

Prestel Verlag
Königinstraße 9
80539 München
Tel. +49 (0)89 24 29 08-300
Fax +49 (0)89 24 29 08-335

www.prestel.de

Prestel Publishing Ltd.
4 Bloomsbury Place
London WC1A 2QA
Tel. +44 (0)20 7323-5004
Fax +44 (0)20 7636-8004

Prestel Publishing
900 Broadway, Suite 603
New York, N.Y. 10003
Tel. +1 (212) 995-2720
Fax +1 (212) 995-2733

www.prestel.com

Prestel books are available worldwide. Please contact your nearest bookseller or one of the above addresses for information concerning your local distributor.

Die Deutsche Nationalbibliothek verzeichnet diese Publikation in der Deutschen Nationalbibliografie; detaillierte bibliografische Daten sind im Internet über http://dnb.ddb.de abrufbar.

The Library of Congress Control Number: 2009921008
British Library Cataloguing-in-Publication Data: a catalogue record for this book is available from the British Library. The Deutsche Bibliothek holds a record of this publication in the Deutsche Nationalbibliografie; detailed bibliographical data can be found under: http://dnb.ddb.de

Lektorat / Copyediting
Reegan Köster, Julia Strysio

Design und / and layout
SOFAROBOTNIK, Augsburg & München

Herstellung / Production
Sebastian Runow

Repro / Origination
Reproline München

Druck und Bindung /
Printing and binding
Druckerei Uhl, Radolfzell

Printed in Germany
on acid-free paper

ISBN 978-3-7913-4310-5